PORTLAND
IN THE 1960s

PORTLAND
IN THE 1960s

STORIES FROM THE COUNTERCULTURE

POLINA OLSEN
Foreword by Joe Uris

Published by The History Press
Charleston, SC 29403
www.historypress.net

Copyright © 2012 by Polina Olsen
All rights reserved

First published 2012
Second printing 2013

Manufactured in the United States

ISBN 978.1.60949.471.1

Library of Congress CIP data applied for.

Notice: The information in this book is true and complete to the best of our knowledge. It is offered without guarantee on the part of the author or The History Press. The author and The History Press disclaim all liability in connection with the use of this book.

All rights reserved. No part of this book may be reproduced or transmitted in any form whatsoever without prior written permission from the publisher except in the case of brief quotations embodied in critical articles and reviews.

For Andy

CONTENTS

Foreword, by Joe Uris	9
Acknowledgements	13
Setting the Scene: Remembering Lair Hill Park	15
PART I: RETROSPECTIVE: FROM BEAT TO HIP	27
Darcelle Looks Back at the Caffe Espresso	28
The Village	31
The Thirteenth Avenue Gallery Goes Dada	35
Days and Nights Bookstore	38
A Way Out Café	40
Franz Schneider Remembers the Music	42
Allen Ginsberg Comes to Town	44
Henk Pander in America	48
The Portland Zoo	52
A Storefront Theatre	56
PART II: COUNTER INSTITUTIONS	63
Emery Ingham and the Psychedelic Supermarket	64
Phantasmagoria	69
The Willamette Learning Center Gives Dropouts a Chance	71

Contents

Outside In from the Ground Up	77
Fitting It into the Gospel: Harper Richardson and the Centenary Wilbur Church	79
KBOO, On the Air	83
The *Willamette Bridge*	86
PART III: ACTION	93
The Life and Death of the *Portland Reporter*	94
Peace Now!	100
The Portland State Student Strike	105
A People's Army Jamboree	111
The Black Panther Party Serves Breakfast	121
George Oberg Leads the Second Foundation	127
Donald Dwayne Downing Has a Spiritual Experience	129
Letters to the *Fountain*	131
Beginning with Red Emma	135
Appendix: 1960s Timeline	139
Bibliography	145
Index	151
About the Author	159

FOREWORD

It was the best of times. It was the worst of times.
It was the best of times for the young adults and teenagers of the 1960s. This was an era of pleasures, both cultural and sensual, a sudden moment of shining fun in a dark and dismal landscape.

Marijuana, once the drug of a narrow audience of hipsters, musicians and persons of color, became sought after and easily available to the white masses of all classes. Psychedelics, mind-altering and perception-changing substances—both natural like peyote and psilocybin mushrooms and easily swallowed lab-produced substances like LSD—could plunge one into a world of seemingly parallel universes. The mass production of LSD created a vast network of casual commerce and ancillary industries like head shops and poster and comic book printing. The world of drugs moved into vast open emporiums in city parks, streets and homes all over America.

In approximately the same time frame, the pill, seemingly safe and effortless contraception, made heterosexual intimacy easy and, in a climate already deeply sexualized by mass media, for young adults, normative.

All this followed closely on the heels of a revolution in popular music that began in the 1950s and was as deep and profound as that of the earlier jazz age. It began with a popular wave of interest in traditional American folk music. At the same time, black music styles ranging from rhythm and blues and rock-and-roll to new forms of jazz and, by the 1960s, acid rock blasted their way into the audio universe of middle-class white America.

In the latter half of the 1960s, this was accompanied by an odd mixture of New Age religion, Asian mysticism and Native American faiths.

Foreword

Suddenly, in the world of pleasures, it seemed anything was possible in a culturally open society. Sex, drugs and rock-and-roll for real in every home, high school, college and club.

No area of popular culture escaped the impact of the '60s. Even clothing styles were altered. Bralessness for women, beards for men and bell-bottoms and long hair for both were seen in every town. Normative expectations were shifting fast. And escapist pleasures were becoming the norm. These cultural changes and nearly biological imperatives were yanking the young into a matrix of youth-oriented hedonistic fun and games.

While these were the temptations of the time, looming far more significantly were serious efforts to accomplish profound changes in society itself. A self-actualized, long-developing African American movement for social and political justice gained attention and white support with the Supreme Court–mandated school desegregation in 1954 and '56. This was followed by the Montgomery bus desegregation struggle, lunch counter desegregation efforts, Freedom Rides and voting rights fights throughout the South. These in turn would evolve, even after legal victories, into nationwide black struggles, which, after many failed efforts at real equality, would yield to strong black nationalist movements demanding Black Power through agencies like the Nation of Islam and the Black Panthers. The FBI and local police would launch campaigns of both legal and illegal repression, most famously through programs like J. Edgar Hoover's COINTELPRO, which carried out every kind of harassment from disinformation to murder.

In the white middle-class student world, demand for adult status at places like Berkeley and Columbia University grew rapidly. In a nation morbidly preparing itself for a doomsday scenario of nuclear holocaust, movements led by students, churchmen and New Left visionaries organized first against the bomb and the Cold War and then more specifically against wars of a colonial nature. Ironically, the peacetime Cold War draft fueled these movements. They culminated in the strong anti–Vietnam War Movement of the 1960s and '70s. It was in part the very failure of this opposition to pointless wars that made the cultural hedonism of the era so popular. It seemed suddenly breathtakingly clear that no amount of opposition in any form could end American imperialism.

The youth of America had all too well absorbed the nation's mystic creed of exceptionalism, freedom and justice. And when the scrim of national ideology was pulled away, in a very real sense, the nation's creed failed to hold up. And with the well-learned American mythology gone, only a

Foreword

wild sense of existential pleasure or need for action was left. Suddenly, for countless youth, a vast wasteland of inequity and murderousness loomed.

In Portland, as elsewhere, the authorities were ill prepared for the onslaught of disillusion, outrage, idealism and hedonism. Polina Olsen has, in these pages, captured much of the facts, moods and ideas of that time in the context of a smallish city on the West Coast. What follows is a taste of the best and worst of times—an amazing moment in modern American history.

Joe Uris

Joe Uris holds an MA in sociology and a PhD in urban studies. He is a semi-retired associate professor at Portland State University and teaches U.S. history. Uris was active in the "Ban the Bomb," civil rights and antiwar movements during the 1960s and was student body president of Portland State from 1966 to 1967. He has written for Willamette Week, *the* Oregonian *and other publications and hosts a talk show with Abe Proctor on KBOO-FM Radio.*

ACKNOWLEDGEMENTS

My first thanks go to the many people I interviewed in person, by phone or by e-mail beginning with Emery Ingham, for memories of the Psychedelic Supermarket and photos his father had the foresight to preserve; Hugo du Coudray and Maurice Isserman, for multiple interviews and ongoing help with New Left politics; and Joe Uris, for insight into every aspect of 1960s life and for writing the foreword.

Thank you for the wonderful stories: Maryalice Cheesman on Phantasmagoria (I would have been your best customer); Vivian Allison, Katherine Richardson Bruna and Bill Wyatt on Harper Richardson and the Centenary Wilbur Church; Steve Baumgarte, Mason Drukman, Barbara Gundle, Jim Houser, Lester Lamm, Michael McCusker, Ray Raphael, Glen Swift, Antonio Valdez and Howard Wascow on the Portland State University student strike, People's Army Jamboree and Vortex Festival; Michael Wells on the *Willamette Bridge*; Darcelle and Larry Howard on the Caffe Espresso; Rondal Snodgrass and William Weissert on Allen Ginsberg's visit; Rondal again, along with Patsy Child, Rochelle Dodson, Bonnie and Peter Reagan and Becky Weggler, on the Willamette Learning Center; Donald Dwayne Downing, George Nicola, George Oberg and Lanny Swerdlow on early gay rights; Alison Draper, Jim Gilbert, Patrick Jones, Margo Maris and Ann Williamson on Lair Hill Park; Bud Clark, Tom Shrader, John Silvertooth and Henry Zenk for helping me picture the era; Don Fiser, Kent Ford, Oscar Johnson, Percy Hampton, Dr. Gerald Morel and Deborah Patterson on Albina and the Black Panther Party; Julie Aitken, John Forstrom and Bruce Stoner on the Psychedelic Supermarket; Peter Gerety and Nicholas Hill on the Storefront Theatre; Tom Grant for mentioning the Village, and Diane

Acknowledgements

and Rex Amos, Gretchen Enyart Young and Carl Smith for filling in the details; Gray Haertig and Bill Reinhardt for early KBOO memories; LeRoy Hathaway on the Way Out Café; Paul Hebb for Thirteenth Avenue Gallery memories and posters; Barbara Gundle, Gretchen Kafoury and Kristan Knapp on Red Emma and women's issues; Mark Meltzer and Rose Rustin, along with Dr. Charles and Linda Rice Spray, on Outside In; Henk Pander for recollections and beautiful artwork; and Mary Ann Pickens and Cheryl Lynne Pickens Rubbo on the Days and Nights Bookstore.

Many thanks to the musicians who shared their stories: Paul Bassett of the PH Phactor Jug Band, Dennis Fagaly and Fred Lackaff of the Tweedy Brothers, Peter Langston of the Portland Zoo, guitarist Mike Russo and Jim Wilkins of Great Pumpkin. Thank you Franz Schneider for memories of Mel Lyman.

The *Portland Reporter* was among the under-told stories I most wanted to include. Thank you Cap Hedges, Amy Klare, Harry Meader and John Wykoff for your memories and photographs. I'm glad I found you.

In addition to those I interviewed, I would like to thank Simon Cheesman for help obtaining the great photo of Phantasmagoria; Jim Felt for permission to use the photo; Dory Hylton for your outstanding thesis on the PSU Student Strike; Jake Kiehle for *One Dollar* magazines; Dave Kohl for insight into gay rights; Stephen Kosokoff for names of interviewees; Walter McMonies for sharing original John Waddingham drawings of the Village; Joan Waddington for permission to publish them; Sandy Polishuk for your note on Allen Ginsberg; Thomas Richardson for bringing my questions to your father when he was too ill for a guest; Susan Stelljes for Storefront Theatre archives; Phil Wikelund for long conversations at the Lair Hill Bistro; Dolores Ashkar, David Celsi, John Dennis, Dick Minor, Susan St. Michael, Jessica Sorensen Storm, Michael Stickland, Antonio Valdez and Bruce Weber for posters and photos; and Peter Bellant for helping me track down Bruce Weber.

Many thanks to Mary Hansen and Brian Johnson of the Portland City Archives for truly spectacular research assistance; the librarians and Jim Strassmaier at the Oregon Historical Society; the interlibrary loan department at the Multnomah County Library; Aubrie Koenig and the other great editors and staff at The History Press; and, finally, my wonderful husband of thirty-six years and best friend, Andy Olsen, for his unending patience and support.

SETTING THE SCENE

REMEMBERING LAIR HILL PARK

In 1867, lawyer, historian and *Oregonian* newspaper editor William Lair Hill purchased what became Lair Hill Park from Finice Caruthers. Steel industrialist Charles E. Smith bought the acreage, built a mansion and donated the house and property to Multnomah County Hospital in 1909. By this time, thousands of Jewish and Italian immigrants called the neighborhood, known as South Portland, home.

The community reflected the immigrants' countries of origin, with kosher butcher shops, Italian delis, synagogues and churches. The National Council of Jewish Women founded the Neighborhood House as a sewing school in 1896 and moved across from the hospital in 1910. In 1921, with the help of Carnegie funds, the library shifted from a house on First Avenue to the Italianate building at Southwest Second Avenue and Hooker Street. When the hospital moved to Marquam Hill in 1923, the city turned the property into a park. The old nurses' residence became the Children's Museum.

The neighborhood changed. Jews started moving to Laurelhurst and Irvington in the late 1920s. By the early 1960s, the South Auditorium Urban Renewal Project had demolished fifty-four blocks north of Southwest Arthur Street.

Fears of further urban renewal inhibited investment, and elderly immigrants made up a high proportion of the remaining residents. Bohemians liked the old homes, cheap rents and proximity to the Portland State campus. By the late 1960s, the area around Lair Hill Park was the center of Portland's hippie community.

Portland in the 1960s

The War Begins

In January 1967, vice squad officers and federal agents raided eleven neighborhood residences, seized $20,000 worth of marijuana and arrested fifty-two people. A February 9, 1967 *Oregonian* article described the scene: "Most of the men wore tight, checkered pants, sweat shirts and wide belts. The girls had long hair and wore black stockings. Their 'pads,' mostly in rundown, multiple-unit dwellings in Southwest Portland, are filthy. The beds are just mattresses spread out on the floor."

An *Oregonian* series on Drugs and Portland Youth followed, with stories like "No Exit, It's Easy to Join the Hippies, but Is There Any Way to Leave?" and "Hippies Argue Whether to Take Over or Co-Exist with Square World." *Northwest* magazine's April 1967 article explained, "Hippies are insisting, usually in a quiet but determined fashion, on the right to a different trip." Soon, another major drug bust shook Portland.

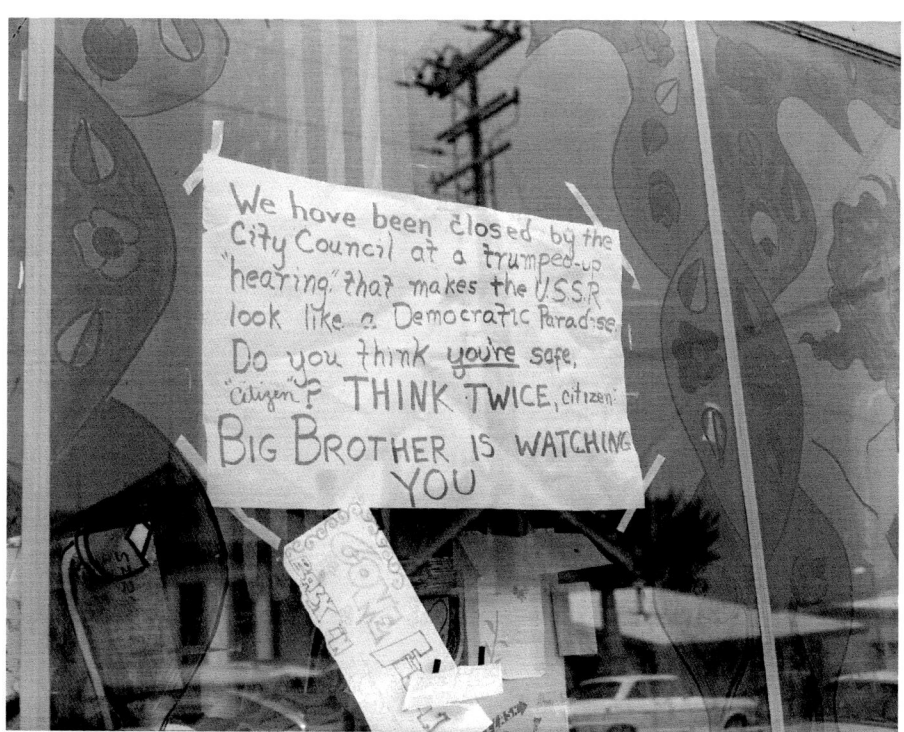

A handwritten sign in the window of the Psychedelic Supermarket. *Courtesy City of Portland Archives, Oregon, A2005-005, June 18, 1969.*

Setting the Scene

But many say the real trouble started when a May 1968 *Oregon Journal* article announced that twenty thousand hippies, having tired of San Francisco, would now invade Portland. *Newsweek* picked up the story with "The Hippie's New Nirvana." (The false rumor started when local politicians misinterpreted statistics cited by a Portland youth worker, according to a June 7, 1968 *Willamette Bridge* article.)

While the prophecy never materialized—the number of young people in Portland that summer reached about one-quarter of those projected—the issue put Portlanders on edge. The last straw came with the desecration of two American flags at a July 4 antiwar demonstration in Lair Hill Park. Commissioner Frank Ivancie declared a "war on hippies" and pushed through an ordinance closing city parks between 11:00 p.m. and 5:00 a.m.

According to James Tucker Jackson's master's thesis, "Culture War: The Battle for Portland's Lair Hill Neighborhood, 1968," the city vowed to "thwart the growth of a concentrated hippie community." Armed with building, fire and other code regulations, it closed the city's top dance venue, the Crystal Ballroom, refused to relicense the Psychedelic Supermarket and condemned Lair Hill homes occupied by student leaders and other troublesome residents.

Patrick Lloyd Jones

According to Pat Jones, reaction to the 1967 drug bust was practical and swift. He and others started a series of concerts that remain among the city's evocative 1960s recollections:

> *After Portland's big marijuana bust, Joe Uris, Antonio Valdez, myself and some musical groups got together to do a free concert in Lair Hill Park. It was a cultural protest. We started doing music every Saturday, and within months, this got huge.*
>
> *Everyone in the neighborhood came. PH Phactor Jug Band and Great Pumpkin always played, but we had other groups. It was a Portland Be-In. I gave away helium balloons. Sightseers in honking cars packed the streets.*
>
> *At this time, a friend of mine rented the Midtown Ballroom and did three dances, and we had dances at the Pythian Building at Ninth and Yamhill. We competed with the Crystal Ballroom. We had local groups as house bands. Young guys, like the Portland Zoo, played for the first time. Blue Cheer stayed with me for two or three weeks and played at the Pythian.*

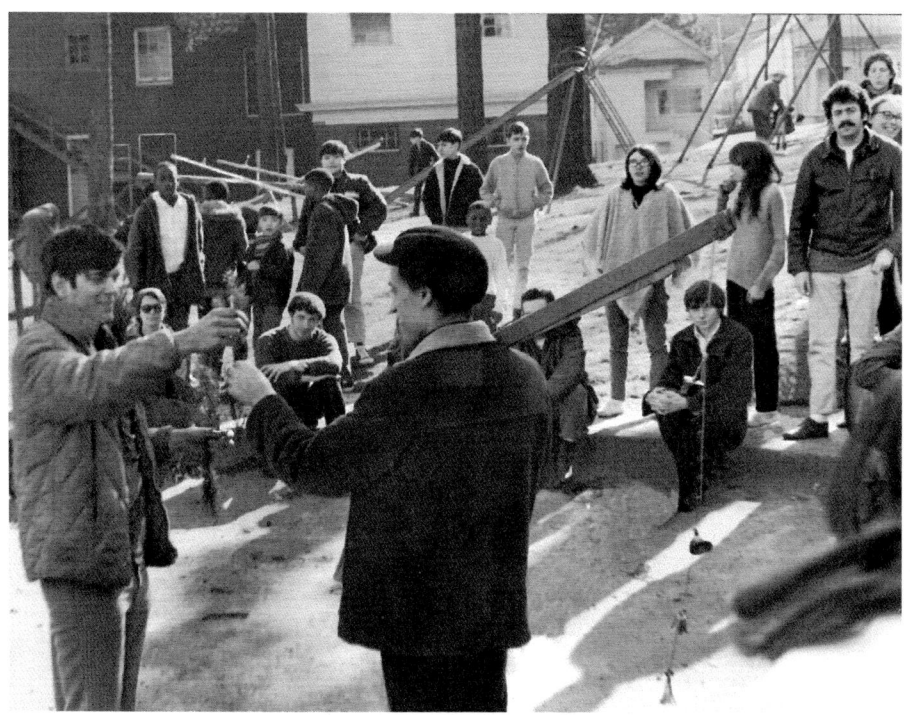

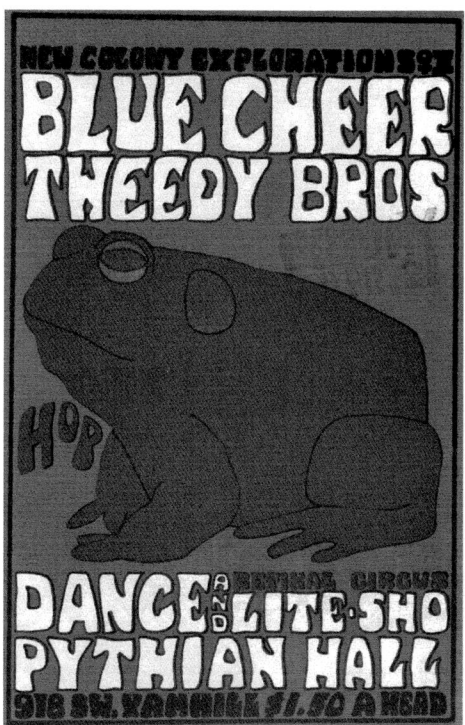

Above: Pat Jones (left) passes Douglas fir seedlings to Paul Bassett and other concertgoers at Lair Hill Park. *Courtesy Emery Ingham.*

Left: Paul Bassett poster. *Courtesy Paul Bassett, Air Sign Co. and John Silvertooth.*

Setting the Scene

It was a subculture. We wanted to broaden this movement through music and a new philosophy that was pacifist and natural. It was exciting. Everyone felt free.

ANN WILLIAMSON

Ann Williamson grew up in the Council Crest neighborhood and graduated from Lincoln High in 1968. Today, Williamson designs one-of-a-kind clothing, which she sells at juried craft shows:

It was cheap to live in those days. Alternative people had communal homes in old houses that nobody wanted. Rent was fifty dollars a month. Friends got together and each paid ten dollars. We went back to nature and had wood heat.

I lived with my husband and a few others in an old Victorian on Second Avenue near Lair Hill Park. We had cast-off Victorian stuff, lace curtains and a wood stove in the kitchen. You'd come in the hallway, and there was a little parlor that we made into the bedroom.

We ate a macrobiotic diet. You'd have brown rice, onions and maybe carrots. One time we had chicken, and a woman said, "I like to do wild things like mix soy sauce and honey and put it on the chicken." We said, "Wow."

People were in and out. One person who lived with us was a magician. A girl stayed in the basement for a while. Now, I think she was mentally ill, but at the time we just thought she acted up.

Music groups were a big deal. PH Phactor Jug Band lived in the neighborhood and gave concerts in Lair Hill Park. Joe Uris was like Portland's Jerry Rubin. The artist, Henk Pander, lived here. He'd recently arrived from Holland and taught at the Museum School. I remember going to parties and watching him draw. I thought, "He's the real deal."

I have mixed feelings about that era. It was after the sexual revolution but before the women's movement. Guys smoked dope while women washed clothes.

Music, women's oppression; some people were lost souls, and they fell into that world and never got out.

Portland in the 1960s

Alison Draper

Founded to help the area's immigrants, Neighborhood House at 3030 Southwest Second Avenue continued to serve the community with a golden age club, nursery school, summer camp and other programs. Starting in the 1950s, the National Council of Jewish Women rented the building to the community for one dollar per year.

Alison Draper grew up in Corbett Hills and graduated from Terwilliger Grade School and Wilson High. She attended summer camp at the Neighborhood House from 1960 to 1967 and worked as a counselor during the summers of 1968 and 1969:

> *I liked the Neighborhood House. Black kids, handicapped kids, boys, girls—we all learned to be together. Summer camp started the Monday after school was out and went for eight weeks. The biggest deal was when they took us to Rooster Rock and Blue Lake. The last day of camp, we went to Oaks Park.*
>
> *In 1967, we started getting park people who were interesting and lolled around all day. The hippies didn't really start until 1968, and '69 was a big year.*
>
> *They were flower children, college kids and probably high school kids, too. They loved to sit in the wading pool. Maybe they hadn't had a bath in a few days. They wore eyelet lace, striped pants with paisley shirts down to their hips and flowers in their long, flowing hair. They didn't shave, and they liked to dance around a lot. Now, that makes me think there was LSD and tons of smoking dope, but I didn't know it at the time.*
>
> *They'd have sit-ins, like for legalizing marijuana. They held signs like Peace, Love and Get Out of Vietnam. Liberal politicians had rallies in the park. But, I liked the music best—harmonicas, kazoos, guitars. They played Pete Seeger and Joan Baez.*
>
> *That's when the Psychedelic Supermarket came. It was a world of black velvet posters, art, pipes and pins with sayings. I'd go inside while I waited for the bus. I loved staring at those hippies, but I was too shy to be part of what they were doing.*
>
> *The hippies were a problem for the camp. They lost business because parents didn't want their kids hanging around. They were afraid of drugs.*
>
> *Hippie concerts did not help our opening and closing camp every day. We were trying to sing songs, and they wanted to be part of our ceremony. I remember them taking over the wading pool. We moved the picnic tables to*

a different part of the park so we could do our arts and crafts unobserved. Duniway Park didn't have a track then. We'd walk over for gatherings because Lair Hill Park was so crammed full of hippies.

THE NEIGHBORHOOD REACTION

Community reaction to the colorful newcomers ranged from neutral to friendly to hostile. Members of Kesser Israel Synagogue around the corner pulled hippies in to complete the quorum of ten men required for prayer service. Others had issues, as reflected in these letters from the Portland City Archives:

May 15, 1968

Dear Commissioner Ivancie:

The Southwest area neighborhood children are having a very difficult time in the use of the small softball field, as well as other playground equipment after school, due to the large concentration of hippies who take over all of the facilities at Lair Hill playground. This situation deprives the children from using the park.

The Neighborhood House Board of Directors, at its monthly meeting on Tuesday, May 14, went on record with the recommendation that some relief be requested from the city for this situation. Would it be possible for the City of Portland to designate this area for use only by children under the age of 18 years? We are in a quandary as to how to cope with this situation. Any suggestion will be greatly appreciated.

Sincerely yours,

Louis N. Gallo, ACSW
Executive Director

Portland in the 1960s

No date—approximately July 9, 1968
Charley & Mr. Buckley

I wonder how long and how much we are supposed to give in to the hippies. They sleep all night in the park—which I felt we should learn to live with. It is now 2:30 in the afternoon and they are still "in bed" in the middle of the playground. Our park is very small and 125 youngsters are here from 9 to 5 each day in a day camp. Activities, watering the park etc. has to be moved away from them.

We lock the rest rooms at night so they use the park or sidewalk or any old place. Mothers are complaining to me and want our students to stay inside the building until they are picked up. Sometimes hippie love is mighty close to sexual intercourse. This morning over 10 garbage cans of wine bottles were picked up by park men. I have just looked out now and all of the teeter totters are manned by hippies.

I feel strongly that we should try and get along with them. They are courteous when they come in the museum—but last year they were thoughtful and considerate outside. This year things are very different. I think it is too

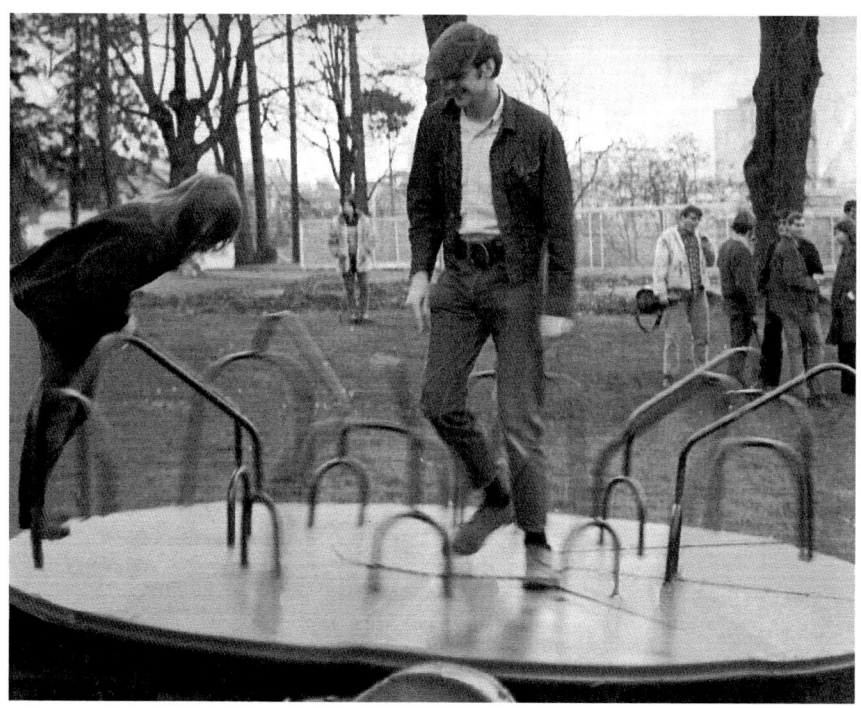

Scene from Lair Hill Park. *Courtesy Emery Ingham.*

Setting the Scene

big a problem for us and we need some help and advice. I have felt that it is a public park and all should be welcome. But this is just too much.

Mary Alice

(Mary Alice Gardner was director of the Junior Museum, later known as the Children's Museum.)

July 15, 1968
Bureau of Park
Frank Amick
Daily reports on use of Lair Hill Park

Dear Mr. Amick:

Commissioner Ivancie has requested a daily report from both you and Mary Alice Gardner relative to the use of Lair Hill Park by hippies. The report should include approximate numbers, general conduct, specific misconduct, etc. We may need this information at some future date to defend any action we may have to take.

Please route the report through this office.

Very truly yours,

Superintendent of Parks.

JIM GILBERT

Fifth-generation Oregonian Jim Gilbert grew up in the Rose City neighborhood, graduated from Madison High and served as student body vice-president at Portland State College. He lives in Molalla, Oregon, where he owns Northwest Nursery and One Green World.

Portland in the 1960s

For Gilbert and others, passing out free soup became a Lair Hill Park tradition during the '60s. Emery and Jo Ingham at the Psychedelic Supermarket on Southwest First Avenue made large pots each Sunday. The idea came from the Diggers, a San Francisco group that envisioned a society free from buying and selling. It provided free stores, free housing, free transportation and free stew, made of donated meat and vegetables and served daily in Golden Gate Park:

> *We lived in a top-floor apartment on Southwest Gaines Street, or maybe it was Caruthers. The apartment house is still there. We knew a sign maker who made up antiwar signs, so we put one in the dormer window. It said Revolt Against the War. It took a long time for people to get it down.*
>
> *We read about the Diggers in Berkeley and wanted to make a statement. The idea was you don't need to pay for your food, and you can do things together. So we got together and made up pots of soup. We free-formed it with whatever vegetables and spices people contributed, and every soup was different.*
>
> *Our primary place was Portland State College. When it rained, we'd bring the soup inside. The cafeteria had an ordinary person's side and the*

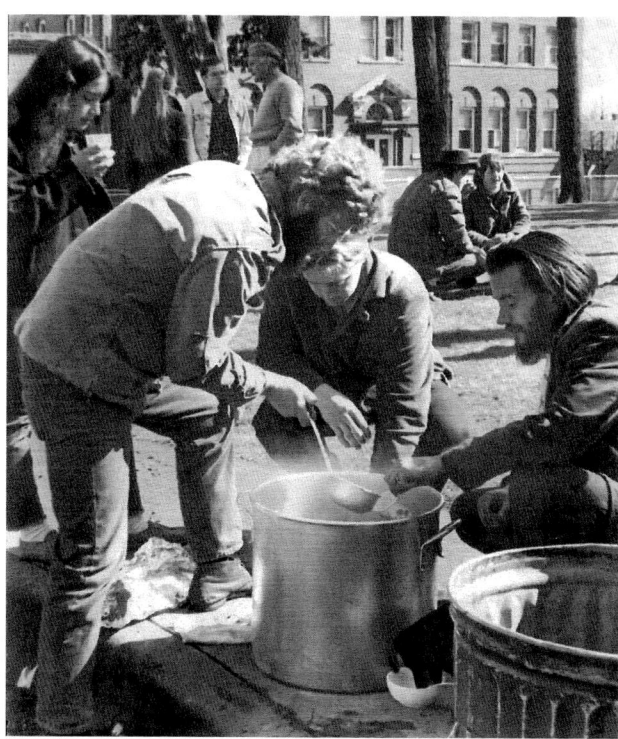

Jim Gilbert (left) doles out free soup in Lair Hill Park.
Courtesy Emery Ingham.

Setting the Scene

fraternity/sorority side. These people were typically uptight and anti-hippie. Once, we were bringing the soup across the room to the ordinary side when the fraternity types came over and harassed us. The administration told us not to bring soup inside again, but we kept doing it.

We made a film about making soup. Ten or fifteen people with candles went up the stairs to the apartment and chopped vegetables. Then, we brought it to Lair Hill Park, which was a gathering place for events like Be-Ins. Ken Kesey showed up once.

In 1967, Lair Hill Park was still hippies and innocent. The drug culture hadn't gotten going. They were smoking pot, but it wasn't hardcore.

Margo Maris

By the late 1960s, individuals and organizations had jumped in to help alienated youth. Schools like the Willamette Learning Center, John and Mary Kerr's School-House and the Metropolitan Learning Center offered alternative education. The Outside In clinic opened in response to drug use.

Churches played an active role. The Centenary Wilbur provided space for philanthropic groups and ran the Ninth Street Exit coffee shop. The Greater Portland Council of Churches (now Ecumenical Ministries of Oregon) Community Action Programs supported youth organizations across the city. One was Youth Ministries of Oregon, directed by Gene Horn.

By 1969, Margo Maris directed a Youth Ministries program across from Lair Hill Park. She'd started as an assistant to Horn and took charge of the project when his focus turned to the Charix coffeehouse downstairs from the First Unitarian Church:

Kids at Lair Hill Park were divided into two sets. The first had left home for legitimate reasons like abuse at home or at school. The second set experimented with drugs and were out for the fun. Both had legitimate needs. What motivated me was how do we keep kids safe?

People woke up about noon, and around four the music started. The atmosphere was electric with crowds, kites, guitars and tie-dyed clothes. Kids wore long skirts, revealing blouses, hip-hugging pants and no shoes. Colors reflected their sense of freedom—deep greens, yellows, reds, blues.

They were always scrambling for food. Our job was walking around talking to people, finding out if they needed help or a place to stay. We

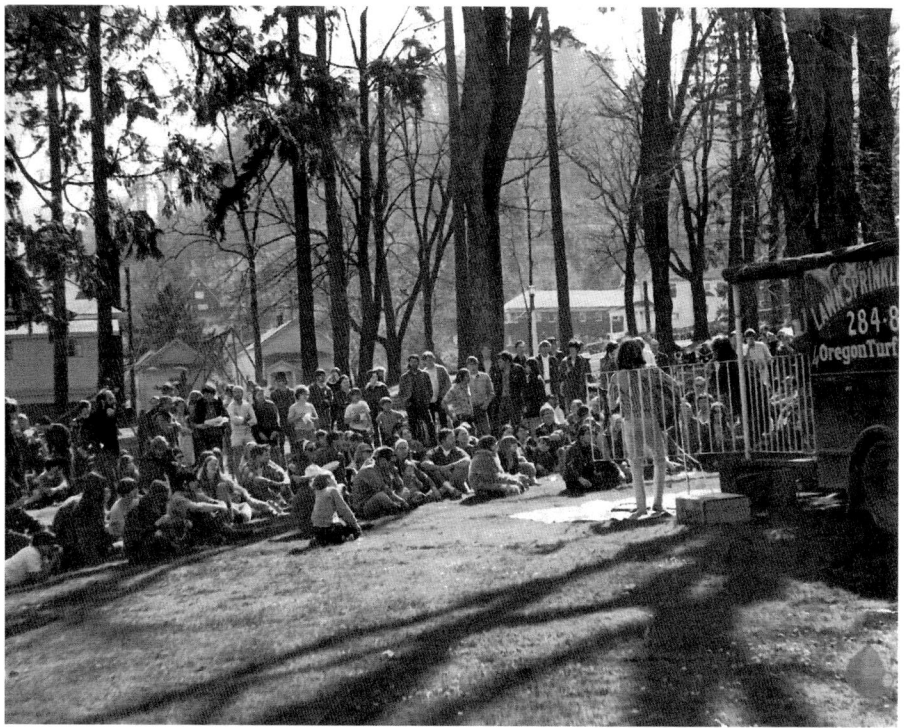

Concert in Lair Hill Park. *Courtesy Emery Ingham.*

placed maybe five kids a month in foster care. Most kids we helped were not from Portland. Kids from Portland knew where to stay.

The problem was, we were not turning kids over to the police. There were huge meetings between the police and district attorney because of the work I was doing. I was trying to find ways we could collaborate and cooperate. They worried we were housing runaways and keeping them from parents. The head of the Women's and Children's Protective Division, Captain Mumford, was so straight-laced. Part of me knew she had paid her dues about being a woman in the police early on but to her everything was black and white.

I learned how to listen and watched kids open up. There was this sense we were all human together. The hippie scene was an affront to the way we'd been raised, but I saw people open their homes as alternative foster care. Kids told their story, and you watched people melt. The movement was about being able to create and live with change. It was like watching something bloom.

Part I
RETROSPECTIVE
FROM BEAT TO HIP

I've always wanted the sound of Muddy Waters' early records—only louder.
—*Eric Clapton, musician*

It began when Lawrence Ferlinghetti opened San Francisco's City Lights Bookstore in 1953—or so the sages of the 1960s era suspect. Then, beatniks' black clothes, poetry and jazz gave way to tie-dyes, folk music and flowers. Bob Dylan's switch to electric guitar in his 1965 single "Like a Rolling Stone" left some followers feeling betrayed. Soon, electric bands left acoustic behind.

Portland followed the pattern. By the late 1950s, the city had its own beat scene centered on the first espresso shop, which was run by the now famous female impersonator Walter Cole, aka Darcelle. Twelve-string guitarist Mike Russo and banjo player Ron Brentano entertained at the Thirteenth Avenue Gallery and Way Out Cafés. In late 1965, Ken Kesey held his sixth acid test at Beaver Hall on Southeast Hawthorne. Soon, light show artist Gary Ewing's creations rivaled anyone's as never-to-be-forgotten groups like Great Pumpkin, Tweedy Brothers, the Portland Zoo and PH Phactor Jug Band took center stage.

This chapter on Portland's 1960s counterculture art scene reflects the local and national progression. Like the rest of the book, it is in no way a comprehensive history. Each story could expand into a book, and many influential people, places and movements have been left out for lack of space. Hopefully, these highlights from Portland's under-told and sometimes forgotten history will provide insight into those times. While some remember naïve or disingenuous young people who exaggerated their importance

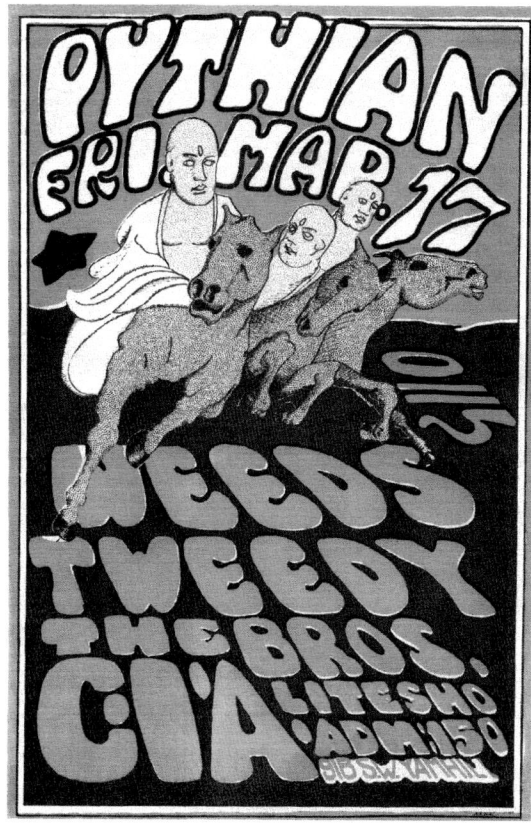

Paul Bassett poster. *Courtesy Paul Bassett, Air Sign Co.*

and ability to influence change, others who lived through the 1960s found themselves forever defined by those years. Note that in this book, the 1960s represents an era, from about 1958 to 1975.

DARCELLE LOOKS BACK AT THE CAFFE ESPRESSO

When Karl Leopold Metzenberg opened Portland's first Italian coffeehouse in 1958, he catered to an offbeat crowd. "They are this generation's intellectual youths," the *Oregonian* wrote. "They favor Sartre and Hemingway and admire 'Pogo.' They accept Ferlinghetti but think it ostentatious to pack a copy of 'Howl.'"

Metzenberg served cappuccino and teas, turned one room into an art gallery and invited folk and classical guitarists until May 1959, when he shot a violent customer in the head. Exonerated, he sold up and left town.

Retrospective

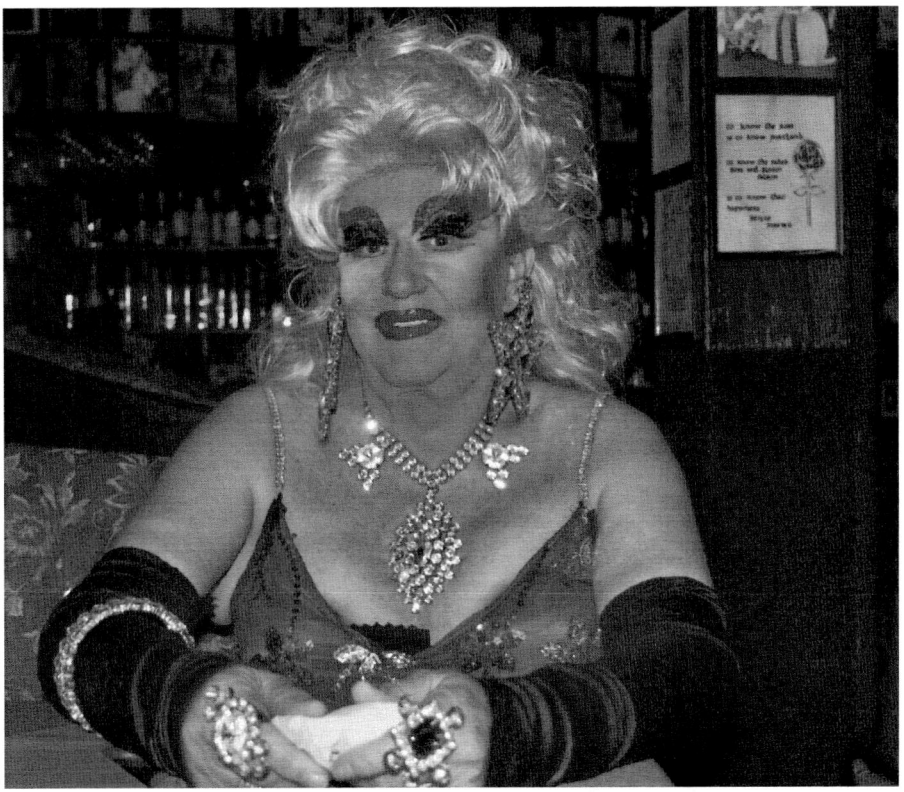

Darcelle in 2011. *Photo by author.*

In stepped Walter Cole, a Linnton native recently discharged from the service. He kept the café through two urban renewal dislocations but in 1968 left for the Northwest Third Avenue tavern he still owns. "It's OK," he said, believing all ends well. "This was a series of steps. I never felt that it was anything but a door closes and a window opens or the other way around."

Larry Howard, who grew up in the Park Rose neighborhood and had recently completed army service, bought Cole's equipment and opened the reincarnated Caffe Espresso at Southwest Twelfth Avenue and Burnside around Christmas 1966. Meanwhile, Cole became better known as Darcelle, his tavern the home of Portland's female impersonator show of shows:

> *I didn't own it at the time of the shooting. I had to put that out of my mind. I got a good price, and it was the beginning of working for myself.*

Portland in the 1960s

I worked for Fred Meyer before I went into the military and again when I came back. I'd worked myself up from box boy to manager and was handing out checks larger than my own. Checkers got overtime and all that. When you're salaried, you just get a salary.

I looked in the newspaper and saw Business Opportunities, Coffee House. The place was on Southwest Sixth and Harrison. And, dumb little Southeast Portland boy, crew cut from the army, glasses, bought it, walked in, and made it successful. No plan, no nothing.

For three years, I worked from 7 a.m. until 3 p.m. at Fred Meyer, took a nap, and opened the coffeehouse from 7 p.m. to 1 a.m. I had to make sure it was going to work. I had a wife, two children and a mortgage.

Then urban renewal handed me a $5,000 check and closed my doors. That's a lot of coffee. So, I rented a place from KOIN-TV on Third Avenue and Clay for $75 a month.

Now the block is a parking lot, but it had an old corner tavern with a basement and upstairs. I put in a bar, installed my espresso machine and built a stage—a little platform and such.

Was this a different world for me? Yeah! I'm a little boy from Southeast Portland, never, ever worked downtown except at Fred Meyer in the office. Totally different! I had a crew cut. These guys smoked dope. But they didn't do it in my place. They respected the fact that I'd kept the coffee shop the way it was. I didn't turn it into a crew-cut place.

They were welcome as long as they bought coffee. It was fifty cents a cup, and no refills. That was unheard of then. I had regular, espresso in a little cup, expensive lattes, cinnamon, peppermint—all kinds of stuff. I had pizza, sandwiches and French pastry from the Beaverton Bakery on Burnside. We had jug bands one night, folksingers the next. I had garage bands and teenage rock 'n' roll bands. At one time, I had an after-hours jazz joint going in the basement and served breakfast.

Gradually, the clientele changed. It wasn't popular anymore to be a beatnik. The nights I had rock 'n' roll bands there were all college and young kids—clean cut boys and girls. When we had folk music or jazz, the place changed again.

I also opened an ice cream parlor on Twelfth and Montgomery. When urban renewal came and closed the Caffe Espresso for the second time, I worked there. Did I tell you they gave me $5,000 again? So, that's two.

We bought the Demas Tavern between '67 and '68. I served beer and wine to street people. None of my gay friends from the other side of Burnside would come over, so I hired a lesbian bartender. We were

officially a lesbian bar, and it was interesting. Lesbians then weren't like today. These were DYKES! DIESEL! They'd throw a pitcher of beer across the room if anyone looked at their girlfriend, you know, that whole thing.

When we bought this place, you couldn't have entertainment in a tavern. I mean you couldn't sing Happy Birthday. And we had to close at 1:00 a.m. Bars could stay open until 2:30.

Then, they changed our time to 2:30 a.m. and gave us the privilege of having entertainment. Somebody could play guitar, but no dancing. We did drag shows, female impersonator shows. We did Barbara Streisand and all these people. We didn't dance, we sang. Then, the law totally changed, and we could stay open until 2:30 a.m. and have all the entertainment we wanted.

What was Portland like? Jazz people were starry-eyed, another culture. Then, I had the ice cream parlor people. The lesbian bar was another society. I had all these levels of relationships. It was healthy.

THE VILLAGE

Some called them shacks or chicken coops; others saw artistic retreats. The bohemian enclave on Southwest Upper Hall Street polarized Portlanders for forty years. Eleven apartments connected by boardwalks and stairs hugged a steep hillside off the hairpin turn on Southwest Sixteenth Avenue. The dilapidated cluster was known as the Village when the city finally condemned it in 1963.

"I was shocked," said chief fire investigator C. Walter Stickney in a 1962 hearing. "It's a hodgepodge of improvised buildings and assemblies of heating, wiring and structural members." Decades of residents disagreed. "They were cute," said Gretchen Enyart Young, a jazz musician who attended the hearings. "The places were old and sturdy. Everyone knew everyone, and everyone fixed up their cottages differently."

Legend claims the apartments originated as platforms for tuberculosis sufferers' tents. A fashionable treatment for the disease included sleeping in fresh air year round. While local newspapers mention such facilities, the Village apparently started simply with healthy residents living in tents, as this June 23, 1917 *Oregonian* advertisement explains: "524 Heights Terrace at 16th and Hall—tent house; have new one and will build more; 20 minutes walk to P.O. Finest air and views of mountains and city; large porches, shower

Portland in the 1960s

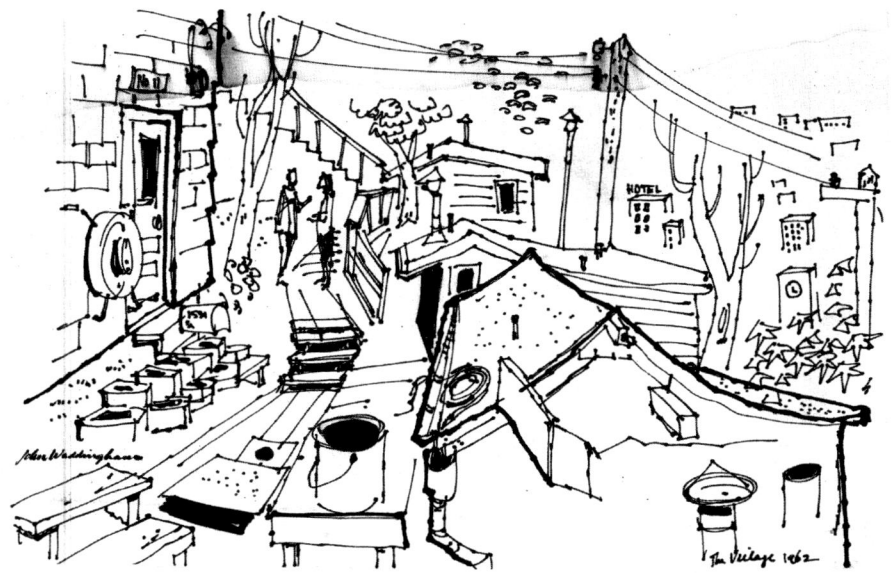

Oregonian artist John Waddingham sketched the Village before its demise. *With permission Joan Waddingham, ©1962 the* Oregonian. *All rights reserved. Courtesy Walter McMonies.*

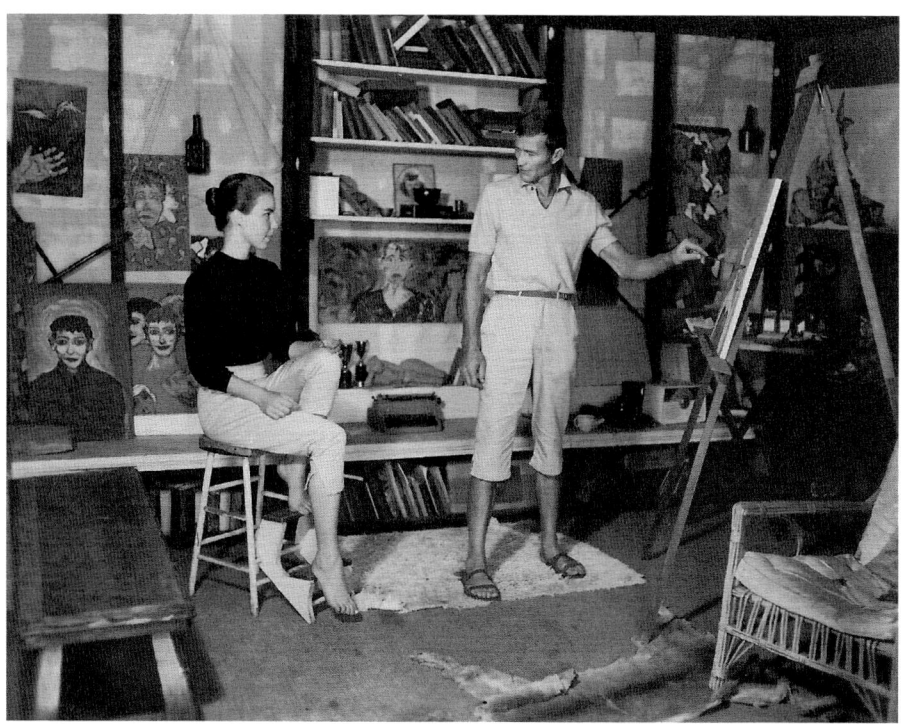

Village resident Con Melland with a model. *Courtesy Diane and Rex Amos.*

Retrospective

bath, phone." (Note that the city later renamed Heights Terrace to Upper Hall Street.)

Nearby homeowners ranted about the "eyesore" until the 1918 city council ordered tents removed. Later that year, the *Oregonian* carried ads for Scenic Lodge Cottages at the same location. Called Artist Colony Lodges by 1929, the landlord promised "rustic wooded, hillside sites, two and four room, private baths; sleeping porches, wonderful view."

Architect Pietro Belluschi moved in during the 1920s. Artists Manuel Izquierdo and Louis Bunce lived there, as did Dr. C. Easton Rothwell, who became president of Mills College. In the end, wealthy arts patron Elinor McMonies owned and hoped to renovate the property. She and residents protested its demise to no avail.

"My sister, Patti Hart, sang at a club called The Shadows on Sandy Boulevard," former resident Gretchen Enyart Young said. "She found out about the Village first. It had ambiance."

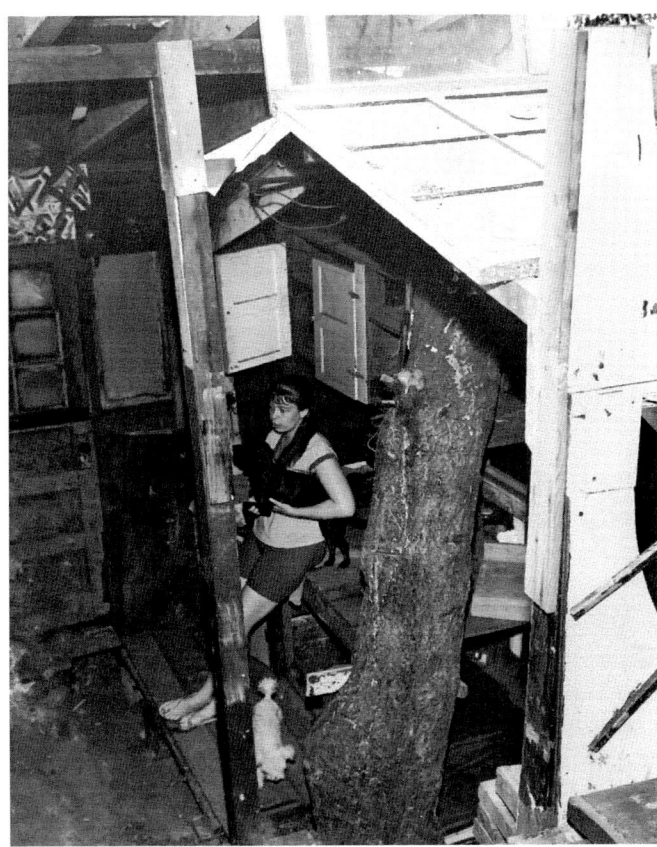

Gretchen Enyart Young at the Village.
Courtesy Diane and Rex Amos.

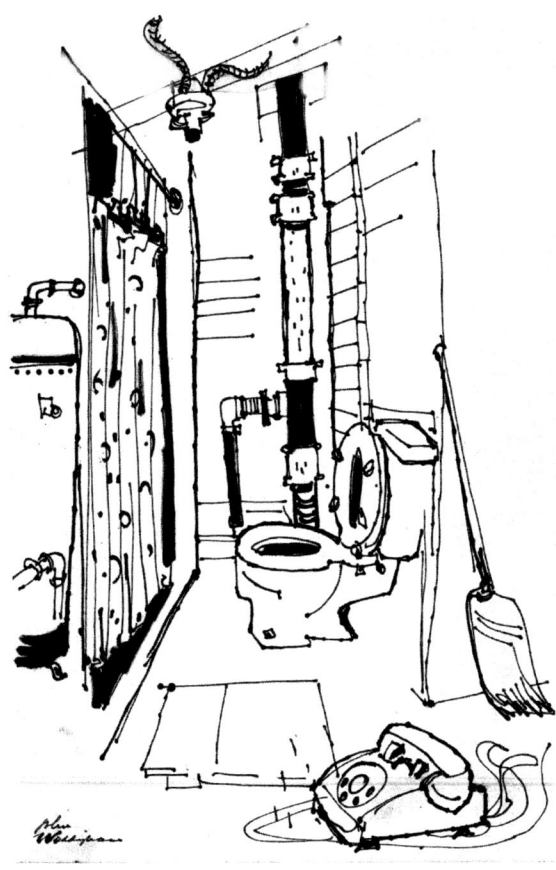

A Village bathroom, by John Waddingham. *With permission Joan Waddingham, ©1962 the Oregonian. All rights reserved. Courtesy Walter McMonies.*

Young played drums and sang in a jazz band, often at Walter Cole's Caffe Espresso, on Southwest Second Avenue and Clay. She moved to the Village around 1959. "Windows with small panes ran across the front of our apartment and opened out like doors," she said. "The fireplace was an upside-down sawdust hopper. There were unusual bathrooms with gas water heaters elevated over the tubs. You lit them with a match to take a bath, and you had only so much water."

Despite talk of shoddy construction, the apartments survived the 1962 Columbus Day Storm. Young woke to the wind and from her window watched Portland power stations blow out one by one. Her sister's husband, musician Carl Smith, walked down Southwest Hall Street and listened to the jazz jukebox at the Gay Nineties pub, which used gas lighting to stay open during the storm.

Retrospective

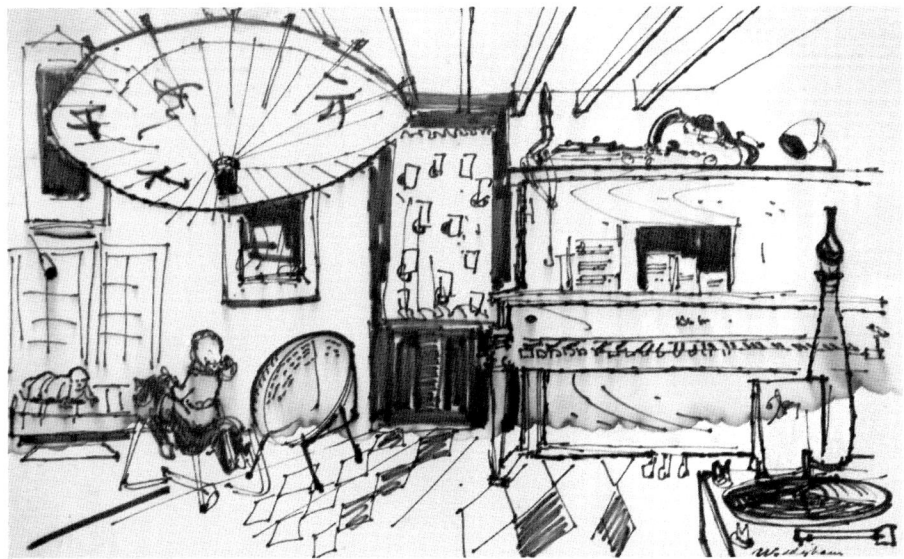

Carl Smith's living room at the Village, by John Waddingham. *With permission Joan Waddingham, ©1962 the Oregonian. All rights reserved. Courtesy Walter McMonies.*

Smith's first acquaintance with the Village came during a jam session where he met saxophonist Jimmy Pepper. He met the building manager, who studied theosophy, and he learned creative people had lived there for years. "I liked it so much, we ended up with the largest unit," he said. "In the '60s, the artistic community—painters, sculptors, writers—were all into jazz. My wife and I had a trio, and we played at the Broadway Inn."

Smith drank wine and partied on the roof deck he built. A paper umbrella became his chandelier, a blackboard over metal filing cabinets his desk. The bathroom tilted—the wrong way, making emptying the tub a chore. "I loved the Village because of the color, the other inhabitants and the close relationships," he said. "From the bedroom window and roof, we could see from Oregon City to Vancouver."

THE THIRTEENTH AVENUE GALLERY GOES DADA

When Paul Hebb opened the Thirteenth Avenue Gallery in 1959, neither coffeehouses nor the neighborhood were part of Portland's scene. Now a trendy area with an old-fashioned feel, Sellwood was a working-class enclave not far from exclusive Dunthorpe, where Hebb grew up. During the café's

Portland in the 1960s

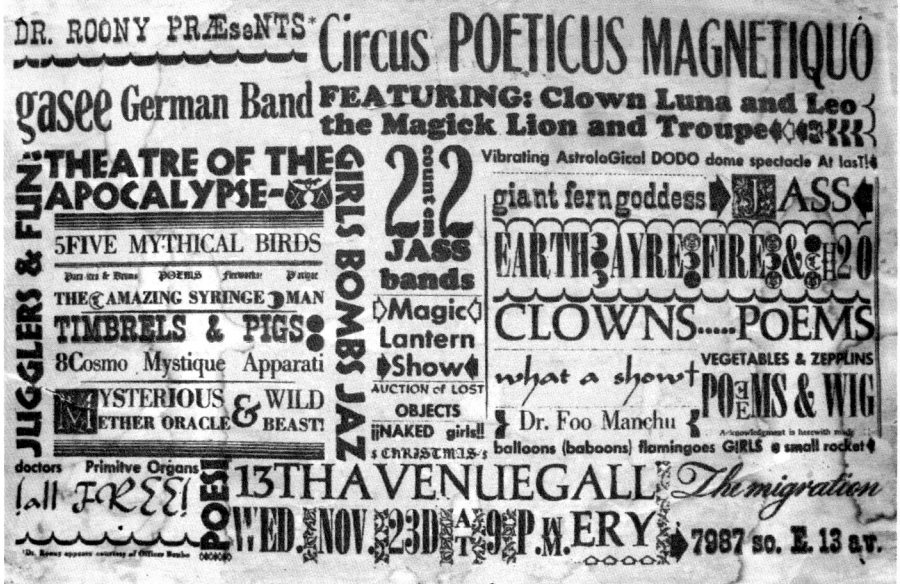

Dada show flyer. *Courtesy Paul Hebb.*

three-year existence, he switched locations five times, always keeping the original name. Today, Hebb lives in Mexico and works with a women's cooperative.

"There was nothing pretentious about the locations or décor," he wrote in a series of e-mail interviews. "We rented a space and cleaned up. The gallery provided a place where art students could exhibit and we could make a social statement. We supported 'Ban the Bomb' and the Poor People's March; we raised money for Reed College's FM station and an Oregon Historical Society study on regional folk music." Hebb stored customers' discarded furniture and gave it to new arrivals.

The idea for a gallery started when Hebb attended the Museum of Art School in Portland. Fellow students and friends from Reed College furnished the first exhibit. He bought bagels from Mosler's, doughnuts from Safeway and coffee from a service. (Admission included two cups.) Posters plastered around Portland advertised weekly entertainment.

Today, the building houses Grand Central Bakery. Hebb says little has changed: "We had small tables, unmatching chairs, a high ceiling and hanging lights. I call the style eclectic Goodwill simplicity. We removed the tables during concerts. Performers should not compete with coffee and conversation."

Retrospective

Hebb remembers a mixed clientele where beatniks joined young families and curious neighborhood teens. Many bartered entrance fees. "People told me they were broke and asked to help," Hebb said. "They cleaned up, hung posters and served coffee. Often, someone handed me money for a previous free admission. After each concert, my wife, the performers and I divided the proceeds. Musicians knew they would earn something, which was better than other places. Financially, the gallery survived."

Notable guests included the chief fire inspector, who walked in while performers led the audience in song. "He smiled, told us we'd broken every rule in his book, asked for a back door exit sign and left," Hebb remembered. "He said, 'People gathered together enjoying music was too beautiful to stop.' Could something like that happen today?"

With traditional music in vogue, gallery performers specialized in blues, bluegrass or Irish and English songs. Mike Russo, one of the country's finest twelve-string guitarists and son of the well-known artist, along with banjo player Ron Brentano, was a favorite. "Woody Guthrie influenced Mel Lyman," Hebb said, referring to the Oregon musician who later joined the Jim Kweskin Jug Band and became a self-declared prophet in Boston.

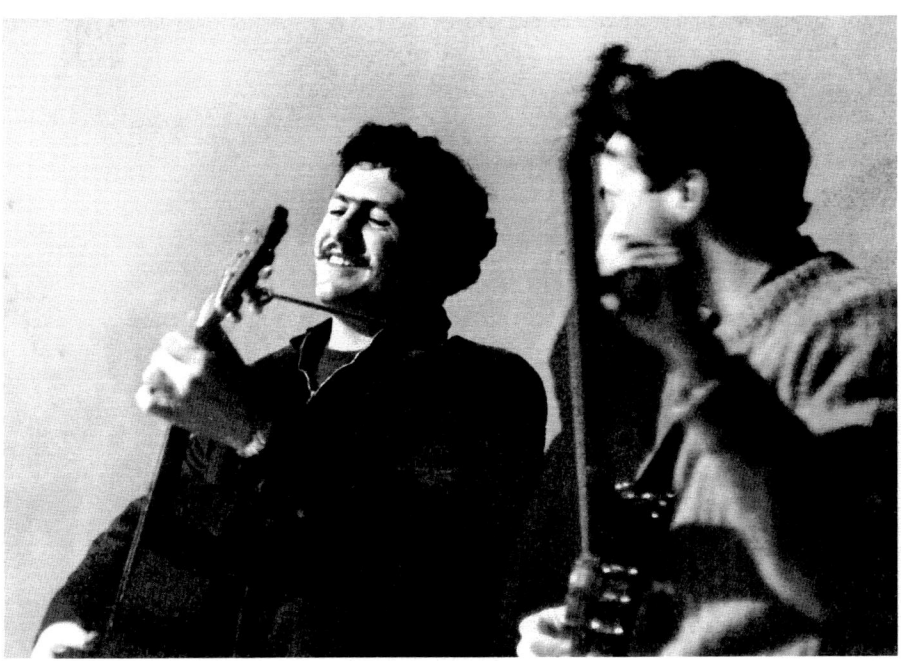

Mike Russo (left) with Ron Brentano. *Courtesy Mike Russo.*

"He had a poor white rural repertoire, plus he looked the role. I called it Folk Gospel."

The musicians became legendary among Portlanders along with the gallery's Dada extravaganza. "We called it Dr. Rooney PRAEseNTS Circus Poetticus Magnetiquo," Hebb said. "Two well-known artists, Manuel Izquierdo and Mike Russo [Sr.] came. They said it was the most exciting Portland art happening they could remember.

"We were beatniks, anarchists and anti-bourgeois, or at least thought we were," Hebb continued. "We felt the art and entertainment world took itself too seriously. Dada poked fun with clowns, art, poets and musicians and exaggerated to the absurd. The Mysterious Ether Oracle, the Giant Fern Goddess and the Magic Lantern Show performed while Jass [sic] groups played."

A band on top of a flatbed truck led a procession of cars to the gallery. "Ladies on the truck wore Christmas tree decorations on their nipples—and nothing else," Hebb said. "I'd eaten something that afternoon and was at Connie Simo's apartment with vomiting and diarrhea, so I didn't arrive until the festivities wound down. Later, we went to a party in Goose Hollow. Ron Brentano's mummy costume was so stiff he couldn't sit—we carried him to the truck. I found him passed out on the lawn, got scissors and revived him. The gauze must have cut off his circulation."

DAYS AND NIGHTS BOOKSTORE

John Paul Pickens (1937–1973) helped jumpstart psychedelic rock in the early 1960s when he played at San Francisco's Grant Street Coffee Gallery with icons like Peter Albin, who later formed Big Brother and the Holding Company. But in 1958, he owned Portland's beat-era bookstore. His wife, Mary Ann Pickens, remembered the city's small alternative community. The May 16, 1959 shooting incident she mentions in this interview caused a sensation. After a judge exonerated Caffe Espresso owner Karl Metzenberg from wrongdoing, he sold the business to Walter Cole, better known today as Darcelle:

> *During the late 1950s, my husband's antiquarian book business took him to Portland, where he met investors who wanted to open a store. They paid J.P. a salary and encouraged him to use his own ideas. We found this space across from Portland State College, painted it and made bookshelves. J.P.*

Retrospective

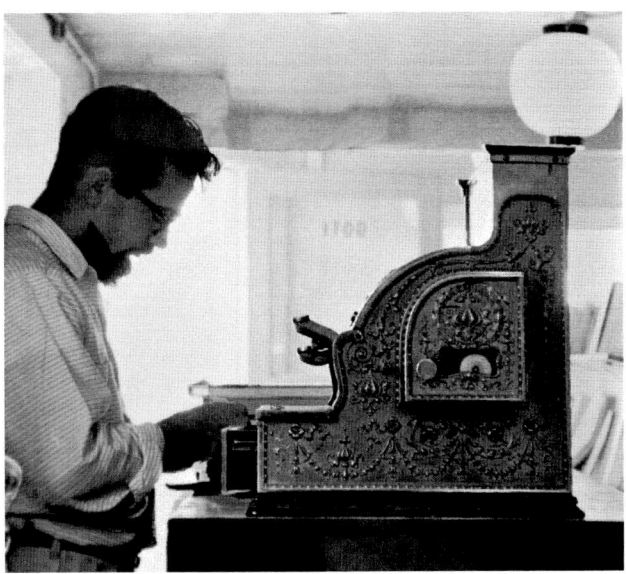

John Paul Pickens at the Days and Nights Bookstore. *Courtesy Mary Ann Pickens.*

officially opened from 9:00 a.m. to 6:00 p.m., but when people driving into town called, he stayed late.

It wasn't big. We had a counter, windows and an antique cash register J.P. found somewhere for fifty dollars. We displayed local artwork, and twelve-string guitarist Mike Russo made our sign. We served coffee, and people played chess. The place became a hangout.

We carried an eclectic mix of mostly paperbacks, including a used-book section, and Folkways records. I remember one, Mating Calls of the South American Frog. *Sure enough, a Portland State student who studied frogs came in and bought it. He and J.P. became steadfast friends.*

We rented an old house on a hill ten or twelve blocks from the store for fifty dollars a month. It was a big change from the Bay Area. Portland was laid back, ultra-conservative and wet. It rained and rained. Our three children kept getting colds. The public market downtown was an adventure. I remember a peanut butter store, meats—horsemeat was a big thing—and shop owners who always gave samples. People went to the Caffe Espresso for coffee and chess. The owner, Karl Metzenberg, and my husband sent each other customers.

We were at the Caffe Espresso during the shooting. I was eight months pregnant at the time. Three or four young men were prowling around, and one tried to get my husband into a conversation. The next thing, the guy grabbed him, threw him on the floor and held a knife to his throat. Another

guy had a gun. I stood between him and the owner, Karl, who took out his derringer and shot him right between the eyes.

Still, the bookstore was great fun. My husband loved it. We thought we'd do well since there were no other stores like ours. But, six months down the line, the investors didn't want to continue. People liked hanging out but not too many bought books. It broke J.P.'s heart.

After the store closed, my husband had a couple temporary jobs and then an interview at Stanford came up. We moved to Palo Alto, where he opened the paperback section of their bookstore.

A Way Out Café

LeRoy Hathaway helped define 1960s Portland. Along with the Caffe Espresso, the Thirteenth Avenue Gallery and the short-lived Days and Nights Bookstore, Hathaway's coffee shops led the way. They preceded psychedelics. With jazz the rage and folk music emerging, clientele emulated *West Side Story* delinquents before moving on to the beatnik age.

He named his first venture Flem Snopes after a William Faulkner character. At 1935 Southwest Third Avenue, it was smack in South Portland, once home to Jewish and Italian immigrants. Soon, urban renewal would demolish the northern section of the neighborhood in favor of high-rises

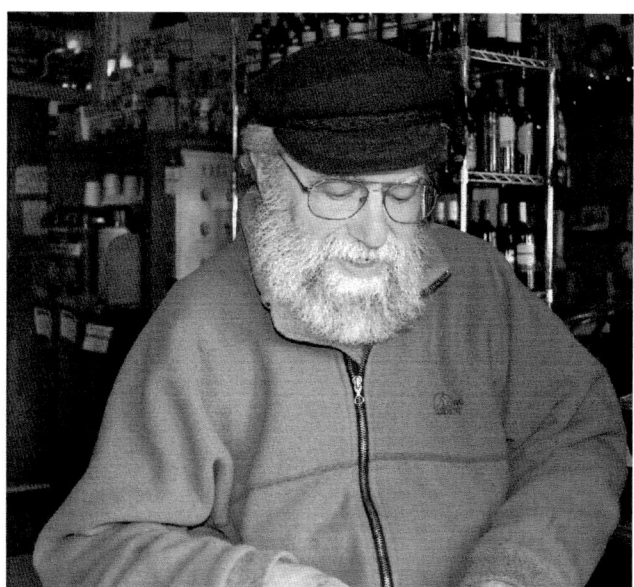

LeRoy Hathaway in 2011. *Photo by author.*

and a business park. The remains of South Portland, known as Lair Hill, would become the center of Portland's upcoming hip era.

"It was a tavern; some guy opened it and drank the profits," Hathaway said, remembering early days at Flem Snopes. "Walter Cole owned the Caffe Espresso a dozen blocks away. People would do two hours there and come to us for the rest of the evening."

When Clarence Stanton Duke hosted KGON's late-night *Jazz Northwest* from Flem Snopes, he selected Miles Davis's "Round Midnight" as the theme song. The godson of Lionel Hampton and son of a local railway porter and jazz impresario, Duke would later move to Los Angeles, complete his PhD and become one of the country's first African American network sportscasters.

"We broadcast remotely over phone lines," Hathaway said. "Clarence had a desk and turntable. He talked about the evening's live performers and introduced the music. At the end of the number, he'd signal for them to take a break, and he'd run a commercial. About a third of the show was recorded music."

With the Caffe Espresso and Flem Snopes in the way of urban renewal "progress," the city paid both owners to relocate. The Way Out, a small jazz café under the Hawthorne Bridge, had recently closed when Hathaway moved in. "Photographer Leroy Hathaway and Deejay Clarence Duke, who has the *Jazz Northwest* program on KGON, have reopened The Way Out, tucked under the east approach of the Hawthorne Bridge," Francis Murphy wrote in his July 31, 1961 "Behind the Mike" *Oregonian* column. "The building has been completely repainted, has one Louis Bunce and three Jim Smith paintings on the wall. One section is devoted to photography in which Hathaway does a top job."

Hathaway remembers a small, dark room with a dropped latticework ceiling and fishnet draped across the walls. Empty wine bottles with candlesticks provided the lighting. Customers wore berets and, true to the era, applauded by snapping their fingers. "A group of professionals, doctors or lawyers, originally put the Way Out together as a nonalcoholic bar," Hathaway said. "It was jazz groups mainly. I went there as a patron. When I bought it, the place was stripped of equipment and furniture, but they left their décor. Local artists loaned us paintings."

Hathaway got the word out. "We plastered the old location with posters that said we'd moved across the river," he said. "We took the jazz musicians with us. We didn't have trouble at Flem Snopes, but they started getting busted when we moved. They just didn't show up, and we'd have nights without music." Hathaway turned to Don Wardwell, the manager of Sixth

Avenue Records. He recruited guest folksingers who played for coffee. Waitresses, too, came for a place to hang out.

"Jazz musicians came uninvited and jammed," Hathaway said. "High school girls gave a set or two. Nick Ogilvie was doing a crude Bob Dylan—raucous protest songs. Reed College students played traditional music.

"We worked terrible hours," Hathaway continued. "I got in before opening to clean up from the night before. We had no way of cooking, so we served coffee, soft drinks, sandwiches and pastry. An old-fashioned brass urn on the bar had the right shape, so the clientele thought it was an espresso machine."

Franz Schneider Remembers the Music

Franz Schneider grew up in North Portland and graduated from Jefferson High School in 1958. Always interested in folk music, he remembers Portland's first coffeehouses and their performers. Schneider later joined the Peace Corp and became an elementary school teacher. He lives in California:

> *I was a red diaper baby; my parents were Communists. The party kept civil rights and folk music alive. I still have my parents' Leadbelly and Weavers 78s.*
>
> *When I was eighteen or nineteen, I was not interested in anything beyond my own head. I attended Portland State College in the fall of 1958 and spent time at the Caffe Espresso. That was the premier beatnik hangout. It was on Sixth and Madison, a block from Old Main at Portland State. It was one of those old-fashioned storefronts with windows on both sides and a door in the middle. There was room for maybe thirty-five people.*
>
> *Sometimes, the owner put a stage in the right back corner and had live music. He sold espresso and soft drinks. My favorite was chocolate orgeat. It cost one dollar, and I could afford it once a month.*
>
> *The restrooms had literate graffiti—beatnik graffiti. People who hung out there were self-consciously beatniks. They'd sit with books of poetry and sometimes jump up and read a stanza out loud. Tourists, high school kids and others came in to look. We'd have parties and invite the first six people who walked through the door. I made good friends that way.*
>
> *I went out almost every Friday with local musicians—Mel Lyman, Ron Brentano, Mike Russo. Later Mel joined the Jim Kweskin Jug Band and became a guru in Boston. He lived in Goose Hollow, and Ron and Mike lived in a duplex on Columbia just west of Fourteenth. I lived with*

Retrospective

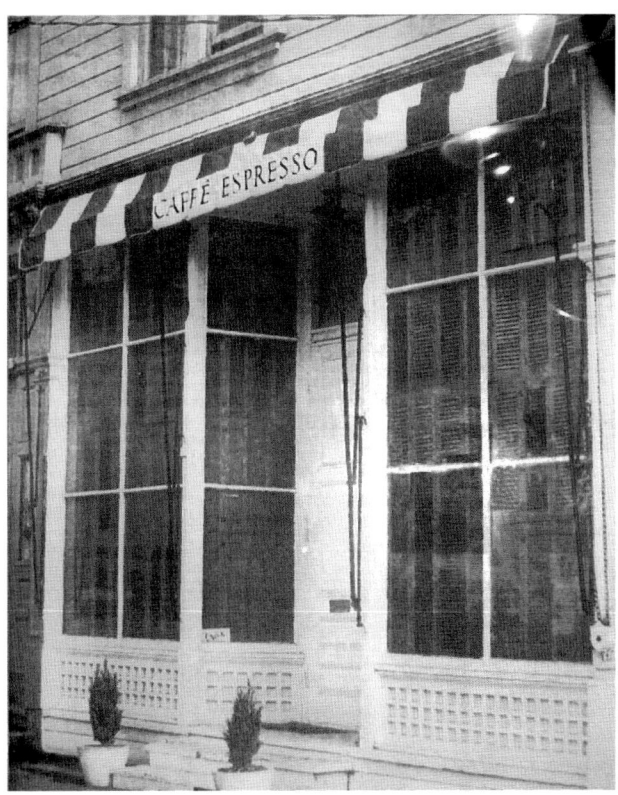

Darcelle's only photograph of the Caffe Espresso. *Courtesy Darcelle.*

a bunch of people in an old mansion slated for the freeway at Twelfth and Columbia.

Mel was interesting and charismatic. He became controversial, and those potentialities were apparent. He had four kids, all under five. His wife, Sophie, had them by the time she was eighteen, I think. He liked ticking people off, getting under their skin. Like, he had a carefully colored plastic turd made and kept it on top of the radio in his living room.

Mel took me under his wing. He introduced me to a number of musicians. Brownie Mcghee and Sonny Terry gave a concert in Portland and afterward went to Mel's house. Brownie Mcghee sat on a stool playing guitar and sipping beer, and I sat on the floor singing. We were up all night.

Mel rode freights around the country and made pilgrimages to see Woody Guthrie. I had been traveling, hitching, so I decided to ride a freight. He and Sophie took me to the Southern Pacific Brooklyn yard in their yellow Studebaker. Mel showed me the yard shack and told me how to tell a yard worker from a railroad bull [detective]. *He asked about a train going south.*

Portland in the 1960s

I ended up taking an empty sawdust car to San Francisco and caught a freight train back two weeks later. I got out of the train, walked to a stoplight, and waited for a bus. Sheer coincidence: Mel and Sophie came along in their yellow Studebaker and drove me home.

Mel had a one-hundred-year-old SS Steward banjo. In 1959, he was moving to North Carolina, so I thought, I have to get a banjo. He set it up and got me started. The songs he played are ones I still play. "Fair Ellender," "Make Me a Bed on your Floor," "Pastures of Plenty." Every couple of weeks I hear a song I learned from Mel.

Allen Ginsberg Comes to Town

"What was our connection with Allen Ginsberg? I don't know how we got him." Rondal Snodgrass was responding to questions about the 1967 Peace Rites Festival. He'd become active in the Society for New Action Politics (SNAP) while working for Upward Bound at Reed College. When they learned Allen Ginsberg was coming to Portland, they put Snodgrass in charge of a fundraising event.

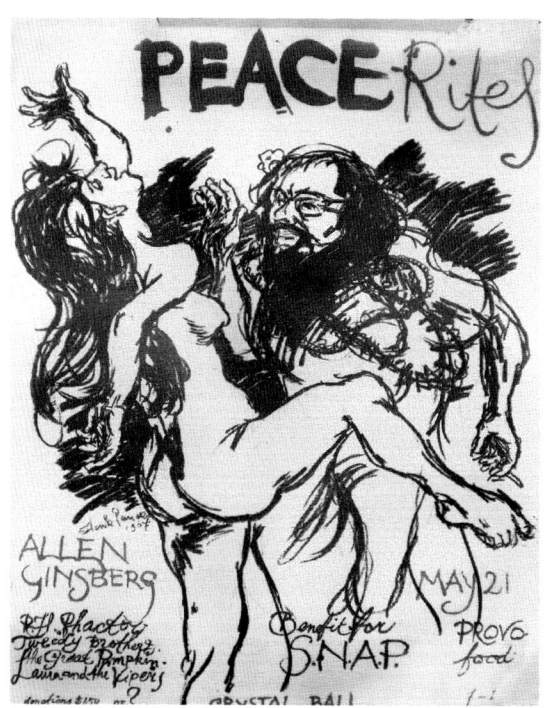

Peace Rites, by Henk Pander.
Courtesy of the artist.

Retrospective

The spotlight turned and Portland focused when Allen Ginsberg came to town. Between May 19 and May 22, he spoke at Reed, Portland State and the University of Portland. The *Oregonian* ran multiple articles, and his photo shut a campus newspaper down. But many say the Peace Rites benefit at the Crystal Ballroom stands out. The poster still hangs in the dance hall's stairwell.

"We wanted a circus poster, one that we could go around and paste, but we lost energy and made it oversized," Snodgrass said. He also wanted a festival as opposed to a poetry reading. He lined up local acts Great Pumpkin, Tweedy Brothers, Laura and the Vipers and PH Phactor Jug Band. "Booths around the dance floor had flowers, incense and candles. Like the Diggers in San Francisco, people doing free food came."

Along with Ginsberg's presence, a balloon drop highlighted the evening. "I wish I could remember this man's name," Snodgrass said.

> *He came to SNAP meetings. He might have been an engineer. He wore a silver suit, and we rigged him up on a rope from the ceiling. It was like a bungee jump. He came down through the net and released hundreds of balloons. We had light shows, which were coming into vogue. They used oil on gelatin and overhead projectors.*

Snodgrass remembers a "scary moment" at the control panel:

> *We burned out a couple of circuits while the band played and I said, "What are we going to do?" So, we put in a bigger fuse, and the hell with it. I overloaded the circuit, which is dangerous, but the show had to go on. The bungee jumping engineer stood behind me and said it would blow before it caught fire. Wires jumped.*

As the queue outside grew, so did worries about maximum capacity. "Here's the fire inspectors, the police, all this stuff coming at me, and I'm just deliriously happy with the event," Snodgrass said. "We negotiated and asked people in the booths to put out their incense and candles. Everyone danced. Ginsberg chanted and read poetry. It brought people from the intellectual community into a psychedelic setting. It was quite wonderful."

Dinner with Allen

Sandy Polishuk remembers working for Portland's antiwar movement. "I was involved in SNAP and became a draft counselor with the American

Friends Service Committee," she said. Polishuk came to Oregon in 1966, when her then-husband Stephen Kosokoff (aka Kaye) joined the speech department at Portland State College.

"We had a big house in Northwest Portland, so a lot of people stayed or came for dinner," she said. "Many were well known, like Joan Baez and David Harris. Most were pretty nice, but none paid attention to my children. Ginsberg was so sweet. When my four-year-old made up a song at the piano, Ginsberg sat down and sang with him. He was delightful and non-arrogant."

Polishuk treated the crowd to vegetarian soup from Julia Child's cookbook. "We had twenty-five people, and I couldn't afford to serve meat," she said. "They perched all over. A babysitter came and put the kids to bed. She almost fainted when she saw who was there."

Hugo du Coudray (aka Maynard) remembers Polishuk's party. "Ginsberg was a nice person, open and a little spacey," he said. "He was there for political reasons, and most people who came to the party talked about strategy, tactics and what the government might do next. Now and then, someone talked about poetry."

On the Portland State College faculty and active in politics, du Coudray had recently lived in the North Beach neighborhood of San Francisco. "Ginsberg showed up now and then," he said. "During the '50s, Allen was in a suit and shaven. He was already reading about Buddhism. By the '60s, people had a growing interest in philosophy and religion. We all read Allen Watts. That became more integrated into who Allen was. He became more guru-like; he brought feelings of peace and harmony. He was well into that character on this visit to Portland."

A News Blackout

"The whole thing was preposterous," the former Portland State College newspaper editor said about a flap caused by a photo. Now a professor at Florida State University, William Weissert remembers the problem he had when Allen Ginsberg came to Portland.

"It was going to be the third week without a photo on the front page," he said. "A faculty member said, 'I have one, but you won't use it.'" On the contrary, Weissert found his suggestion perfect.

"The photo was from the book *Nothing Personal*," Weissert said. "It's Allen Ginsberg—exceedingly hairy—naked with a hand over his groin. It's always been my contention that if he were less hairy, this wouldn't have been a big deal."

Retrospective

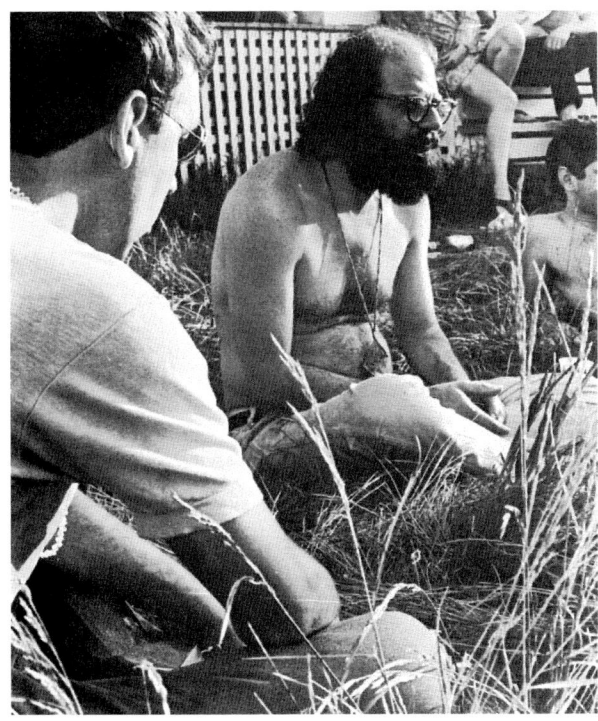

Allen Ginsberg outside the home of Phil Wikelund during a 1967 visit.
Courtesy Special Collections, Eric V. Hauser Memorial Library, Reed College.

The uproar started soon after the May 22 publication. During the next three weeks, the *Oregonian*'s thirteen stories on the issue included regular updates, letters to the editor, legislative reaction and an editorial.

"Two front-page photos, including a picture of poet Allen Ginsberg naked, led to the suspension late Thursday of the PSC newspaper, *The Vanguard* by college President Branford P. Millar," headlined the May 26 front page. "In suspending publication, Millar stopped the press run for Friday's issue and ordered all copies already printed to be destroyed or impounded."

A May 28 editorial made the paper's position clear:

> What puzzles us about the Allen Ginsberg fuss at PSC is why students who must scratch for money to get an education are willing to spend it to support a weirdo who makes a good living by substituting depravity for talent...The filthy free verse Ginsberg read for the students was about as meaningful as adolescent scribbling on a toilet wall.

Meanwhile, Weissert reflected, "That photo did something. Nobody outside the college knew who Ginsberg was until we published it. Then,

when it appeared and was publicized, the public got all excited about the guy."

Faculty and students divided. Some advocated retaliating with an off-campus publication, while others vowed to enforce new regulations. State legislators issued a declaration: "We abhor such misuse of public monies and commend the recent action whereby a college administrator saw fit to remove an offending publication and its obviously incompetent staff."

Finally, Ginsberg responded in a June 4 *Oregonian* letter to the editor. He noted two erroneous newspaper reports: one, that he'd agreed to keep his clothes on during the Portland visit, and two, that the nude photo degraded his poetry:

> *Such a great nonsensical flap has been made over the circumstances attending a poetry reading I gave at Portland State on May 27, 1967 that I would like to add a few clear words and perhaps calm those curious who are calmable. Portland State's student newspaper published a photo story prior to my reading. The text included an inaccurate report that the school had requested and I had complied with a request to behave at Portland State with some especial "propriety." Fortunately, for everybody's sanity no such request had been made. It would have been a provincial and ill-educated request; it remains a provincial and ill-educated fantasy.*
>
> *The uproar was caused by people who did not attend the gathering and who assume that I am some sort of obscene quack ripping off my clothes in public, mouthing four-letter words exclusively and mouthing them exclusively at Portland State, all this supposedly done for private financial gain or in an un-American attempt to subvert our tender youth who should be in training to die in Vietnam rather than listening to filthy poetry readings.*

HENK PANDER IN AMERICA

Experts call Henk Pander brilliant. The celebrated artist's work hangs in the Portland Art Museum, Rijksmuseum in Amsterdam and public buildings throughout Oregon. Stunning art fills his Southeast Portland bungalow and backyard studio. His work shares multicolored living room walls with his father's drawings, a cousin's oil painting of a dog and his late wife Delores's embroidered self-portrait.

Born in Haarlem, a town near Amsterdam, in 1937, Pander is the eldest of ten. He graduated from the State Academy of Fine Arts in Amsterdam,

Retrospective

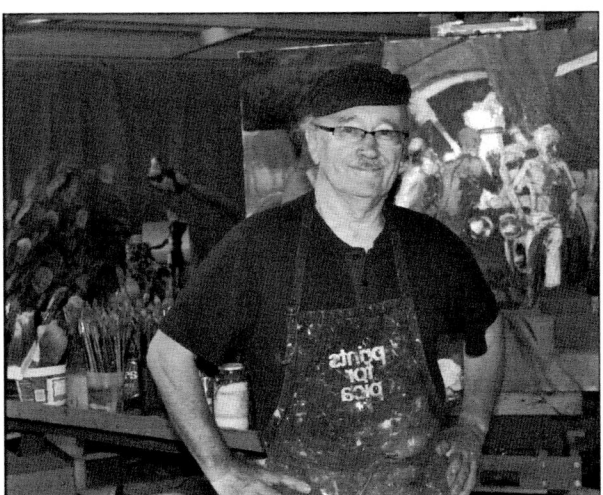

Right: Henk Pander in his studio, 2011. *Photo by author.*

Below: Fifth Avenue Portland during a 1965 American Legion Convention, by Henk Pander. *Courtesy of the artist.*

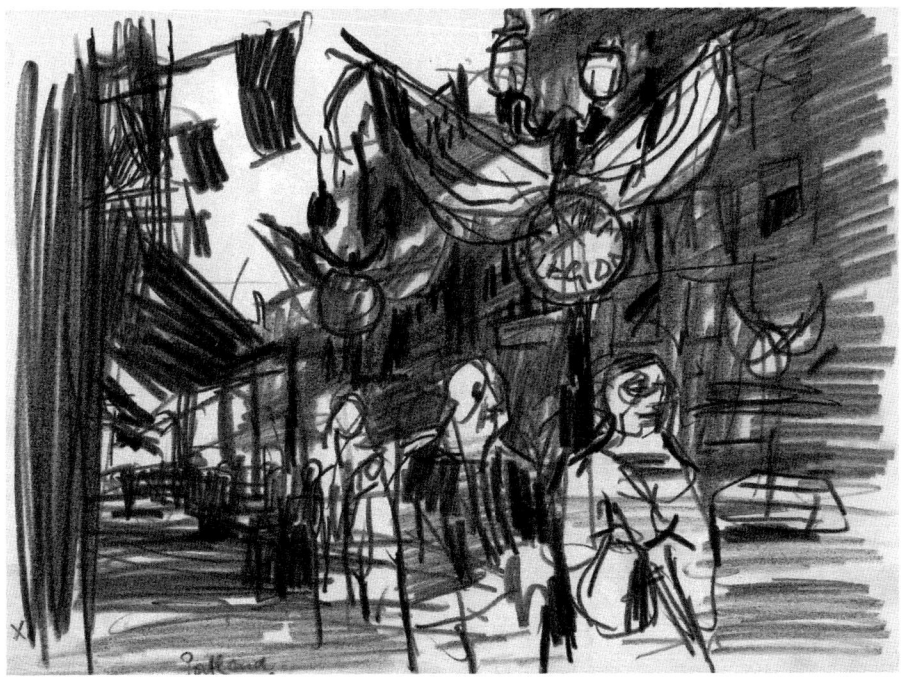

married an Oregonian and came to Portland in 1965. "I felt part of a large historic reality—dangerous, exciting," he said. "I was wrapped up and close to art but involved in the issues of the time. Art should integrate itself into society; it is a seamless part. I found a place as an artist outside the art world."

Pander began teaching at the Museum Art School, now the Pacific Northwest College of Art. Anti-Vietnam demonstrations reminded him of Haarlem during World War II. "I had grown up with violence and bombing raids," he said. "I made connections and still do. A sign in the Haarlem parks said Forbidden to Jews, and I saw hippies not allowed in Lair Hill Park. I drew sharp images that reflected this. It appealed to the underground class."

His work also appealed to critics. "The paintings of Henk Pander are blunt, forceful, and their impact is immediate," Harry Widman wrote in an April 9, 1967 *Oregonian* review. "He holds nothing back. His themes are love, violence, age and death. He paints figures that are animal-like, performing animal acts, displaying animal characteristics." Still, others considered Pander's 1969 Portland State University exhibit pornographic. "It was terrifying," he said. "I was broke, and I had two children. It blemished my reputation and made it hard to be taken seriously. The only gallery in town wouldn't have anything to do with me."

When the National Guard shot four Kent State University students during a 1970 antiwar demonstration, Portland exploded with a student strike. Pander recorded events with his sketchpad and contributed to the alternative newspaper the *Willamette Bridge*. By then, he lived on North Russell Street, a violent area in the city's black neighborhood.

"It is more lively here than in other parts of the city," he wrote to his friend Willem in Holland. "People are more outside and are freer."

Pander wrote to Willem for years. Today, the letters are together in a bound volume, thanks to Delores Pander, who once typed as her husband translated them from Dutch.

"I don't feel like a foreigner except when a situation is over my head," one 1970 letter said.

> *Then, I think in Dutch to create a distance from it. My reality over the past five years has been America—the language, the culture—and whether I have enjoyed it or not, the experience has influenced my personality.*
>
> *I think of Holland as my youth, an experience out of a remote past. I complain about Portland in my letters, but there are many good things. It is one of the most livable cities in the United States, with cheap housing, beautiful Victorian neighborhoods (a few left) and relatively little political repression. Over the last number of years, Portland has gotten the reputation of being an oasis, and people from around the nation come here for "the quiet life."*

Retrospective

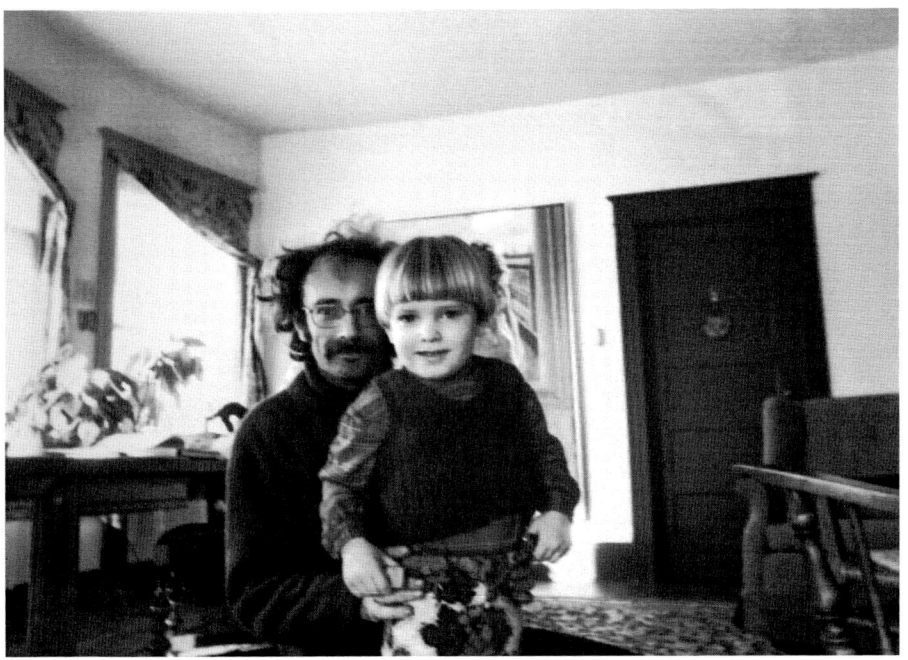

Henk Pander and his son, Arnold. *Courtesy Henk Pander.*

Pander found differences between himself and the local art community. "They were abstract painters and modeled themselves after what was happening in New York City," he said. "A lot were into modernist art and minimalist painting. I'd come from a different cultural background. Essentially, I was figurative.'" He found the like-minded at Portland's new avant-garde theater, as shown in this 1971 letter:

> *This year, I have become involved with a loose, commune-like group who call themselves Storefront Theatre. The core consists of a number of professional actors who did Off Broadway plays in New York and worked for The American Theater Company and Seattle Repertory Theater. After 25 years of legitimate theater, they were so sick and tired of the professional dog-eat-dog rat race that they went underground.*
>
> *There is a lot of talent in Portland, underground talent—writers, film-makers, poets, actors, dancers, set designers, rock bands. A lot of this creative energy has centered itself around Storefront. It is housed in an old shop on Russell Street, a five-minute walk from my house in the oldest part of the ghetto. The space is approximately 25 meters deep and 10 meters wide,*

with tall brick walls, and a balcony-like floor in the rear. It is available for anyone who wants to use it. The $50/month rent is raised by having parties the last Friday of every month, where a $1 donation is requested. To these parties come filmmakers with their films, rock bands, and all kinds of other musicians. They do theater skits and audience games. There are magicians and experimental dance groups. Every party is different, and I am never bored.

Every Wednesday evening there is a meeting of everyone who is active in the theater. They do theater games, and there is a general workshop where plans are made for the Friday night parties. Dancers do dance numbers, actors do acting numbers, yogis do yoga trips, and a good time is had by all.

THE PORTLAND ZOO

Once called the "world's most ethnic phantasyrock group," the Portland Zoo was one of the city's popular 1960s bands. Their original compositions incorporated gypsy jazz, black blues, Hungarian folk, German avant-garde theater, Appalachian mountain music and more.

Lead guitarist Peter Langston joined while still a student at Reed College. At that time, the group consisted of Sharyle Patton on rhythm guitar, keyboard and vocals; Lynn Parkinson on bass; Larry Whitney on drums; and Langston on lead guitar, mandolin and vocals. The group performed until about 1971. After leaving, Langston taught audio recording and computer science at Evergreen State College, researched computer music and graphics at Bell Labs, started a games company for George Lucas and taught at music and dance camps:

What do I remember about the band? The inventiveness and creativity, our wide range of interests, our ideas. I wrote one song about putting things off in life. It's quiet and contemplative. It builds to a tsunami of sound and stops dead. I'd jump off stage and throw the breaker panel switches. Sensory overload, sensory deprivation.

I'm from Manhattan, Greenwich Village, and came to Oregon to attend Reed College. Reed was famous for being a good place for people who didn't fit in and needed a supportive environment. Having spent four years in a repressive all boys' school, I went from a geek to a popular person. I bloomed, although not academically. This was 1963.

At Reed, I fell into the music scene. I started with generic folk music; I'd heard the Weavers' recording of their Christmas 1955 Carnegie

Retrospective

Bruce Weber poster.
Courtesy of the artist.

Hall concert. I played at the Way Out, a small coffeehouse under the Hawthorne Bridge. Then, I hooked up with other musicians and formed the Indisputable Jugband Itself. We got notoriety for playing at a SNCC [Student Nonviolent Coordinating Committee] *get-together.*

One jugband member was friends with Reverend Gary Davis, who was in town during the KPOJ Battle of the Bands. Gary came with us to KPOJ at 7:00 a.m. We stopped by this wonderful hotcake house at the end of the Ross Island Bridge where an off-duty cop ran the cash register and a woman named Goldie cooked. Anyway, here we were in a booth with this whooping and hollering black man. We looked around and realized everyone was terrified of us.

At the contest, we were counterculture, obnoxious Reed students, and everyone else was cheerful, all-American Kingston Trio types. Everyone stared at Gary whooping and hollering from the audience while we played.

Portland in the 1960s

The Portland Zoo started when an accomplished blues player named Tom McFarland needed a rehearsal band. Lynn Parkinson always wanted to play the bass, and Sharyle Patton played a little folk guitar. Sharyle and Tom walked into the Lewis & Clark College coffee shop, looked across the tables and said—"There's the drummer!" They walked across to this guy and asked, "Do you play drums?" He said, "No, but I've always wanted to." They got together and rehearsed.

One day, Tom walked off and left his expensive Gibson guitar by the side of the road. So, here was the band without a lead. Sharyle said, "I know this person at Reed; let's ask Peter Langston."

About the Music
The Zoo was a test bed where you could try any idea. Sometimes, Sharyle dressed like an old lady and went through the audience selling flowers. When she got near the stage, we'd sing a British Music Hall song:

Don't cry lady,
I'll buy your damned violets,
Don't cry lady,
I'll buy your posies, too.
Don't cry lady,
Take off those dark brown glasses.
Hello, Mother, I knew it was you.

We became the house band for the Charix, the Unitarian church's outreach coffeehouse. Of course, Charix was fabulously successful; it was the place everyone bought drugs. So, we wrote an operetta called Ahead of His Time, *about your average hippie who comes to Charix. Terry Schrunk was Portland's mayor, so we called his daughter Violet Shrink. Our hero is a local rock 'n' roll star and the mayor's daughter is his fan, whom he rebuffs. The nefarious narc throws him in jail, and then he woos the mayor's daughter. We included familiar situations, like people taking drugs and avoiding narcs that they assumed hid behind every corner.*

*The majority of what we did was our own or something people hadn't heard like British Music Hall songs or religious music. None of us was religious, but the music is wonderful. We turned Blind Willie Johnson's "God Don't Never Change" into a rock 'n' roll thing. We often wrote songs related to early folk music. For instance, we turned an English ballad—*Love grows older and waxes colder and fades away like morning dew*—into a Beatle's song.*

Retrospective

Portland Zoo at the Charix. *Courtesy Peter Langston.*

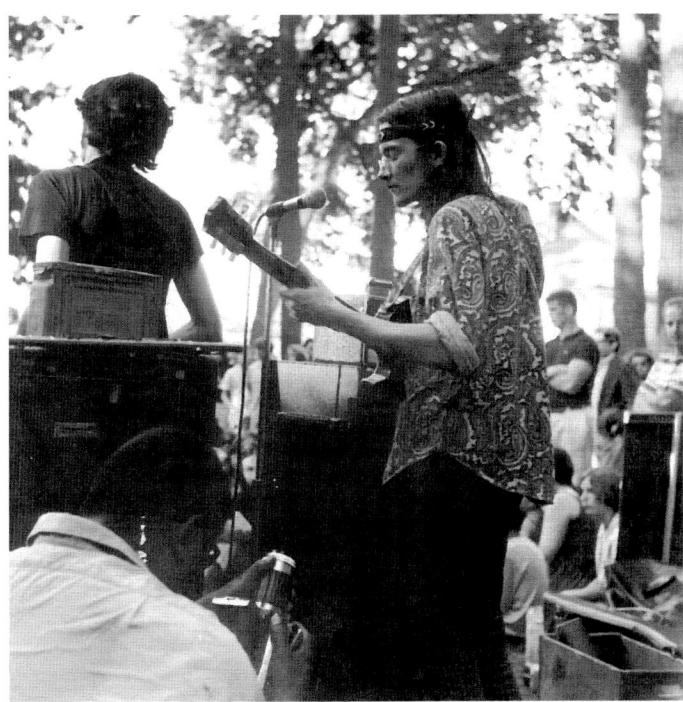

Portland Zoo at Lair Hill Park. *Courtesy Peter Langston.*

> *We played all over the place. One time, city commissioner Francis Ivancie decided the hippies were out of line and put a curfew on park hours. So, we threw a party for him starting half an hour before the curfew and invited the media. He had no choice but to show up and act like he was pleased. We played at the Pythian, the Agora Coffeehouse, the Crystal Ballroom and Springers, a big venue in the southeast. It was a country western dance hall but had large gigs, like the Youngbloods.*
>
> *It was very nice. It was not like paparazzi followed us, but people stopped on the street and said, "You're the Portland Zoo." One big guy named Tiny helped us move equipment around. There was a fair amount of that hangers-on subculture. They probably made their living in the drug trade and belonged to the local motorcycle gang. I met some years later only to discover they were a state Supreme Court judge or in some other responsible position. One is among the country's foremost violin bow makers.*

A STOREFRONT THEATRE

The Storefront Theatre's first show stands out for raunchiness, free spirit and promise of things to come. The avant-garde, never-to-be-forgotten troupe of musicians, artists, non-actors and even a few actors jumped in with its production of *Lysistrata* on a Washington County farm.

It was June 1970. The Vietnam War raged as the United States bombed Cambodia that April. Student strikes followed, killing young people at Kent and Jackson State and sending thirty-one Portlanders to the hospital, some with cracked skulls. Thousands marched to city hall. Wanting to make an antiwar statement, theater director Tom Hill chose Aristophanes.

"It was wonderful," said Joe Uris, who played a soldier in the Greek farce where women withhold sex until their husbands stop the Peloponnesian War. "Bold, sexy, it cut to the core of issues like women's power, war and peace and why men fight. Henk Pander put together sets from virtually nothing. They got columns from my old house. And the production had beautiful costumes."

When the troupe reminisces about *Lysistrata*, costumes come up fast. "Everyone met at our place to make their phalluses," said Nicholas Hill, who is the son of director Tom Hill and his actress wife, Anne Gerety. "One soldier had four-inch-thick hemp rope that went all the way to the floor and khaki-colored balls. Another made red and white stripes with a blue and white star tip. Did the audience laugh? Not really. When they came

out like that, Peace also arrived. She was a naked woman holding a dove on her finger. That was more unusual than anything in 1970."

Everyone had a riotously great time. They made campfires and slept overnight in the hay. Twenty-one years of Storefront followed. Beginning in gritty North Portland, it moved to a former porn house off Burnside in 1980 and to the Dolores Winningstad Theater in 1988. Although Tom Hill and Anne Gerety left in 1974, luminaries like Ric Young, Henk Pander, John Morrison and Izetta Smith carried on. "Storefront didn't even exist until 1970, but its spirit was all '60s, counterculture, communal, hippified," theater critic Bob Hicks wrote when the theater closed in 1991.

Tom Hill as Jack Rance, by Henk Pander, *Courtesy of the artist.*

An American Theater

The seeds of Storefront started in 1967, when Portland State College agreed to host and house Portland's first professional theater company. It was called the American Theater, and Tom Hill was hired to direct. Formerly director of the Seattle Repertory Theater, Hill had twenty years' experience in acting, directing and production.

Victoria Mercer worked with the theater from its inception through its demise. "Tom Hill and Anne Gerety came to town to start a teaching equity theater that was another stop in a West Coast string," she said in a taped oral history taken by Susan Stelljes in 1997. "There was one in San Francisco and one in Seattle, and this one would be in Portland. It incorporated students in productions and actors as teachers. In 1968, I got a job in the costume room as a seamstress. I had other jobs because I certainly didn't make enough money to live on."

According to Anne Gerety, at that time American theater companies rarely chose American playwrights. "It was euro-centric, and Tom became obsessed with rediscovering our theatrical roots, our heritage, and spent

years digging through plays and discovering a thread of myth that moved him," she wrote in a 2002 memo to Mercer.

"We did *The Gladiator* with a black Spartacus, *Camino Real* with near nudity, *The Balcony* with an exposed breast and finally *The Cherry Orchard* about the dissolution of a culture," she continued. "We naively didn't realize how controversial we were, and we found out that we wouldn't be at the university after the 1970 season. John Morrison and Peter Gerety were also members, and Ric Young was the designer. We talked about finding a space where we could do what we wanted without the repression of the hierarchy."

According to her son Nick, Gerety stumbled on the North Russell Street storefront when she got off at the wrong bus stop on her way to Kaiser Permanente. Once the home of Polish immigrants, the industrialized neighborhood now lay decrepit and abandoned. Gerety looked around the rat-infested space, saw plaster falling off brick walls and thought, "Perfect." Around the corner from the White Eagle Tavern, and today the fashionable home of Widmer Brothers Brewery & Pub, the place rented for fifty dollars a month. Her brother, Peter, built a lighting system from tomato cans.

On Strike

Many believe Tom Hill and Anne Gerety's firing from Portland State was more in response to their support of the student strike than on-stage nudity or controversial material. "That season we did a Jules Feiffer, a Chekhov and a Genet," Peter Gerety said. "We weren't exactly running naked thru the aisles. The firing had to do with the politics of the day and our vocal positions. That vote gave them the smoking gun."

The gun was loaded on April 30, 1970, when President Richard Nixon announced the bombing of Cambodia and called for an additional 150,000 troops. Campuses around the country erupted in demonstrations. On May 4, the Ohio National Guard shot four Kent State students dead and wounded nine others. In reaction, student strikes closed hundreds of colleges and universities, including Portland State.

Anne Gerety learned about the Kent State murders while rehearsing *The Cherry Orchard*. "We struck with the students and used the storefront for the first time as a rehearsal space for street theater that we performed around Portland that week," she wrote. "We postponed the opening of *The Cherry Orchard*."

Protestors in fatigues and black armbands surrounded the campus theater. "No one would have crossed that picket line to see a play," Peter Gerety said. "Nevertheless, before dismissing us for the duration of the

strike, the head of the theater department demanded a vote on who backed the strikers and who believed that the show must go on. Only Tom, Anne and myself voted with the strikers. Shame!"

After the vote, students and others adjourned for the first of several all-night sessions. "You could barely fit all the people in Tom and Anne's house," Peter Gerety said. "They just wanted to know what and how. Tom reached into his bag of tricks and pulled out the Group Theater. During the Depression, they confronted the public in Union Square, New York, with political skits at noon that they had whipped up from that morning's newspaper."

Peter Gerety as Sweeny Todd, by Henk Pander. *Courtesy of the artist.*

The troupe woke up early, drove to the *Oregonian* and grabbed papers hot off the press. They selected stories, created skits and performed at lunchtime on the Park Blocks or around city hall. "We found articles that resonated, sometimes about the war, but often about how the war affected us," Gerety said. "It could be about Agent Orange or the response of the Buddhist community. Once, Ric came up with a three-thousand-year-old Vietnamese legend. We hammered it out and improvised. It was the most exciting time of my life, and to me it was the birth of the Storefront."

The Storefront's First Years

Victoria Mercer remembered the Storefront's production of *Girls of the Golden West*. "This was the summer, and the actors wore giant fur coats," she said. "Alice Deane and I stood on either side of the stage trying to make it snow. We could only afford one box of plastic snow, and we swept up afterward. It got browner and dirtier, and in later performances, you'd hear nails fall because we didn't sift through it.

"By that time, we'd rented the space next door, too," she continued. "The first act was in the original theater and the second was next door, so the audience picked up their cushions and folding chairs and moved. Then we made them move back for the third act."

Of course, theater on a shoestring precluded niceties like air-conditioning or central heating. Warmth came from a wood stove cleverly built into the set. The first few years included *Salome* by Oscar Wilde, *The Tavern* by George M. Cohan and *Glassy Alice Wandering Through Looking Land* by Steve and Gary Smith.

"The biggest show was *Hustle and Bustle on Russell*," Mercer said. "It was a three-ring circus with death-defying acts. One night, Peter Gerety cut himself on the thunder sheet and needed stitches. So here's Emanuel Hospital emergency room full of circus performers with a Storefront twist."

Storefront stories could fill a book or a lifetime of cast reunions. One of Peter Gerety's favorites came during Julie Bavasso's *Down by the River Where Water Lilies Are Disfigured Every Day*:

> *The audience was raised on the wall. We built two shelves, and they climbed up a ladder and sat down. The floor was fake grass. Tom Hill and another man were in drag as two fat black women, Missy and Sissy. Each evening, they entered through the theater's front door.*
>
> *As luck would have it, an elderly black gentleman (street drunk) decided he was in love with Sissy. All he knew was these two fine women came out of one door on Russell Street every night around the same time, flirted with him (in character) and went into another door.*
>
> *One night he followed. It was dark on the stage. All you could see was green grass. There was no way he could see the audience up on the wall. And the audience didn't know that he wasn't in the show. He tried to engage Sissy in small talk, but she ignored him. Just as the scene was about to end, he decided he needed to piss. And he did, on the grass.*

Staying afloat required creativity and resilience. Tom Hill and Anne Gerety took over the macrobiotic Wayfarer Restaurant, first on Friday and Saturday nights and eventually full time. Weekend Indian feasts came compliments of Tom Hill's cooking skills, acquired growing up in India with missionary parents. Rent parties modeled after Harlem, New York, during the Depression helped pay bills and started the Storefront's vaudeville tradition. Flyers plastered in likely venues invited all to perform. Acts ranged from Monty Python skits to scenes from *Oh! Calcutta!* to Tom Hill's unforgettable

Retrospective

Wayfarer Restaurant, by Henk Pander. *Courtesy of the artist.*

rendition of Lou Costello and Sid Fields's "Slowly I Turned...Step by Step." White Eagle Tavern performers like the Fly by Night Jass [*sic*] Band and Holy Model Rounders stopped by to join the fun.

Looking Back

"The Group Theater was a seminal force," Peter Gerety said, reflecting on the legendary New York troupe. "They had no hierarchy. They tried to create theater that reflected their time, community and issues of the day instead of just being a vehicle to entertain."

Tom Hill and Anne Gerety believed in the Group Theater and emulated it when they could. "If you wanted to do a show, you went to a meeting and made a presentation," Victoria Mercer said. "It was freezing in that place, and we had hideous meetings that went on forever. People said, 'I'll do the costumes, I'll direct, I'd like to run the lights.' It was like that."

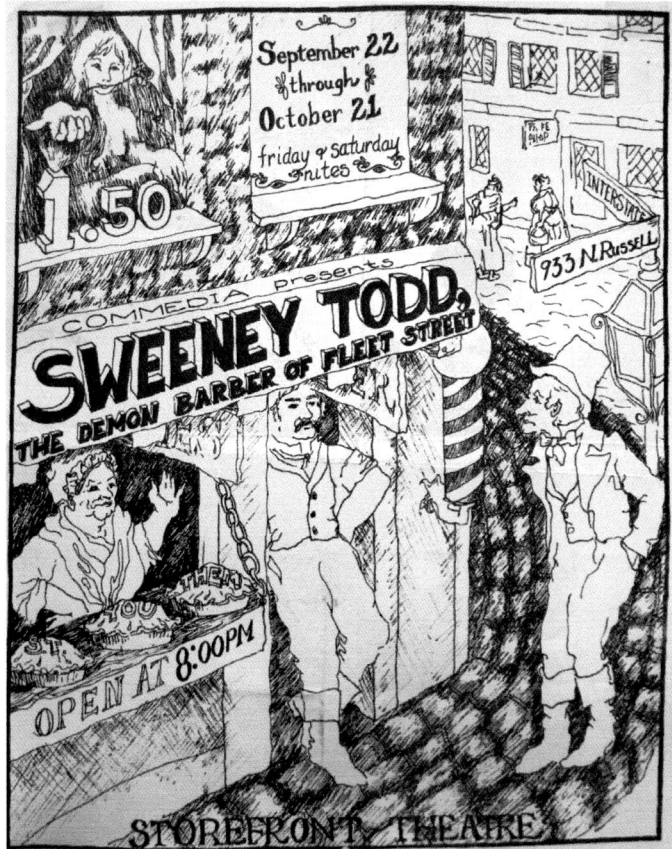

Demon Barber of Fleet Street, by Leslie Morrison Sears. *Courtesy Henk Pander.*

Mercer remembered a strong contingent of gay men and throngs of children. "Young men who had a hard time in school were drawn by Ric Young, who was outspoken," she said. "The kids were raised by a village. Some went to the Metropolitan Learning Center, like Tom and Anne's kids. People in their early thirties had young children. All came together and coexisted."

Close, lifetime friendships formed. Many Storefronters lived with or near each other clustering around the theater, in Lair Hill or in Goose Hollow, where some worked at Bud Clark's tavern. "It wasn't so expensive to live, so people could do things," Mercer said. "I don't think people have that kind of freedom now. We'd take handbills to the quick print, get five hundred copies and paste them up all over town. We charged fifty cents for the plays and took whatever people brought."

Part II
COUNTER INSTITUTIONS

If the institutions of a society are unjust, unfair, racist and inadequate to serve the needs of the people, what you do is create "counter-institutions" that answer all those questions. You have your own food cooperatives, your own schools, your own clinics, your own music and your own culture and these are counter to the mainstream.
—Bill Ayers, Fugitive Days

Among those representing the 1960s, Peter Berg and the Diggers stand out. Taking their name from fifteenth-century English communists who disdained private property, the San Francisco group synthesized bohemian art with radical politics. They passed out free food in Golden Gate Park and opened a free store with "liberated" merchandise. They performed street theater like the *Death of Money Parade* and coined phrases like "Do your own thing."

Portland had its own version of counterculture institutions, several of which live on. What started with Maryalice Cheesman's second-hand shop became citywide vintage chic. Alternative education envisioned by A.S. Neil of Summerhill in the 1920s went mainstream with Portland Public School's Metropolitan Learning Center, which, along with the Willamette Learning Center, Albina Youth Opportunity School and John and Mary Kerr's School-House, grew into the city's charter school movement.

KBOO-FM Radio remains on the air, and the *Willamette Bridge* morphed into today's *Willamette Week*. Outside In, the clinic that began with a vision and shoestring, has turned into a major nonprofit with job training, case management, medical facilities and other services for homeless youth.

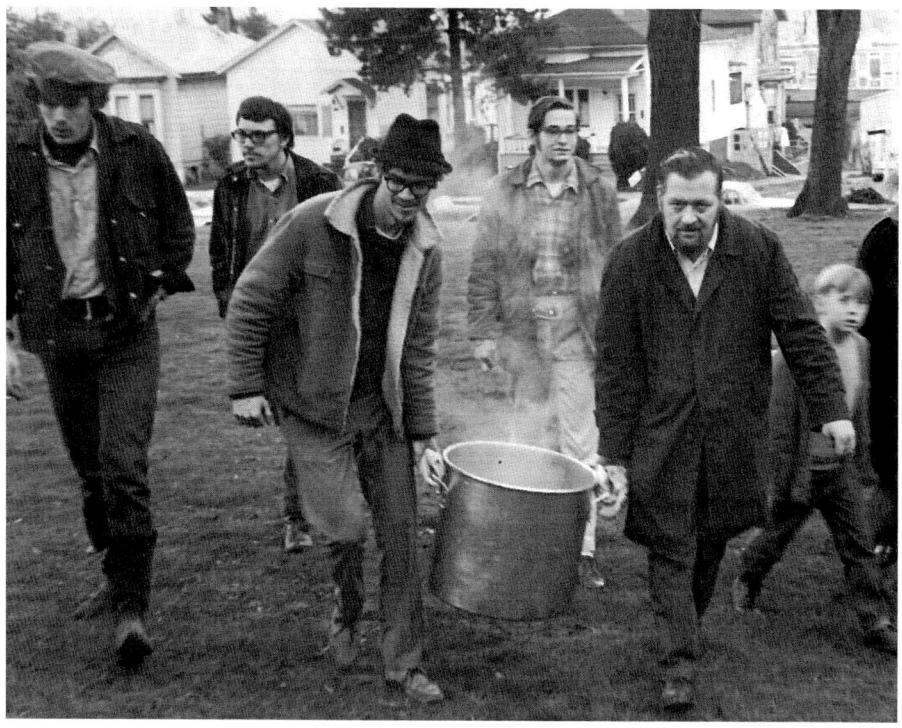

Ben Jacobson (right) and Peter Nicholls bring free soup to Lair Hill Park. *Courtesy Emery Ingham.*

Emery Ingham and the Psychedelic Supermarket

When the Psychedelic Supermarket moved into Mrs. Maccoby's old grocery, the Lair Hill neighborhood's transformation was complete. Opened in 1967, it lasted only five years but remains iconic. The legendary proprietor, Emery Ingham (1933–2010), had eight children. His only son, also Emery Ingham, administers the Facebook page "I Remember the Psychedelic Supermarket" in his honor.

The young Mr. Ingham remembers windows covered with psychedelic paintings by light show artist Gary Ewing, the smell of incense and posters on the walls. Customers made sandwiches gratis from always-available peanut butter, jam and day-old whole-wheat bread. The bulletin board posted neighborhood news: missing person, need a ride, looking for a place to crash.

Pipes, jewelry, belt buckles and even Hells Angels' courtesy cards covered glass display cases. Floor-to-ceiling black lights and black light posters followed. Local seamstresses made and sold clothes. "In back, a

Counter Institutions

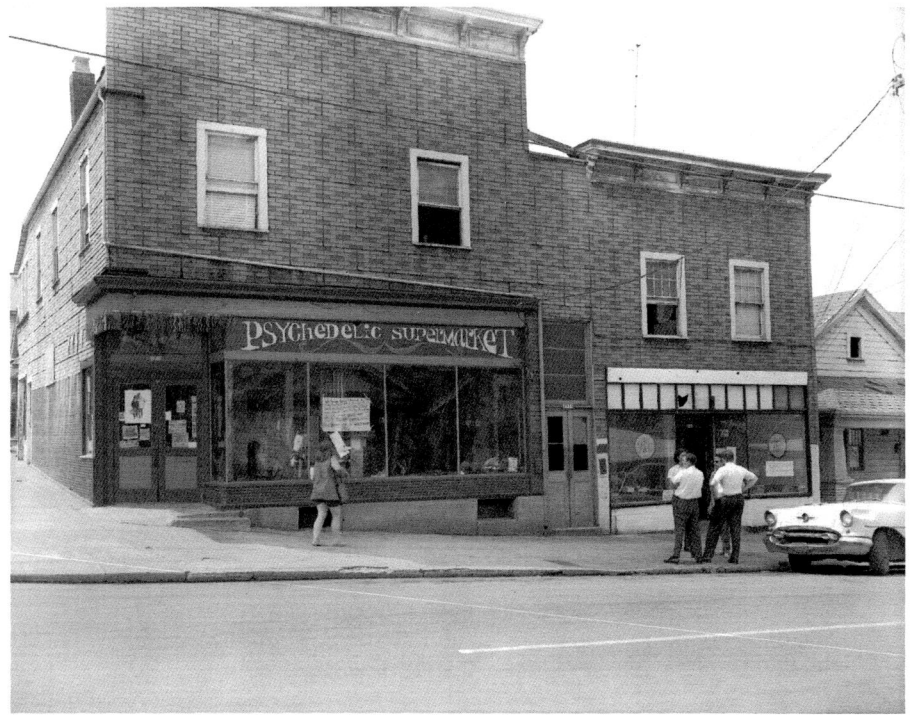

Psychedelic Supermarket. *Courtesy City of Portland Archives, Oregon, A2012-005, June 18, 1969.*

large wood stove always burned in cold weather," Ingham said, "to warm up wandering souls."

Bill Grano, a regular contributor to the "I Remember the Psychedelic Supermarket" Facebook page, remembers peanut butter sandwiches and the man who ran the store. "[The year] 1968 was a confusing [one]," he once wrote.

> *I was alienated from the folks and starving. I ended up, thank God, at the market smelling incense and eating pb&j sandwiches. It was at this point that Emery and Jo protected me from an unsavory predator character they noticed and immediately banned. I'll never forget Emery Ingham or his forever wife. He also had me sell* Willamette Bridge *newspapers for spare change.*

By the time she was eighteen, Julie Aitken owned the Cuckoo's Nest, a hip store located in Old Town. "A large group of girls came to Portland on the

Portland in the 1960s

Emery Ingham Sr. owned the Psychedelic Supermarket. *Courtesy Emery Ingham.*

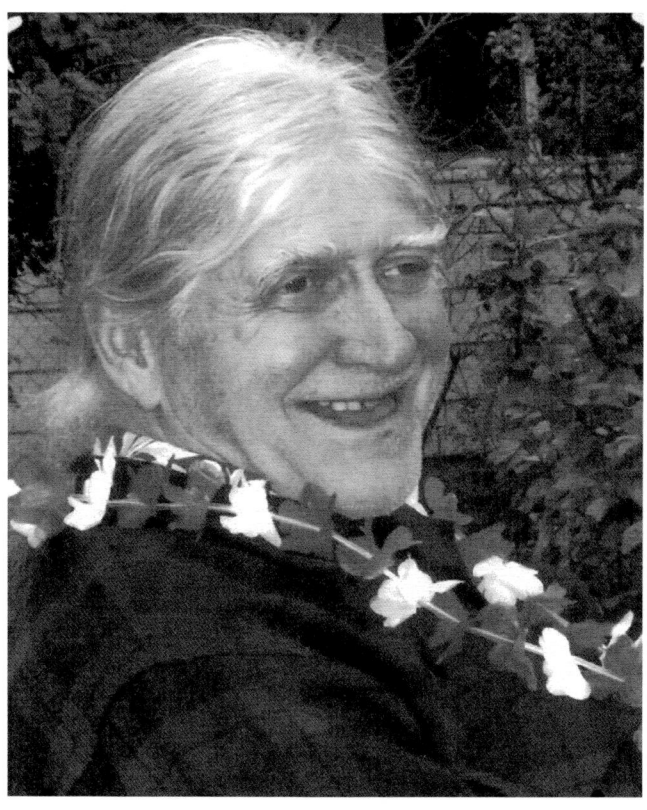

Emery Ingham Sr. later in life. *Courtesy Emery Ingham.*

bus from the suburbs," she said, remembering earlier teenage years. "Emery looked over us because he knew we were young and not telling the truth about how old we were. Emery and Jo were fabulous. They gave free food to people who were hungry. What a sweet man."

My Life at the Psychedelic Supermarket

Bruce Stoner was among seven partners who put up $100 to open the Psychedelic Supermarket. Eventually, all but Emery and Jo Ingham dropped out of the venture. In this 2011 interview, Stoner refers to the Vanport Flood of 1948, which destroyed the nation's largest housing project and Oregon's second-largest city:

> *When she died, it must have blown his mind. Emery and Jo Ingham were close. They were like a couple of kids. Emery was a big teddy bear kind of guy, laughing and jovial. I met him in college in the early '60s.*
>
> *I grew up in Portland and played football at Roosevelt High before Portland State College. We lived in Vanport until I was six. My folks went crazy trying to find me during the flood; I was out riding my bike. They say one hundred people died, but I saw fire trucks stacked with feet. After the flood, there was no housing anywhere, so my mom and dad put me in a Catholic boarding home for a year.*
>
> *The supermarket opened during an exciting time of radical change. Young people were unhappy with the status quo. It was fun because we put it together without money. It had two rooms, an ante and a back room. Someone gave us a tall, unwieldy display counter and stool, which I used as a lectern to pontificate on my recent studies in meditation.*
>
> *I don't remember selling much of anything. Free information was our most popular item. I'd string beads and put them on roach clips. We had long dangling clusters of beads and cigarettes. Like a thrift shop, people brought things around, and we gave them away. We cooked hobo stew in a giant military pot with whatever we had and took it up to Lair Hill Park along with everything we collected that week.*
>
> *I was twenty-seven, and my girlfriend was only seventeen. She had blond curly hair, and we looked like the quintessential hippie couple. One time, this Methodist minister from the suburbs came into the store and asked me to speak to his youth group. I thought, "This is a broad-minded fellow. Nice guy." My girlfriend came with me.*
>
> *We went to a church meeting hall in an upper middle-class neighborhood halfway to Beaverton. At least fifty straight little kids sat in a circle. The old*

priest sat in back, disapproving of me; the young priest stayed open minded, and I answered questions. I was adamant about my right to experiment with marijuana and LSD. No one had the right to tell me not to as long as I wasn't a burden on anyone. My dad was a truck driver, and I was always a hardworking American boy—an "A" student. I wasn't promoting drugs; I wasn't a salesman; I did not grow pot. In fact, nobody at the Psychedelic Supermarket sold anything.

The whole supermarket era was a special time. We put on dances, too. There were emerging bands—PH Phactor Jug Band, Country Joe and the Fish. Interesting times. Sometimes you'd go out and have—like a Woodstock, but on a nano-particle scale with fifty hippies running around naked in a park.

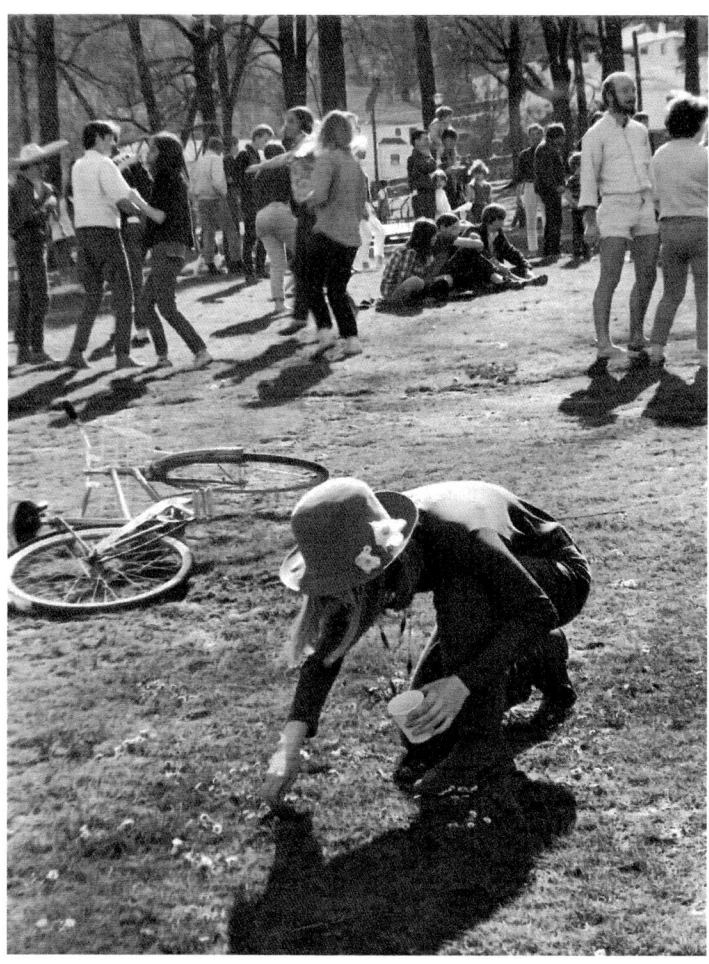

Flower children in Lair Hill Park. *Courtesy Emery Ingham.*

Counter Institutions

Phantasmagoria

Vintage clothing is all the rage today, but when Maryalice Cheesman opened Portland's first shop in 1967, the idea was new. The grande dame of Portland's hip community, Cheesman grew up in southeast neighborhoods, graduated from Washington High in 1957 and waitressed at the Way Out Café in the early 1960s:

> *It might have been the first vintage store on the West Coast. The Third Hand Store in San Francisco opened right before us or right after us, I forget. The only place we could afford was a 1890s Victorian house across from Goodwill on Southeast Sixth and Stevens. Arthur, me,*

Phantasmagoria's second location at Southeast Tenth Avenue and Washington Street. © *Jim Felt/studio3.com.*

Portland in the 1960s

our two kids and my sister moved in with $850 we borrowed from my parents.

The two front rooms, divided by open pocket doors, became our shop. A mammoth moose head festooned with leather hung over the entrance, so you had to fight your way in. We lived in the upstairs two bedrooms and bath and the downstairs kitchen. We put a three-foot 1930s Minnie Mouse on the roof, tucked under the peak.

The name, Phantasmagoria, just came to me. There was no sign, and when you looked in you couldn't see jack shit. It was madness. The shop arrangement changed depending on what we had for sale. Constants were a Victorian circular iron rack full of clothes, a Thonet hat rack and a Deco glass showcase for jewelry with a Victorian brass cash register on

Dolores T. Ashkar's portrait of Maryalice Cheesman. *Courtesy Maryalice Cheesman.*

top. Quilts on the ceiling drove the fire marshal nuts. When he came, the basement was full of junk—old paint cans, paper, magazines, crap. The only things he focused on were the quilts.

We didn't have a business license. One day, we had this huge amount of Masonic gear—robes, hats, etc. This guy came in and was outraged because here the hippies had his lodge and secret mojo stuff. The upshot was he wanted us to give it all to him. We said, "I don't think so." He said, "Perhaps you don't know who I am," whipped out his city badge, and asked for our business license. So, we handed in our thirty-five dollars and got our business license.

At first, we sold stuff we already owned. We had truckloads of junk—clothes, quilts, stained glass, old kitchen stuff, anything that was interesting. Every morning, I was over searching Goodwill bins. There weren't other hip stores, but we went to antique shops. People in the shops looked at us like we were crazy. They said, "Take that stuff away, it's embarrassing."

People called with closets full of clothes. Could we come get them? Sometimes they didn't even want us to buy it; they just wanted us to get it out of there. One guy said we could have a brass bed if we took everything else in the room.

One time, Arthur and I bought bales of velvet clothes from a rag company. We played with them most of the night and went to bed exhausted. We forgot to lock up and slept through shop opening. Four hours later, we came downstairs to a heap of papers, a ton of money and a couple of people pawing a floor full of unpriced dresses. People had tried things on, purchased them and left notes like, "Bought a beautiful green velvet gown... left $20."

THE WILLAMETTE LEARNING CENTER GIVES DROPOUTS A CHANCE

Rondal Snodgrass remembers Freedom Summer 1964. A graduate of Reed College's master of arts in teaching program, he volunteered in Mississippi, lived with a local family and taught at a Freedom School. He wanted a school like it for Portland and found allies at the Centenary Wilbur Church in the Buckman neighborhood. With the help of philanthropists like Sue Malarky, Bill DeWeese and the Collins Foundation, the Willamette Learning Center (WLC) opened in 1969.

"The Centenary Wilbur gave us this wonderful area with a large skylight," Snodgrass said in a phone interview from his home in California. Dedicated

to the social gospel, Reverend Harper Richardson and his congregation rented space cheaply to nonprofits like FISH, the War Resisters League and the Willamette Learning Center.

Like many late 1960s alternative schools, the WLC was responding to soaring dropout rates. According to a November 7, 1971 *Oregonian* article titled "Willamette Learning Center, A School for Dropouts," 6.3 percent of Portland's high school students ran away, withdrew or were expelled. At schools like Washington High in the Buckman neighborhood, rates topped 10 percent.

WLC students ranged between fourteen and nineteen years old. Most were white and from low-income families in the neighborhood. They received a credit diploma through Washington High or prepared for a General Education Certificate. The WLC also offered a special certificate that required passing the GED, living communally and completing an independent project.

Teachers lived near the school, and many shared their homes with students. Some were conscientious objectors from the Vietnam War, fulfilling mandatory community service requirements. Volunteers filled in. "They heard about us on the radio," Snodgrass said, "and came forward."

School started at 10:00 a.m. "A lot of kids hitchhiked, so we started late," Snodgrass said. "We had an orientation meeting and then classes or one-on-one tutorials. Every Friday, we'd have a field trip. For a class on historic

WLC student housing at the farm. *Courtesy Bonnie and Peter Reagan.*

Portland, we looked at homes. And we had camping trips. Once, we took eighteen kids backpacking at Mount Jefferson."

Soon the campus split into two locations, Centenary Wilbur Church and a 240-acre farm near Sandy. Snodgrass, his family and a few students moved to the farm while other teachers and students commuted a few days each week. "We did general farm work and fished," Snodgrass said. "Volunteers taught cross-country skiing and gardening. When Portland Neighborhood Centers brought elementary school kids, they watched us milk goats and make cheese. Sometimes we had horseracing with the ponies. Our kids became counselors."

Teaching at the WLC

When Bonnie and Peter Reagan graduated from Reed College's master of arts in teaching program, job prospects looked bleak. Furthermore, inspired by Vietnam War draft resister David Harris's 1968 campus visit, Peter became a conscientious objector, which required community service. Both found teaching jobs at the Willamette Learning Center.

"Certain classes occurred regularly, but there was an amount of sitting around," Bonnie Reagan said remembering a routine that included weekly commutes between the church and farm. "We were full-time teachers and full-time parents. We brought our two children to work and set aside a classroom for napping."

Bonnie taught English, swimming, photography and psychology. Cooking class started with grocery shopping at Corno's and ended with bagels, cream puffs or beef stroganoff. Hand-crafted fortune cookies had messages like "Kiss the person next to you" or "The person next to you likes you very much."

"One dinner, we faked a fast-food restaurant," Peter said. "Some worked behind the counter, and some were customers. By the end of the evening, you wanted to strangle the customers. It was nice to see what it felt like to work short order. Then, one Thanksgiving, a group fasted. The theme was 'appreciate your food, don't take it for granted.' We played charades that night."

"The Reed background worked well," he continued. "The program was so radical, it didn't teach how to get on in public schools. We also saw the downside. The basis was individual learning, but that morphed into lack of structure. Kids struggled, and nobody told them what to do. You can't just say do whatever you want because the kids want to sit around and smoke dope."

They also saw the upside. "WLC students didn't get in trouble with the law, which was not true prior to coming," Bonnie said. "They had something

Portland in the 1960s

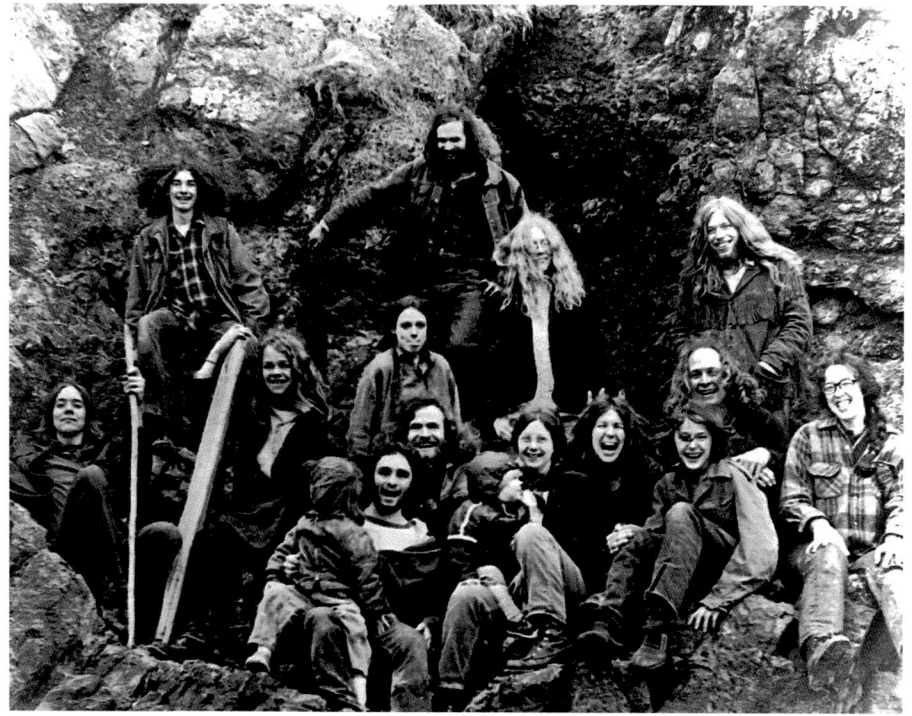

WLC staff and students at the farm. *Courtesy Bonnie and Peter Reagan.*

to do, and they knew people cared about them. We weren't constrained by a curriculum or evaluation, so we could concentrate on the kids. We were with the students a lot, not just during school hours. We weren't just academic teachers; we were role models."

Learning at the WLC

Becky Krall Weggler graduated from the WLC in 1970. While most students were low income and came from the Buckman neighborhood, Weggler's father was a physician, and she grew up in the affluent West Hills. She went on to receive a master's in public health. Today, she teaches at a private school in Tulsa, Oklahoma:

> *I was disgusted. I was in ninth grade at Lincoln High, and I'd been suspended from German class because I shut my book two minutes before the end of class. I got in trouble because I didn't stand for the flag at*

Counter Institutions

assembly. The teachers seemed unapproachable. I'd had enough and was ready to drop out.

My sister saw an article about the Willamette Learning Center in the Willamette Bridge. *I visited, and they invited me on a camping trip to Mount Jefferson.*

The school was in the Centenary Wilbur Church. We had almost one floor. There were several big rooms and one central room with an office and loft. It was cozy with old couches, easy chairs and rugs.

We had classes in other rooms. John Whitehead taught literature. We read In Watermelon Sugar *by Richard Brautigan and poems by Gerald Manley Hopkins and Ferlinghetti. I took a wonderful drama class with Howard Thorenson. We did a scene from* Uncle Vanya. *Wayne Rifer taught algebra II. I was the only person in the class, so it went fast.*

A volunteer named Mary Collins was a proper lady and amazing seamstress. She taught me to sew and took me under her wing. One summer she made costumes for a Washington Park production of The Tempest. *Mary and I sewed costumes in the director's basement.*

When I was sixteen, I went to live with John Whitehead, his wife Hannah and another student. And, I lived on the farm for a few months. Nothing was structured. I learned cooking, had a spinning wheel and knit. We walked around the woods. Maybe there were six of us, plus Rondal, Beth and their two little kids. They lived in the main house. I slept in the bunkhouse away in the woods.

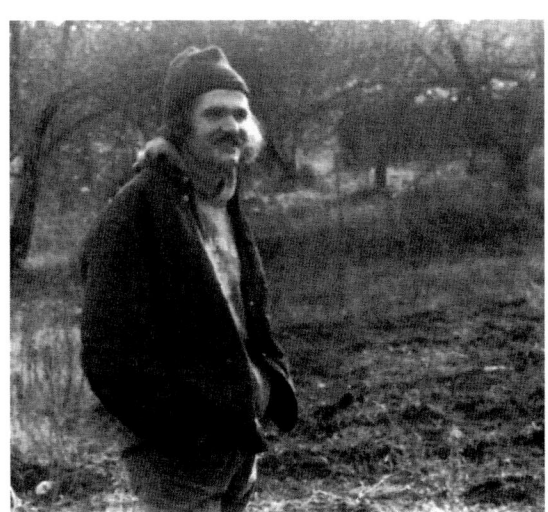

Rondal Snodgrass at the WLC farm. *Courtesy Bonnie and Peter Reagan.*

Portland in the 1960s

We could get up and go. That was one of the benefits of a small school. Every Friday we had an outing, everything from roller skating to visiting the beach. One time there was a festival at Reed. Ken Kesey held court and told stories. He had an American flag tattooed on his tooth.

The WLC gave me a sense of myself and of community at a time when I was vulnerable and insecure. My interest in education flourished as opposed to being stomped out which I thought public school was doing. This was a respite for alienated kids. You only get one chance to grow up, and I was fortunate to find this niche.

Patsy Child attended the WLC from 1969 to 1971. She lives in Portland and works as a musician:

First I played piano, but then I got a guitar. I had a jazz group Honeychild and the Three Bears. I played around Portland when I was a teen and, dig this, I wasn't twenty-one. I'm all dressed up, the only chic in the band. I could be on stage but not in the bar.

It was my mom and me until she met my stepfather. I could do anything; my mother never knew. I had pot parties at my house. They'd say, "We can go over to Patsy's." We hung out at the Caffe Espresso. It was an underground thing that we thought was cool. Something was going on, and we wanted to be part of it.

High school wasn't working out. We didn't like the jocks or socials, and the girls were snotty so I took this other path. I was the only white kid in one assembly, and I got onstage and sang "Cocaine Habit." You could have heard a pin drop; you never saw so many shocked faces.

I got suspended. They called my mother, who had never been to the school. When they played a video of the assembly for her, she said, "You look pretty good on TV."

So, I thought Washington High was not the school for me. They were too uptight. I somehow found out about the Willamette Learning Center.

There were like eighteen kids there. We studied astrology and science fiction. I had math, writing and an automotive class. At that time, girls couldn't have anything to do with cars. My eighth grade home ec teacher traumatized me, but an older woman at the WLC taught sewing and skills like ironing. Living communally was cool. This was the school for me.

Counter Institutions

OUTSIDE IN FROM THE GROUND UP

It started when the city threatened to shut down Charix. Opened in 1967, the First Unitarian Church's basement coffee shop served as a rock venue and center for alienated youth. Now, a citizens group that had recently closed the Crystal Ballroom accused Charix of promoting drug use and antiestablishment ideas. An outraged internist named Dr. Charles Spray stopped by the church to help.

Unitarian church leaders told Spray that what they really needed was a free clinic and pointed to the one in Haight Ashbury as an example. They envisioned a bridge that would help kids outside of the establishment ease back to the mainstream. Despite a full-time practice on Canyon Road, Spray grabbed social worker Arnold Goldberg and applied for a public health service grant.

Not everyone shared the doctor's enthusiasm. "I'm not interested in helping create any hippie heaven here in Portland, and I'm sure the people of Portland are not interested in having that kind of reputation," city commissioner Frank Ivancie told the city council. "One sure way to have such an invasion is for everybody to keep talking about one and talking about accommodating these people."

Dr. Charles and Linda Rice Spray in 2011. *Photo by author.*

Still, the public health service awarded the grant. Spray rented a tiny house on Southwest Thirteenth Avenue and Salmon Street and opened "Outside In, a Socio-Medical Aid Station" in June 1968. "The clinic will provide avenues for medical attention for alienated youth or for anyone who drifts in," he told the *Oregonian*. "It also will provide an avenue for the entire adolescent population in the community to have counseling services, not strictly establishment-minded, a place where they can get advice on drugs and talk with adults without parental interruption."

Registered nurse Linda Rice, who is now married to Dr. Spray, had a young son and part-time job when she volunteered at Outside In and directed the nursing team. "Mostly we had young, idealistic and alienated clients," she said. "They may have seen us as in loco parentis because they didn't trust most adults. If their hair was long, they didn't feel welcome at an emergency room."

Rice and other volunteers watched for streetwise warnings. "One night, KINK Radio announced 'Don't use orange wedges,'" she said, referring to a type of LSD. Apparently, a bad batch sent people out of their heads. The clinic posted a warning on the door, and before long, a terrified college student arrived.

"I reassured him until he realized he wasn't going to have a bad trip," Rice said. "It taught me about our street crowd. People knew we were aware. If we said it's bad, people understood."

The clinic referred serious physical or mental illness elsewhere. Although it targeted alienated youth, others dropped in.

"We had one streetwalker probably in her forties," Rice said. "She told us she'd been sitting in a bathroom stall at the Heathman Hotel when another woman reached in and put a hand on her leg. She hit her and came to us with a broken hand. I took her up to emergency room and waited while she got a splint."

Hot summer nights followed. "One time, a young man came in complaining of excruciating feet," Rice said. "He'd been on the road for who knows how long and had not taken his boots off." She and a volunteer sat on the curb, took deep breaths and pulled. "I don't know how long it took, but we got them off. The volunteer said, 'So this is what Jesus meant by washing people's feet?' They were macerated."

With few paid staff, the clinic depended on volunteers. Rose Rustin (née Rose Von Flue) grew up in a Silverton community she describes as a cross between Old Mennonite and Amish. She became medical office assistant to urologist Dr. Arnold Rustin, whom she married some years after his first wife's death.

"I wanted to know about the rest of the world, so I jumped at every chance to do things," Rustin said.

> *I looked for volunteer work because I was learning about social responsibility. When you work in a urologist's office, you get acquainted with sexually transmitted diseases, and I learned how to do stains to identify gonorrhea. Outside In dealt with promiscuous kids and deemed me knowledgeable enough to volunteer. It was an overall learning experience about a culture that was foreign to me.*

Controversy continued. "What we were doing seemed totally right, and I thought everyone else would think so, too," Spray said. "The naivety was in not realizing we raised certain people's hackles. They presumed we lured kids away from their families and undermined parental controls. People who early on recognize a problem and try to fix it are often blamed for the problem."

Things came to a head when it came to raising money. On the same day the *Oregonian* headlined "Drug Abuse Spreads among Area Schools," it reported that city commissioners had denied Outside In a permit to solicit funds. "[The commissioners] had serious misgivings about the permissive approach to these troubled young people," the story said. "They also told [Spray] that if he wanted their aid, he must make his peace with the Police Bureau, the Women's Protective Division, and whatever other official agencies have the authority—and the responsibility—for troubled and runaway children."

Again, defenders won the day. According to Spray, Don Clark from the Multnomah County Commission told Portland mayor Terry Shrunk that the clinic was essential for their mission. "So they backtracked and gave us the license," Spray said. "The events brought us a flood of volunteers and gave us caché."

FITTING IT INTO THE GOSPEL:
HARPER RICHARDSON AND THE CENTENARY WILBUR CHURCH

Roots go back to the 1890s. Once among the largest Methodist churches in Portland, Centenary Wilbur on Southeast Ninth Avenue and Ash Street attracted the silk-stocking crowd. Then Sandy Boulevard came, and the neighborhood changed. When the 1962 Columbus Day Storm damaged the sanctuary, the church moved into the gymnasium. By the time Harper

Portland in the 1960s

Reverend Harper Richardson and Ruth Haefner. *Courtesy Vivian Allison.*

Richardson (1928–2011) became pastor in 1965, the church had dwindled to one hundred parishioners.

Legend says the bishops didn't know what to do with Richardson or the Centenary Wilbur so they put them together. What came next affected many aspects of Portland's counterculture beginning with meeting and office space. Alternative education, draft resistance, antipoverty programs, gay rights, women's rights, the underground press and others at one point or other moved into the church.

"We tried to be a voice for people who didn't have a voice," Richardson said in a 2005 interview conducted by Portland author Dave Kohl and KBOO Radio host Barbara Bernstein. "When I got there, the church had a reputation of being so Republican and white. Most parishioners were elderly widows. They were faithful Methodists but out of touch with the community, which was a poverty pocket. I'd been appointed to a retirement home in a museum."

The conventional church didn't work, Richardson thought. He wanted something different, but what? The answer came during a visit to Glide Memorial Church in San Francisco, where freethinking pastor Cecil Williams had transformed a dying congregation. "Glide was in touch with the counterculture, gays, alcoholics," Richardson said. "Hippies danced around a fire on the church floor. My eyes opened to a different style of ministry."

Counter Institutions

FISH office at the Centenary Wilbur Church. *Courtesy Vivian Allison.*

Soon, welfare mothers asked for meeting space at the Centenary Wilbur. They insisted on smoking cigarettes, and Methodists don't smoke. "I told the board, 'We're supposed to serve the people, and these are the people,'" Richardson said. "The chairman left, but no one else followed. It was the breakthrough."

Richardson started the Police Ad Hoc Relations Breakfast, which attracted officers and the socially concerned. The Ninth Street Exit Coffeehouse began when Paul Libby convinced parishioners to convert the choir room to a hippie hangout. They installed a stage, used coffee cans for light fixtures and served apple juice from the church's food cooperative.

"Paul Libby was like an overgrown kid, and he liked the counterculture," Richardson said. "He wasn't turning them into Christians, but he could talk to them. They'd try their wings at singing or playing the guitar. The coffeehouse had gay men's night, lesbian night, yoga, a bit of everything. Sometimes I'd be afraid to look in there; how would I defend what I'd see?"

Word spread. "It was organic," Richardson said. "I fit it into the gospel so church people could identify." When Reed College graduate Rondal Snodgrass wanted to open an alternative school for dropouts, Richardson donated the church's top floor. "I told the kids, 'If you're gonna smoke marijuana, you're gonna lose this place.' The point was not to give authorities an excuse."

Portland in the 1960s

The Willamette Learning Center made headlines in 1969, when first lady Pat Nixon's visit included a stop at the church. "The Republicans were trying to make a big thing out of how good they were to poor neighborhoods," Richardson said. "Two busloads of correspondents showed up. When Pat Nixon came into the building, the young people dropped papers that said, 'If this were napalm, you'd be dead.' Secret servicemen got her out of there in a hurry. The kids were political. It was a master stroke."

Director Peter Fornara and the Actors Theatre Company shared space with Sunday worshippers. "One of the first sets had a toilet in it," Richardson said. "Of course, I had a sales job. But I said, 'This is the real world, and we're supposed to be a congregation that lives in the real world.'"

The gay Metropolitan Community Church met at Centenary Wilbur on Wednesday evenings while theater people developed sets. Neighbors without facilities dropped by for showers. On cold nights, hippies slept in pews. "As long as they weren't intoxicated, setting fires or creating a ruckus, I did my thing," Richardson said. "Although, there was so much graffiti in the male lavatory, we had to paint it black."

The youngest of eight, Richardson's daughter Katherine Bruna remembers an energetic man with a booming laugh. "My father got himself kicked out

Gay rights advocate Peter Fornara speaks during a church service at the Centenary Wilbur. *Courtesy Vivian Allison.*

of Duke Theological Seminary in 1953 when he questioned the segregation of worship," she said. "He was an activist and believed the church should be a community resource. Centenary Wilbur was a vibrant place with potlucks after service. He and my mother loved nature and organized hikes."

Vivian Allison joined the Centenary Wilbur in 1968. "Harper wasn't just an activist," she said. "He had a strong theological basis for what he did. His sermons were intellectual, full of interesting ideas, and he attracted people who didn't want to just hear platitudes. In older times, they called this the Social Gospel. It was hard for older people to adjust to a more radical ministry, but some embraced it. Others felt nervous but were loyal to the institution."

Like many parishioners, Allison believed in pushing aside the church's serious financial problems. The benefits of helping the community outweighed a leaking roof and outdated plumbing.

"Centenary Wilbur made my children compassionate," she said. "They weren't afraid of being around a different lifestyle or social class. They'd roam the building, and if they saw a man and his little kids come out of the women's restroom because they had been taking a shower, well, OK."

KBOO, ON THE AIR

They called him a strange kind of genius. Lorenzo Milam, the founder of KBOO, the Johnny Appleseed of listener-supported community radio and the author of ten books, including *Sex and Broadcasting*, developed a nebula of stations across the country after founding KRAB in Seattle in 1962. His interest began at KFPA in San Francisco, part of the Pacifica "First Amendment Radio" group, whose controversial and avant-garde outlets promoted world peace and pacifism (hence Pacifica), like WBAI in New York.

Established in 1964, Portland Listener-Sponsored Radio eventually asked Milam for help. When the *Willamette Bridge* published its first issue in June 1968, it printed the recent FCC telegram granting KBOO permission to broadcast.

"My job was chief engineer," Gray Haertig said about early KBOO days. "The transmitter was ten watts. All it did was repeat KRAB in Seattle. A liberal lawyer donated an eight- by twelve-foot office on Southwest Third Avenue where the Federal Building is now. We put programs guides together at Michael and Mary Wells's store, the Green Mitten. The studio wasn't

Bruce Sorensen poster of Hound Dog Taylor, 1971. *Courtesy Jessica Sorensen Storm and Bill Reinhardt.*

big enough. Our equipment was less than reliable. We went off the air, got distorted and the tapes wouldn't work."

Bill Reinhardt started as a volunteer for KBOO's Walt Curtis show, *The Talking Earth*, and ended up as the station's program manager. "Classical music purists started KRAB and KBOO," he said. "I came along when they got a one-kilowatt transmitter and started expanding. We were in a dank one-room basement office. Everything was hodgepodge; the turntables hummed. Then we moved to a storefront on Southeast Belmont. It was my first paid job in Portland, and I felt like the cat's pajamas. I lived and breathed KBOO. I slept there."

With commercial radio limited to popular entertainment, KBOO's founders sought new directions. They broadcast Portland State University lectures and community concerts. Affiliated stations shared tapes by mail.

Counter Institutions

"We had an open forum where we let people rant for half an hour," Reinhardt said. "We had Scientologists, Hari Krishna and Christians who wanted to preach. Left-wing radicals who wanted to burn down the Bank of America would occasionally be on the air. Joe Uris was a writer and radical. He'd come in and out."

KBOO started the day with classical music followed by bluegrass, blues and jazz. Antinuclear activist Norman Solomon hosted a public affairs show. Nationally known performers like Joan Baez and Country Joe and the Fish stopped by when in town.

"I had my own late-night program called *Radio Lab*," Reinhardt said.

Legions of stoned hippies gathered around the radio and waited for me to blow their minds. With two turntables and several tape recorders, I mixed between five sources at once, sometimes including live phone-in conversations. I'd mix readings from Marshall McLuhan and Kurt Vonnegut with recordings

Pen-and-ink poster by Michael Strickland, including an illustration of Bill Reinhardt.
Courtesy Michael Strickland and Bill Reinhardt.

RADIOLAB

Saturday Nights KBOO-FM
Presented by Bill Reinhardt

of the Firesign Theater. I played progressive music and outrageous comedy that nobody ever heard on mainstream radio—Ken Nordine, the father of trippy head poetry, Frank Zappa, Alice Cooper, Monty Python.

Reinhardt insisted on an eclectic mix avoiding bubblegum and other genres available on commercial radio. When he wasn't broadcasting, he listened and advised. "I called people on the air and said, 'Don't play that crap,'" he said. "Once, the news department locked themselves into the control room because I told them to stop ranting about personal issues."

KBOO attracted a cross section of urban and rural listeners from Portland to Salem. Market research consisted of noting who wrote or called. Still, the new listener-sponsored radio excited Reinhardt, Haertig and growing numbers of subscribers. "It was this wonderful variety, and you never knew what would come on," Haertig said. "I always found some fascinating thing I'd never heard about."

THE WILLAMETTE BRIDGE

Decentralized and spontaneous, underground newspapers shot up across the country in the mid-1960s. Starting with the *Berkeley Barb*, *East Village Other* and *Los Angeles Free Press*, hundreds developed within a few years. Some lasted one issue; others continue today. Most were not underground at all. They circulated freely among millions of readers who couldn't get news that mattered to them any other way.

The miracle of photo offset printing technology made it possible. With a typist, scissors, rubber cement and a kitchen table, anyone could paste copy onto backing paper and have it photocopied. A few hundred dollars produced thousands of newspapers.

A hip version of the Associated Press called Liberation News Service united the counterculture by providing articles and graphics by subscription. Meanwhile, a network of papers called the Underground Press Syndicate shared stories copyright free. From marches on Washington to local demonstrations, they got the word out; 1960s activists didn't have social media, but they did have the underground press.

Portland's first alternative paper may have been the *Seer*. Published by Antonio Valdez and peddled during the 1967 Rose Festival, it ran just one issue before the municipal court shut the operators down for selling it in a city park without a permit. Soon, Michael and Mary Wells got involved.

Counter Institutions

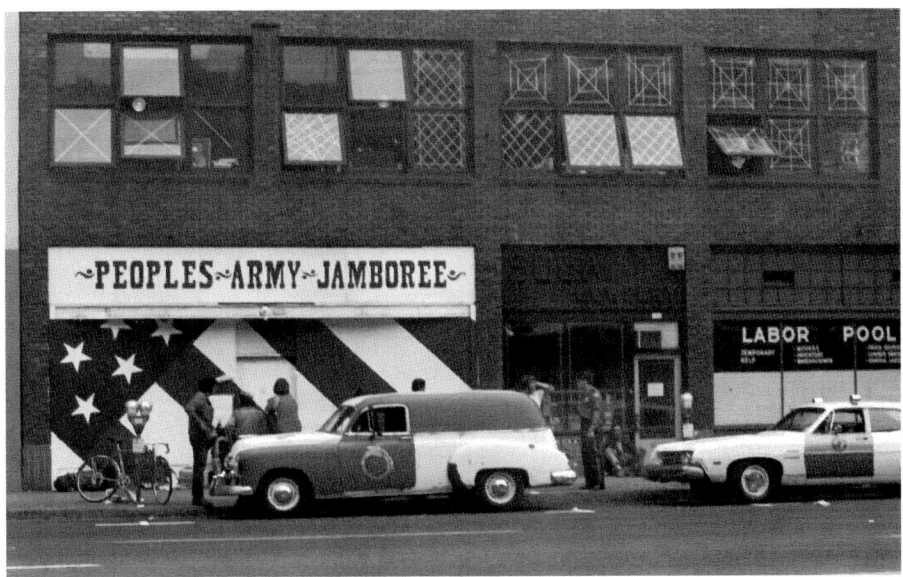

The *Willamette Bridge* office was upstairs from the People's Army Jamboree headquarters on West Burnside. *Courtesy John Dennis/*Willamette Bridge.

Originally from Massachusetts, Michael Wells refused induction into the army in 1964 and became a conscientious objector. The couple moved to Portland, opened the Green Mitten crafts store and, on June 7, 1968, published the first issue of the *Willamette Bridge* with $300 borrowed from a friend. It became Oregon's fourth-largest newspaper with bimonthly runs of fifteen to sixteen thousand copies.

"The *Bridge* was more about community organizing than journalism," Wells said. "Neighborhood newspapers didn't exist, and the two daily papers, the *Oregonian* and *Oregon Journal*, were pro-war and not interested in other things that were happening. The *Bridge* was the first newspaper in Oregon to be involved in women's rights, gay rights and ecology as a political issue. It offered information on yoga, arts and crafts, music and religious issues."

Although Wells was editor and publisher, he ran the paper as a collective. "We had interminable meetings about what to print," he said. "I got involved in politics through the pacifist civil rights movement and was involved in hippie long-hair things, so we were open to pretty much anything."

The first issue opened with a welcome message. Wells explained the paper's vision of uniting counterculture Portland and requested letters, suggestions and calendar events. "We will not attempt to appear objective about material we have definite feelings about," he wrote. The *Willamette Bridge* would "provide

Portland in the 1960s

Michael Wells with Joan Baez at an antiwar rally at the Centenary Wilbur Church. *Courtesy John Dennis/*Willamette Bridge.

a platform from which controversial issues and topics can be expressed" and "print news the mainstream press ignores either by accident or by design."

The mainstream press caused citywide angst by ignoring the paper's first issue. A rumor that twenty thousand hippies would soon invade Portland even made *Newsweek* magazine. Turns out, it boiled down to a misinterpreted request for aid, explained Council of Churches worker George Volts on page two of the *Bridge*. Other first issue highlights included the FCC telegram approving KBOO-FM Radio and a petition against a recent city ordinance that closed parks at night. Calendar items listed a Malvina Reynolds concert, the Albina Arts Center rummage sale and an invitation to join the War Resisters' daily induction center leafleting.

The bimonthly paper cost fifteen cents. One article headlined "Free Free Free" carried on the tradition of the Diggers in San Francisco:

> *Free Liquor: Blitz Weinhard serves free beer after daily tours*
> *Free Movies: Hand out promo sheets for the PSU Film committee*
> *Free Land: Write to Green Revolution in Maryland.*

Counter Institutions

Small movements found adherents through the *Willamette Bridge*. Sandy Polishuk's January 16, 1970 announcement of informal discussion groups helped jump-start Portland women's liberation. In "The Toxins Come Home to Roost," Christopher Condon wrote, "If you're not part of the solution you're part of the pollution." The group Survival listed meetings to "stop further deterioration of ourselves and our environment."

When the paper refused to carry an advertisement—"Longhaired gay man seeking the same for a long-term relationship"—staff writer John Wilkinson submitted an open letter. "Dear gay, young & lonely" detailed the city's dearth of gay activities and made Wilkinson the Rosa Parks of Portland gay rights.

Meanwhile, financing remained a problem and ultimately caused the paper's 1971 collapse. By this time, Michael and Mary Wells had left Portland for Massachusetts. When they returned two years later, they started a new paper, the *Portland Scribe*.

Maurice Isserman worked for the *Willamette Bridge* and the *Portland Scribe*. A Reed College dropout, he lived in a collective and started at the *Bridge* shortly after Wells left in 1970:

> *After Michael left, there was no strong editor. We met at the start of the week and figured out stories to cover. For the most part, we signed articles with just our first name, a mark of revolutionary informality.*
>
> *We laid out the papers every week in a big room with tables. That was a social event. People brought potluck, or advertisers paid us with food from their restaurants. We'd be there all night.*
>
> *When the paper came out on Friday, a horde of street sellers gave us a down payment, went off and sold them. Supposedly, they would come back and pay the rest, but often they didn't. We sold papers, too. We connected with all aspects of production. We'd solicit advertising, sell the papers on a street corner and this, that and the other. There was quite a competition for the best street corner.*
>
> *Why did people buy the paper? Some were stone cold revolutionaries. A lot bought it because we listed events and clubs that the* Oregonian *was too snooty to include. We had music reviews, granola recipes and classified ads like "I need a ride to Berkeley."*
>
> *The* Bridge *was on the second floor of a building on Burnside, which was much the wino district. We were proud to be in this corner of the world, although street people wandered in, which was sometimes not helpful for production. According to left-wing folklore, our building had been part*

Portland in the 1960s

Maurice Isserman, circa 1969. *Photo by Michael Kazin.*

of the Industrial Workers of the World. We identified with the IWW because they were indigenous American, decentralized and local.

I went to work for the Bridge *in the summer of '70, and by the summer of '71, it had collapsed. Nobody was minding the store. Nobody kept tabs on whether we paid taxes or on the flow of money. Ads came in willy-nilly. Finally, some financial crisis did it in.*

After the Bridge *collapsed, I got involved with another paper called* Willamette Rising. *We'd published just one issue when we heard Michael Wells was back, so we folded our effort into his. The* Scribe *came out in early spring 1972. Our office was in the Centenary Wilbur Church.*

Counter Institutions

The Scribe *and* Bridge *were different. We had an advertising person. The idea was to be more professional and less free form. We wrote a lot about the local Black Panther Party. Our Vietnam political perspective was clear but had less heated revolutionary rhetoric. The last issue of the* Scribe *coincided with Nixon's resignation. We had been covering Watergate. Nixon came on television as we were putting the paper to bed. We poured into our cars and drove up and down the main streets hanging out the windows and blasting our horns.*

Part III
ACTION

We thought we could change the course of history. We thought history was moving in our direction. And indeed, the world seemed to be in revolution. From the streets of Paris to the third world, especially Cuba and Vietnam, the old order was crumbling—the old order being imperialism, the old order being the United States throwing its weight around in Vietnam and elsewhere. But also, in terms of culture, in terms of the relationship between men and women, between whites and blacks, between gays and straights, everywhere you looked the old certainties and the old structures were falling apart. Writing about the '60s, I argued that the left lost the political war and won the cultural war. While the politics of the country in the decades that followed the 1960s swung dramatically to the right, the right could never win the culture war. It could never go back to the prevailing culture of the 1950s.
—Maurice Isserman, *co-author of* America Divided: The Civil War of the 1960s

Everything changed during the 1960s. The civil rights struggle led by Dr. Martin Luther King, the free speech movement at Berkeley and the escalating war in Vietnam roused campuses across the country into political action. Movements followed Betty Friedan's *The Feminine Mystique* and the Stonewall Riot in New York City.

In Portland, the decade started with a bitter newspaper strike that left unions broken and a lifetime of acrimony. Induction center sit-ins and anti-Vietnam War rallies began around 1965 and exploded a few years later. Gay Liberation came out with a 1970 letter to the underground press. The women's movement took off about the same time.

Portland in the 1960s

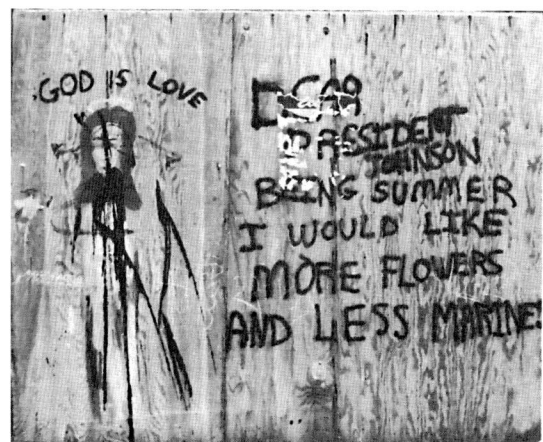

Graffiti. *Courtesy Emery Ingham.*

This chapter highlights selected local events from the era. Important people, places and movements could not be included due to lack of space. In particular, 1960s stories on Portland's Urban League, NAACP and Congress of Racial Equality must be a separate book. Broad-based environmental awareness started in the late 1960s. Books on the Oregon Beach Bill, bottle bill, bicycles, food co-ops, organic food and more wait to be written.

The Life and Death of the *Portland Reporter*

Most Portlanders remember truck bombings, conspiracy theories and endless picket lines. But those directly involved with the 1959–65 newspaper strike remember exhilaration, opportunity and, finally, bitter loss. It broke lifelong friendships; it ended careers. Labor rights advocates say it provided a template for union busting copied throughout the publishing industry. For some, it demonstrated the futility of fighting the moneyed establishment; others spent their lives advancing the union cause.

The *Portland Reporter*, a newspaper founded by *Oregonian* and *Oregon Journal* strikers, was published between 1960 and 1964. The life and death of the *Portland Reporter* and the newspaper strike it came out of remain among the city's most searing experiences.

Problems ostensibly began when stereotypers called a newspaper strike on November 10, 1959. Most of the *Oregonian* and *Oregon Journal*'s 850 union members walked out in sympathy. Three major issues emerged: first, the *Oregonian* planned to streamline publication with a new machine while workers

Action

Reporter and labor activist Gene Klare. *Courtesy Amy Klare.*

worried mechanization would cost jobs; second, publishers said foremen represented management while workers insisted that foremen belonged to the union; and third, publishers claimed union rules on substitute workers resulted in unnecessary overtime costs. "Stereotypers Local 49's members called the strike because the negotiators for the *Oregonian* and *Journal* insisted on contract terms they knew the stereotypers would not accept," Gene Klare would later write in a Northwest Labor Press series about the strike. Once an investigative journalist at the *Oregonian*, he quit during the strike and helped start the *Portland Reporter*.

Some background to the situation is helpful. By 1959, Portland was a two-newspaper town. Charles Samuel Jackson founded the *Oregon Journal* in 1902 and passed it to his widow and son, whose wills specified that the paper must remain in local hands. New Yorker Samuel I. Newhouse purchased the *Oregonian* in 1950. Strikers believed Newhouse provoked the strike in a scheme to buy the *Journal* and create a Portland newspaper monopoly. Although *Journal* trustees were instructed to sell only to a local company, the financial chaos caused by a strike could force them to approve the sale to Newhouse.

John Wykoff Sr. was the *Oregonian*'s night news editor. "The strike was a personal thing with my father," his son, also John Wykoff, said. "When he

helped found the local chapter of the newspaper guild in the early 1940s, reporters made forty bucks a week. Unions were instrumental in bringing a living wage."

Reaction

The day after stereotypers called the strike, the *Oregonian* and *Oregon Journal* produced a single newspaper headlined with both nameplates. Despite the specialized skills required, qualified non-union workers from around the country were available within a day.

The publishers locked out striking employees and co-published one paper. Picket lines formed; scabs crossed. By the year's end, anti-unionists had run down a picketing striker, and pro-unionists had mugged distributors and attacked non-striking employees. Then, Klare wrote, "came the boom-boom-booms of Sunday night, January 31, 1960."

The 1959 newspaper strike. *Courtesy John Wykoff.*

Action

Simultaneously, at about midnight, dynamite blew up six parked newspaper delivery trucks in Oregon City and five in Northwest Portland. There were no injuries. Authorities arrested and convicted union man Levi McDonald and his hired help. Later that year, an unknown assailant shot *Oregonian* production manager Don Newhouse, the brother of owner Sam Newhouse, through his basement window.

The Portland Reporter

Meanwhile, the truck bombings horrified Portlanders, and while most unionists disavowed the violence, it damaged their credibility. With a quick resolution unlikely, strikers started an interim newspaper. On February 11, 1960, the *Portland Reporter* launched with eight pages and a press run of sixty thousand. "This is the first issue of a new weekly newspaper sponsored by the unions whose members are on strike or observing strike picket lines at the plants of the *Oregonian* and the *Oregon Journal*," the front-page editorial said. They vowed to publish until all parties reached an honorable settlement.

John Wykoff Jr. became the night sports editor and his father the managing editor. "I'd put the sports section to bed about 1:00 a.m.," Wykoff said. "The Gay Nineties was open until 2:30 a.m., and a bunch of us met there to drink beer. We'd break into songs like 'We Shall Overcome.' It sounds silly today, but it was an idealistic time."

The *Reporter* became a daily in February 1961. Most staff still received only strike benefits as pay. When they moved into the old Railway Express Agency Building at Northwest Seventeenth Avenue and Northrup Street, they got their own equipment, including an 1890 letterpress they christened Little David.

Picketing continued. "We had three days a week for an hour or two," Wykoff said. "I organized a demonstration at Portland State and picketed the courthouse. People honked and waved, and we got TV coverage. Another time, when the *Reporter* was in trouble, we threw a rally with the hottest folk singers in town and urged people to buy stock. It was the stuff naïve idealism is made of, us against the world."

John Kearney (Cap) Hedges met Wykoff at the Portland State College newspaper. "John brought a lot of us over to the *Reporter*," he said.

> *They needed cheap people, and we were excited about what they were trying to achieve. As a kid from college stepping into a newsroom with seasoned professionals, I was awestruck. These were hard-nosed, hardball journalists. The camaraderie was tremendous. Working with Gene Klare*

Portland in the 1960s

Pressroom at the *Portland Reporter*. Courtesy John Wykoff.

was the highlight; he was such a character, so positive. He could step in a pile of shit and find some way to enjoy it.

As an advertising salesperson, Hedges understood the paper's major problem. "We were going up against the established Newhouse," he said. "Acrimony between the *Oregonian* and strikers was intense. During our Lloyd Center special, I got small merchants, but the bigger merchants didn't want to be associated with us. There were bad feelings because we were on strike. The stigma, not wanting to accept the *Reporter* as legitimate, was widespread.

"In any newsroom you have the excitement of putting out the daily news, but within the *Portland Reporter* it was the drama of survival," Hedges continued. "One day, a group invested; then something didn't go through. There was uncertainty that we'd live to see another day. It was an interesting time, and quite a challenge, and it was sad that we didn't make it."

Aftermath

The *Portland Reporter* printed its last issue on October 1, 1964. On April 4, 1965, unions abandoned the strike after sixty-five months. As predicted, Sam Newhouse purchased the *Oregon Journal* on August 3, 1961. The *Oregonian*

Action

and *Oregon Journal* published as one paper for the first six months of the strike, with the *Journal* permanently moving into the *Oregonian* building. They declared an open shop and continued as two papers under one owner and one roof until the *Journal* folded in 1982.

Many *Portland Reporter* workers returned to the *Oregonian/Journal* or joined papers in other cities. Some were blacklisted locally and never worked in news again. John Wykoff Jr. often reflects:

> *The stereotypers started the strike, but in retrospect, if it hadn't been them, it would have been somebody else. The* Oregonian *would have forced a strike from somebody. This strike came along quickly, and it took like twenty-four hours to bring in professional strikebreakers from Texas. There was no reason not to settle as time went along and yet, they had no interest.*
>
> *Unions were a thorn in the side of the publishing business; they wanted them out. It was all part of the downward spiral of the union movement in the United States. It allowed them to develop a pattern that Newhouse could use elsewhere. Picking Portland first was a smart move because this was a weak town when it came to unions.*

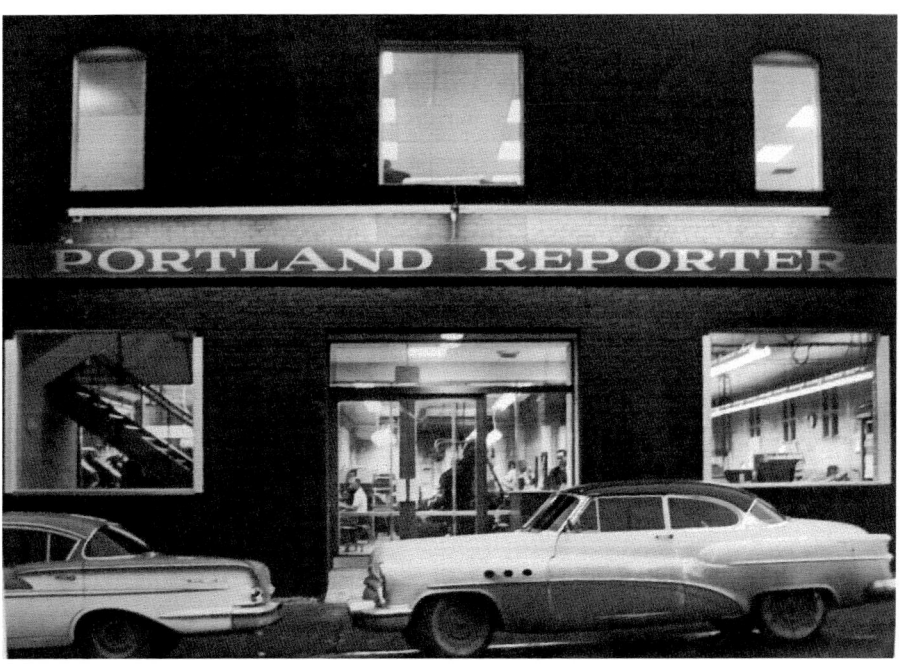

The Portland Reporter Building. *Courtesy John Wykoff.*

Portland in the 1960s

I remember the day they announced the Reporter *was going out of business. I was working sports, and Dad came over. He had tears in his eyes. He handed me this press release and asked me to call a list of people and read it because he couldn't do it. Given the emotional component to health, I've often thought that was the beginning of what killed him. He ended up with multiple myeloma. He was in a depression for a long time.*

Peace Now!

While Portland's antiwar movement crested during the 1970 Portland State University student strike, the wave began in the early 1960s. Demonstrators predicted World War III annihilation, denounced the 1962 Cuban blockade and demanded that Britain demolish Scottish missile bases. As the Vietnam War escalated, nuclear disarmament groups migrated. Half a century later, 1960s activists remember the years as naïve, optimistic and exhilarating. They believed they could influence change.

They also remember the omnipresence of the police intelligence unit, or "Red Squad." Informants, under the direction of Charles Trimble, kept

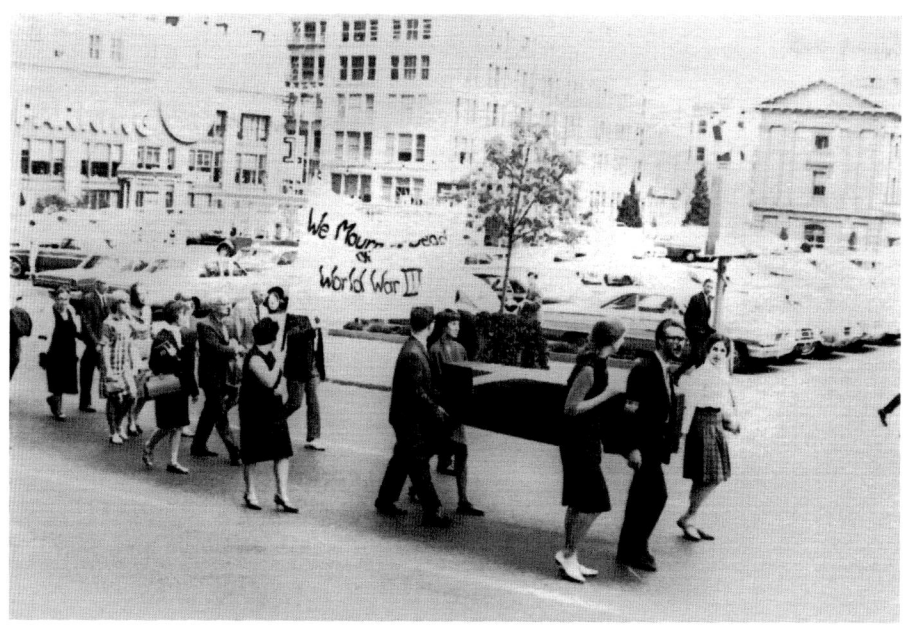

A 1966 nuclear disarmament protest. *Courtesy City of Portland Archives, Oregon, American Friends Service Committee (AFSC)-2/3, A2004-005 December 31, 1984.*

Action

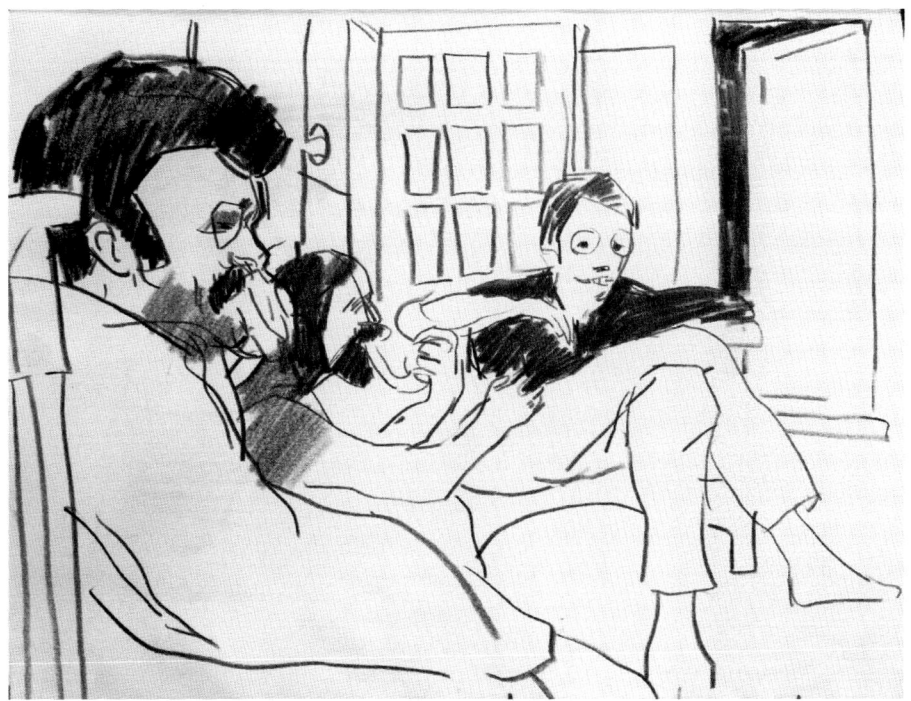

Joe Uris at a political meeting, by Henk Pander. *Courtesy of the artist.*

records of meetings, members and even the license plates of cars parked in activists' driveways. A police terrorism expert disobeyed orders to destroy the Red Squad files and hid them instead, according to a 2002 *Portland Tribune* report under the headline "The Secret Watchers." Today, they are open to the public at Portland City Archives.

Portland State University associate professor Joe Uris became a local spokesperson and leader during those years. He jumped into "Ban the Bomb," civil rights and the antiwar movements after arriving at Reed College in 1958. He served as Portland State student body president from 1966 to 1967.

"My involvement started with a student organization called Focus," he said. "We invited every traveling lefty of any persuasion to speak. We talked to Dorothy Day, Dave McReynolds, Michael Harrington and Elizabeth Gurley Flynn, a famous old communist who went back to the start of the Soviet Union. We made money putting on concerts with Pete Seeger, Sonny Terry and Brownie McGhee, that sort of thing. It slipped seamlessly into Portland's tiny bohemia, which was jazz clubs, the Days and Nights

Bookstore and the Caffe Espresso. This was the 'underground wore black,' not the underground wore cool clothes era. The first major action was when a math student at Reed organized Saturday picketing at Kresses and Woolworths in support of the earliest sit-ins in the South."

By 1961, Uris was president of Portland Students for Peace. "The object was to end nuclear testing and create a climate where cold war turning hot would be impossible," he said.

> *A Reed professor taught beautiful calligraphy so we had cool sandwich boards. We picketed the British Council as part of the Aldermaston demonstrations and organized a march with the Quaker Fellowship, American Friends Service Committee and the Fellowship of Reconciliation. When I got the permit, a cop said, "You're playing into the hands of the communists."*

Former Reed College professor Mason Drukman dealt with Charles Trimble, the director of the Police Intelligence Unit, or Red Squad. "He tried to find out what Reedies were up to and what the antiwar students were planning," Drukman said. "I would not tell him, but we had interesting conversations." Drukman remembers the amicable relationship between the Portland police and the peace movement ending with Vice President Hubert Humphrey's 1966 visit.

"What otherwise appeared to be a peaceful demonstration exploded into a club-swinging mêlée by policemen when a cordon of blue-uniformed officers moved out of formation at the entrance to the Sheraton parking lot and began to haul away the demonstrators who had sat down on the pavement," the September 28, 1966 *Oregonian* said.

"They waded in with flashlights and started bopping people," Drukman said. "When I asked to see a plainclothes person's ID, a uniformed cop threw me into the paddy wagon.

"I remember occupying a downtown post office," Drukman continued. "We were arrested, and U.S. attorney Sid Lezak marched us out and released us immediately. That night, the local ABC news led with the story."

While the Citizens Coordinating Committee on Vietnam provided the umbrella organization for Portland's early antiwar groups, by 1967, activism had spread beyond Vietnam to include the farm workers' grape boycott, Native American fishing rights and other causes. The Society for New Action Politics (SNAP) grew out of CCCV and reflected the expanded scope.

Action

Activist Antonio Valdez at an antiwar rally.
Courtesy Antonio Valdez.

Hugo du Coudray (aka Maynard) studied at the University of Oregon and Stanford before joining the psychology department at Portland State in 1967. He belonged to the Vietnam Day Committee in the Bay Area.

"When I came here, the Resistance was just forming," he said, referring to the organization started by David Harris that encouraged non-cooperation with the Selective Service System. "That's when I met Steve Kosokoff [aka Kaye]. I went to a meeting at a church, and there he was at the microphone. When his wife came through collecting draft cards, I gave her mine. I'd spent three years in active duty, so I wasn't liable for the draft, but it was illegal not to carry your selective service card."

Vigils and demonstrations at the Armed Forces Induction Center started around 1965. By 1967, Kosokoff, du Coudray and others rotated shifts. "We spoke to the guys," du Coudray said. "They knew they were going straight to Vietnam. We coped with their parents, who were sometimes angry with us—fathers especially—for trying to impede their sons from going to war. There was pushing and blows. We used nonviolent tactics."

Maurice Isserman is a professor of history at Hamilton College and author of several books on the New Left. In 1969, he dropped out of Reed, joined a Portland political collective and wrote for the city's underground press, the *Willamette Bridge*. By this time, the government had deployed half a million

PORTLAND IN THE 1960S

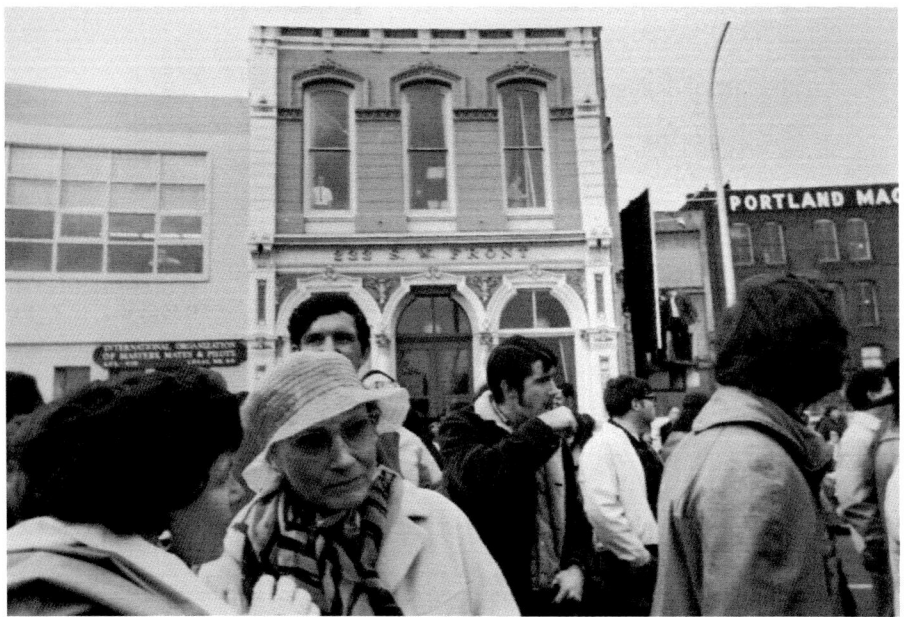

The 1969 Moratorium. *Photo by Henk Pander.*

people to Vietnam, and forty-five thousand Americans had died. According to the British Broadcasting Network, the October 15, 1969 Moratorium Against the Vietnam War may have been the largest demonstration in U.S. history, with an estimated two million people involved nationwide. In Portland, more than four thousand attended:

> *Everybody was involved in the Moratoriums. There were meetings at Reed, Lewis and Clark, and I'm sure elsewhere. The October event was huge by Portland standards, with everybody from liberal Democrats to the Black Panthers participating. Follow-up Moratoriums in November and December were smaller.*
>
> *All of this was significant, because it represented a rebirth and broadening of antiwar activity, which had fallen off following Nixon's election the previous November. Many took a wait-and-see attitude toward the new administration in its early months to see if Nixon would really enact his "secret plan" to end the war. My friends and I had no illusions on that score. By the fall, it was clear that the war was going to go on. The air war, etc., actually stepped up, even while ground forces began to withdraw.*

Action

The other significant thing about the fall moratoriums is that they drew vast numbers of students into their first protests. This laid the groundwork for the even more massive and spontaneously generated student strike against the war that followed the invasion of Cambodia and the killings at Kent State University in early May 1970.

THE PORTLAND STATE STUDENT STRIKE

When the Ohio National Guard's murder of four Kent State University students sent shock waves through the country, some people wondered why. It was May 4, 1970. By this time, thousands had died in Vietnam, the Student Non-Violent Coordinating Committee had given way to Black Power and Students for a Democratic Society, having given up on nonviolence, splintered and collapsed, leaving the small Weather Underground faction vowing to overthrow the United States government. Still, when President Richard Nixon's escalation into Cambodia ignited demonstrations across the country, activists expected the usual arrests and cracked heads. The scene of American demonstrators gunned down by other Americans left them in disbelief and facing a new paradigm. The National Student Association and Vietnam Moratorium Committee called a national student strike. Hundreds of campuses closed.

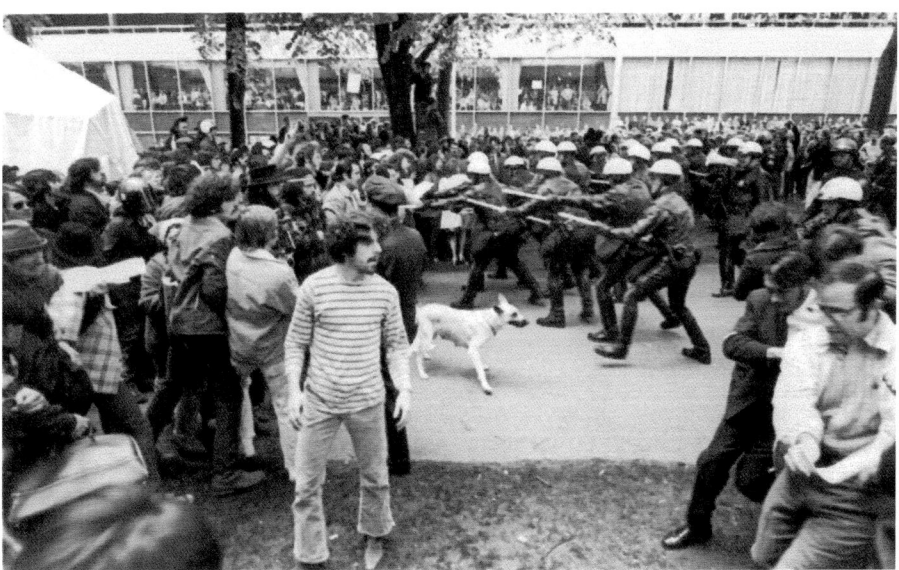

The 1970 PSU student strike. *Courtesy City of Portland Archives, Oregon, A2004-005.*

"The Kent State shootings were a big shock, although not unexpected," said Portland State University psychology professor Hugo du Coudray (aka Maynard). "The police were pushed hard and taking the brunt of the politics. Something was going to happen, someone was going to crack and someone was going to get killed."

The day after the Kent State shootings, Portland State University's response crystallized. Although unlike other campuses PSU did not have direct ties to companies like Dow Chemical and its professors did not handle war research, events precluded business as usual. Two thousand students joined the ad hoc committee calling for a student strike with mainly symbolic demands:

Withdrawal of troops from Indo-China.
Detoxification of nerve gas.
Release of Bobby Seale and other political prisoners.
An official day of mourning for the dead Kent State students.

The strike started on May 6. That evening, PSU president Gregory Wolfe closed the college until Monday, May 11.

"My first act of civil disobedience occurred on Wednesday," Lester Lamm, a former dramatic arts student, said. "Earlier that day, there was a rally outside the Park Blocks. Speakers called for action. As a result, a dozen ran into Smith Memorial and got into a food fight. They came back with hamburgers in hand, like they were proud of ripping off the institution."

Now referred to as "The Great Cheeseburger Rip-off," the scene further polarized pro-strike and anti-strike forces. Counterculture and conventional students sat on opposite sides of the cafeteria. As speakers urged demonstrators to "liberate food," the two groups almost broke into violence. "It angered me," Lamm said. "I stepped up on stage and snapped that the response to the killing of U.S. citizens who were exercising their right to protest was not to throw hamburgers. If you want to send a message of protest, shut the college down."

On the way back to the Theater Arts Department, Lamm had an inspiration. "If we were going to shut the school down, we needed to block it off," he said. "A few of us picked up park benches and blocked off the side street. Others saw what we were doing, and in less than an hour, there were barricades to all the campus access points."

The barricades took names and personalities. "The Bobby Seale Memorial" changed to "Wipe Out Alley" after a garbage truck smashed

Action

Fort Tricia Nixon. Lester Lamm is seated in the armchair flashing a V-sign.

it at 3:00 a.m. Other barricades included "The Society of Strangers," "Freedom Suite," "Katanga Junction," "One-Way Barricade," "The Pentagon" and "Hell or Water." About half the people staffing the barricades were not students.

"They populated themselves with birds of a feather," Lamm said. "Ours was mostly theater arts students." Lamm named his barricade "Fort Tricia Nixon" in reference to Ms. Nixon's recent comment that she could not understand why her father's policies angered students.

"Two park benches were inadequate, so we found fifty-five-gallon trash barrels, anything that wasn't nailed down," Lamm said. "We had plastic sheets for when it drizzled. We liberated an old couch laden with vermin from the Theater Arts Department." Fort Tricia Nixon staffers found a mattress, boxes, chairs and a black and white TV, which they plugged in with an extension cord running from inside the building.

Like 134 of the 755 PSU faculty, Hugo du Coudray supported the strike. "We had individual ways of handling it," he said.

I met my classes and asked for a vote on whether we should have regular material or discuss the war. Some faculty fiercely held classes. They didn't agree with the students' rights. Students organized teach-ins, and of course,

there were angry exchanges. A contingent was against the strike; there was a conservative student union. Faculty relationships stayed cordial.

Meanwhile, the campus hummed. The Stranger's Collective, a group of science fiction enthusiasts led by Michael Zaharakis, kept students apprised of strike events with their mimeographed newsletter, the *Barricade*. When master KBOO engineer Gray Haertig set up "Radio Free Portland," the alarmed Federal Communications Division quickly closed it down. Police arrested twenty-four during an induction center demonstration; protestors picketed the docks. In an action that attracted non-student partygoers and dismayed political activists, an unauthorized all-night dance at the Smith Memorial Union left $19,070 in damages.

Life at Fort Tricia Nixon

Protestors operated the barricades twenty-four hours a day and worked in shifts, according to Lester Lamm, captain of Fort Tricia Nixon:

> *It was a mellow five days. People came and went. They'd go home, they'd go to work, they'd bathe with family or friends. People applauded our efforts or vilified us for being communist. Once in a while, a passerby launched a beer bottle, but by far more people honked their horns in support. If something occurred at a barricade, they sent their runner to sound the alarm.*
>
> *Peter Fornara, Kevin Mulligan and Doug Weiskopf were already engaged in student protests. After Kent State, they formed a strike committee. They said, "We need to organize you guys." We weren't part of them—we were a spontaneous act, we just happened. Since they led the parade for so long, they tried to unify a herd of cats. But we were proud of our structure.*
>
> *You can't believe how much food materialized. Faculty like Steve Kosokoff, Hugo Maynard [du Coudray], Larry Stewart and David Horowitz visited. This wonderful lady who lived in the Ione plaza brought a casserole to die for. Given the fact there was a generational divide, it was out of sync. She was in her seventies. It was something nobody there ever forgot.*
>
> *Up until then, I didn't like the war, but I wasn't energized enough to do anything. But on that Wednesday when we went into the barricade I had a political mindset that has lasted my entire life.*

Action

Showdown

On Monday, May 11, the university reopened—to the relief of taxpayers and students who saw the closure as capitulation. City government and the college administration wanted the barricades down. Few resisted as the police dismantled them until only the geodesic-domed hospital tent remained. Students insisted that their permit for the dome ran until the next day. Meanwhile, the TAC Squad, the riot-control division of the Portland Police, assembled two blocks away.

Who initiated the events that followed remains unclear. With Kent State in mind, PSU's President Wolfe worked to prevent violence and keep police away. Many say Mayor Shrunk left town, and Commissioner Frank Ivancie gave the order. In any case, police captain Norman Reiter failed to convince his superiors to leave the hospital tent standing, and police escorted him off campus. The TAC squad moved onto the Park Blocks. Lester Lamm remembers what happened next:

> *For us, it started at Barricade Tricia when police cars lined up on Broadway. Captain Reiter said, "It's over, it's got to come down." I think the world of him. He listened to us. I said this was debris, so rather than have the*

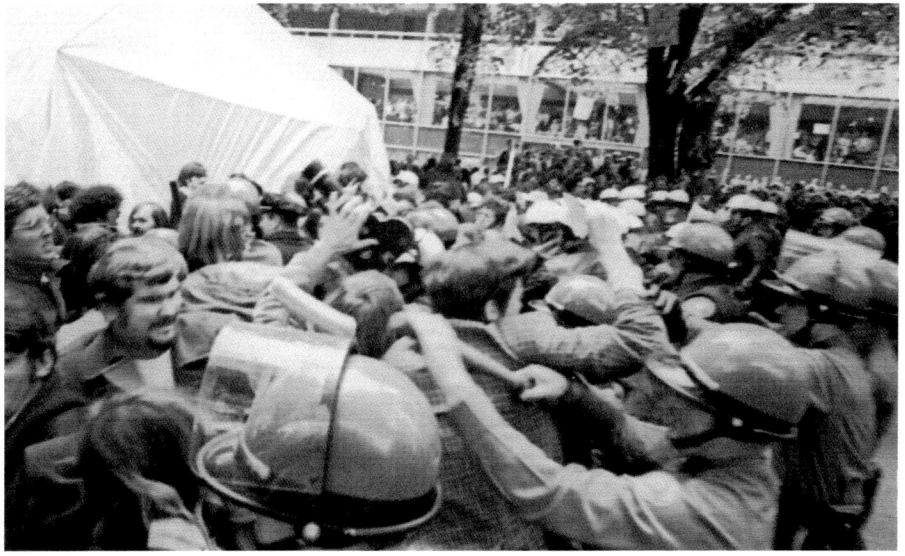

Police and protestors clash at the Red Cross tent during the 1970 PSU student strike. *Courtesy City of Portland Archives, A2004-005.*

> *police dismantle it, bring the garbage trucks, and we'll help clean up. In less than half an hour, the garbage trucks came, and we helped bring the barricade down.*
>
> *Then we formed a human barricade back and forth across the crosswalk. If a car came, we let it through. Word spread that the police were coalescing at Shattuck Hall, so we all ran up there. They were in the parking lot, police in blue uniforms and the TAC Squad in white.*
>
> *A ton of people were at the hospital tent. The police were going to take it down, and we knew we had a permit. When Captain Reiter was relieved of his command, there was a sense of panic. We heard they were going to arrest people who blocked the tent, so we looked for help with bail.*
>
> *The TAC Squad formed a block away and marched forward until the point of their wedge came within sixty feet. The bullhorn said, "Disperse or you will be arrested." The response was, "We have a right to be here, screw you, etc."*
>
> *Then everything went into slow motion as the TAC squad stiffened, grunted, growled and pointed their clubs forward in unison. They stepped forward, stomped their left foot and jabbed straight ahead in this wedge formation. It didn't take twenty seconds before the point of that wedge came in contact with protestors. That's when the clubs came up, and they started beating people. I saw Jeff go down. Roger was standing adjacent to me, and I heard his head split like a pumpkin.*
>
> *I got out of there as quickly as I could. You couldn't run because you were against this mass of people behind the tent. People who were getting pummeled couldn't run anywhere.*
>
> *I'm telling you the TAC Squad were salivating. You could see it. They were smiling. It was a jovial gathering before they formed their wedge.*

Hugo du Coudray joined the line protecting the hospital tent. "Suddenly, there was a police presence on campus," he said.

> *A number of faculty came to the scene. It wasn't organized, we just showed up. When it became evident that the TAC squad was going to remove the tent, some of us decided to get in the way. There were two rows.*
>
> *I'm a psychologist. It was amazing to see people turn into machines. Their faces went blank. They took a step and shoved, bashing through the crowd. It was frightening and merciless. I saw heads cracked; we were thrown in all directions. My sturdy 1960s glasses got smashed, but they saved my head.*

Action

Amid the chaos, facts emerged. The TAC Squad did not attempt to arrest demonstrators; despite the wind at their backs, police did not use tear gas. According to the Metropolitan Human Relations Council report, "Moving and still photos along with eye witnesses attest to the fact that officers struck people with their batons, often raising the batons over their heads in doing so. Thirty-one persons were treated at hospitals as a result of injuries administered by police officers."

The next day, 5,000 faculty, students and members of the public marched to city hall. Many who disdained the strike joined, appalled at the unnecessary police violence. Still, the hospital tent's removal signaled the strike's end. When troopers fired into a crowd at Jackson State University, killing two on May 14, outrage was comparatively muted. Although the National Student Association proclaimed May 20 the final strike day and urged major demonstrations, only 1,500 from Portland State turned out.

A PEOPLE'S ARMY JAMBOREE

By the summer of 1970, Americans expected violence. In 1968, assassins killed Robert Kennedy and Martin Luther King, and between ten and fifteen thousand Vietnam War protestors clashed with police and National Guard troops at the Democratic Presidential Convention in Chicago. In 1969, Hell's Angels killed a concertgoer at Altamont, and police shot, or some say murdered, Black Panther Fred Hampton. By March 1970, Students for a Democratic Society had disintegrated into factions, including the Weathermen, who blew up a Greenwich Village townhouse, went underground and declared war on the United States government.

President Richard Nixon escalated into Cambodia and increased troop levels in the spring of 1970, despite millions marching for a nationwide moratorium and polls showing that the majority of Americans were against the war. Ensuing riots left Kent and Jackson State University students dead.

Portland had seen its own violence. Following the Kent State shootings, Portland State University demonstrations ended with the TAC Squad sending thirty-one protestors to the hospital, some with cracked heads. Five thousand marched to city hall the next day.

Now, thirty thousand American Legionnaires planned to hold their national convention in Portland between August 28 and September 3, with President Nixon as keynote speaker. Antiwar activists timed a demonstration to coincide, hoping to attract twenty-five thousand from across the country.

PORTLAND IN THE 1960s

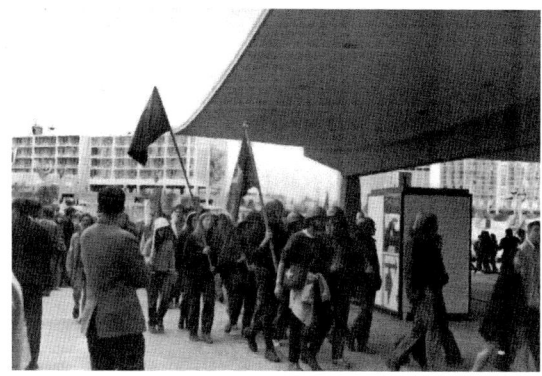

Antiwar activists marching outside Memorial Coliseum during the American Legion convention. *Courtesy City of Portland Archives, A2004-005. A2001-005.*

Factions questioned each other's motives. Where Vietnam War opponents felt they must answer a display of pro-war nationalism, an alarmed FBI saw the American Legion Convention as an excuse for anti-government extremists to infiltrate Portland. The New Left hoped to direct the momentum built during the PSU student strike toward its vision of society. Others sympathized with the antiwar sentiment but worried that potential violence would be counter-productive.

Despite the explosive culture clash, few problems arose. Antiwar demonstrations were smaller and less violent than predicted. Some believe clever government tactics usurped a major political statement. Others saw fading citizen involvement, a victory for nonviolence or simply a job well done.

Getting Organized

Newspapers, interviews and declassified FBI documents illuminate events leading to Portland's August 1970 American Legion Convention. Plans for the antiwar demonstration, first called the Revolutionary Festival of Life and later the People's Army Jamboree, began that February. By June, memos sent to student body presidents across the country requested support. Hugo du Coudray (aka Maynard) helped organize:

> *The antiwar movement was well aware of the vigorous defense of the war by the American Legion, and Portland was hosting the legion's annual National Convention. A new declaration supporting the war was expected, and there was talk of a visit by President Nixon. The legion had to be answered.*
>
> *The American Legion takes the position that they represent American veterans, and there were a lot of veterans, including me, who thought this*

Action

was unrepresentative. We organized the People's Army Jamboree, as a counter to the legion.

A few of us met at a restaurant in Chinatown with two people from the governor's office. Their thrust was to get us to cancel. We made it clear that we were not going to give up. This couldn't stand without an answer from the people's army.

Of course, officials worried. We worried about the same thing. We were still wedded to nonviolence. We were not planning to attack, but we knew they might attack us. Our strategy was to keep angry people away from each other.

The FBI got busy. Portland's SAC (special agent in charge) asked locations around the country to send news of people coming to Portland during the convention. Agents infiltrated meetings, watched post office boxes and recorded the license plates of cars parked in antiwar leaders' driveways. The Multnomah district attorney published Disorder Contingency Plans as the police and National Guard braced for mass casualties and arrests.

The FBI's Point of View

Five hundred pages of declassified FBI files obtained through the Freedom of Information Act include regular summaries sent to the Office of Special Investigations; U.S. Marshals; Office of Alcohol, Tobacco and Firearms; U.S. Postal Inspectors and others. Informants relayed inflammatory messages like: "Portland is going to have one of the bloodiest weeks it has even known," and "[] continued that his group had a plan whereby it could nullify the effectiveness of the Portland Police Department." Many familiar with the situation believe informants exaggerated and misrepresented their experience.

Authorities had four major concerns: Nixon's potential appearance, White Panther Party threats, the Seattle Liberation Front's participation and the underground press.

While the FBI could not confirm Nixon's visit, things seemed on track according to this July 27, 1970 memo from the Portland SAC to the FBI director's office (capitalization is theirs):

As referenced communications will show, all current information indicates—that thousands of dissidents, hippies, anti-Vietnam and anti-military protesters and other individuals generally bent on bringing down society, the government, and all its representatives, will be gathering in

> *Portland for the American Legion National Convention, August 28– September 3, 1970 and probably for several days in advance. Volatile conditions could exist throughout the city during the entire period.*
>
> *President NIXON and other dignitaries are scheduled to be in Portland for the convention. In addition, as the Bureau may already be aware, a conference of the National Association of District Attorneys is to be held in Portland, August 17–23, 1970, and the featured speaker will be Attorney General JOHN N. MITCHELL.*

The White Panther Party was a national New Left organization founded by Caucasians in 1968 in support of the Black Panther Party. Informants warned that a small Portland cell planned attacks during the American Legion Convention. A July 22 memo said that the WPP Portland "has been acquiring firearms by legal purchase and thefts and has eight sticks of dynamite." In addition, agents found this letter in the July 24–30, 1970 *Berkeley Barb* (spelling is theirs):

> *Tricky Dick and his band of Amerikan Legionnaires are holding a convention in Porkland, August 28 to Sept. 3. The People's Army Jamboree was originally conceived to confront these "people" with the real problems of today. People's Army was co-opted by liberals who now intend the same old no result peace march. The White Panthers and Portland Liberation Front call for the support of all brothers and sisters of the Revolution to assist here.*
>
> <p align="center">*Power to the People*
White Panther N.W. Regional Office
3035 SE 10th
Portland, Oregon</p>

The Seattle Liberation Front also made the FBI nervous, as indicated by the following two memos:

> *August 10, 1970: SLF collectives have instructed members to hold intercommunal meetings to discuss and plan specific action to be taken at the PAJ assembly in Portland. One collective reportedly obtained 500 two-inch firecrackers, which had been reloaded with a stronger explosive. These firecrackers may be used by SLF members to blow out plate glass windows. Several collectives have also begun collecting spray cans of oven cleaner to use in spraying the faces of "pigs."*

Action

> *August 25, 1970: During the weekend of August 22 last, three leaders of the PAJ traveled to Seattle where they met with representatives of the SLF. During the meeting, according to a source who has furnished reliable information in the past, stress has been place on the use of oven cleaner spray against both legionnaires and police. [] source has told police that "hippies" have bought chains and spray oven and window cleaners.*

FBI files include articles from the *Berkeley Barb, Los Angeles Free Press* and other papers, but most clippings came from Portland's underground press, the *Willamette Bridge*. For example, according to a June 18 FBI memo, the June 12 edition announced plans for a school dedicated to "bringing the mother down and bringing the people up" with classes like urban survival, self-defense, youth and revolution, imperialism and karate.

Maurice Isserman worked for the *Willamette Bridge* during the PAJ. Now a professor at Hamilton College, he has written extensively on the New Left:

> *The PAJ was the period when the paper was the most relevant to the politics of the moment. The* Bridge *was the main voice. That's where meetings and planning were announced.*
>
> *I think the PAJ was clear about its nonviolent intentions. We warned against police provocateurs creating incidents that could be used to justify police violence. We printed a special pull-out section a week or so before the Jamboree, with suggestions on what to wear (loose, comfortable clothing) and what to avoid (dangling earrings), how to protect yourself against tear gas (a rag soaked in vinegar) and so on.*

How Portland Prepared

Portland got ready for the worst. Civic leaders led by Craig Berkman organized People for Portland to form a human buffer between protestors and legionnaires. Their rumor control office at the Centenary Wilbur Church handled untrue stories of trashed banks and blown-up bridges. Another group set up the legal aid team they assumed protestors would need.

PAJ organizer Hugo du Coudray helped with the radio system:

> *Much of the planning took place in my house on Thurman Street, which became the communication headquarters. People from Seattle came to help. These weren't the big public meetings where people got up and spoke.*

> *We were sure there was at least one government informant at every meeting. We often speculated about who it might be. It was a given for the times. One standing joke was that the American Communist Party would long have been disbanded without regular dues paid by government informants.*
>
> *We never knew how many people to expect at the PAJ, but we thought it would be a big crowd. The underground press publicized it all across America. Tensions were high, and we had to be ready for provocative acts by the PAJ, American Legion and the police. We had no indication that anyone planning the PAJ intended violent incidents, but we were not so naïve that we thought it could not happen.*
>
> *Antiwar demonstrations were often occasions for violence, but the cause was in the eye of the beholder. The people who frightened me the most were the enraged counter-demonstrators supporting the war, and the police, who were mostly of a pro-war sentiment and had the right of legal violence. By the late 1960s, counter-demonstrators or the police had brutalized many antiwar protestors, and they came prepared to defend themselves.*
>
> *By the time we reached the negotiating stage with the city, I was on the sidelines developing the CB radio system. Monitoring emergency radio bands is legal. We had an interest in keeping track of the police as a way to head off violent confrontations. Our field monitors had handsets, and the communication center was the top floor of my house, where I'd rigged an antenna on the roof. It was a good spot, in Willamette Heights.*

The medical community turned to Dr. Charles Spray, founder and director of Outside In, Portland's alternative health center.

"The first I heard of [the PAJ] was when the Multnomah County Medical Society asked me to plan for a disaster," Spray said. "I met with state officials who were charged with setting up preparations for a riot and possible injury to Nixon and Agnew, who were supposed to come."

Outside In head nurse Linda Rice was concerned enough to write a will. "Charlie and I got trunks of emergency supplies," she said. "The Red Cross let us train using their dolls and equipment. We pulled together fifty volunteers to be outside with armbands, filled the room with suture kits and prepared to be swamped."

Others jumped in. The Seattle Liberation Front planned the Sky River Rock Festival for Washougal, Washington, during the same period, and a group led by Ron Abel and Howard Weiner applied for a permit to hold a Free People's Pop Festival in Delta Park.

Action

On August 25, Mayor Shrunk assumed sole control of city government during the convention. On August 28, the governor's office announced that President Nixon would not attend. According to an August 29 FBI memo, press secretary Ron Ziegler "informed Ron Schmidt, Governor McCall's secretary, that Nixon was not coming." Some PAJ leaders saw this as a triumph. Vice President Spiro Agnew would still address the group.

Vortex

In a twist *Life* magazine would later call "diabolically clever," Governor Tom McCall OK'd the nation's first state-sponsored rock festival. The idea started when a group called The Family decided to counter potential violence with a Woodstock-like festival.

An FBI memo dated August 13, 1970, explained, "The Family has been granted use of 800-acre McIver State Park, some 25 miles east of Portland. This festival is to be held during the same dates as the legion convention and is sanctioned as an effort to drain young people from the downtown area in the hope of lessening chances of a violent confrontation."

Glen Swift was a member of The Family:

> *You know about the People's Army Jamboree? They had two public meetings at the dining room in the basement of the Centenary Wilbur Church. They were packed.*
>
> *Anyway, they were talking about what they wanted to do, and I got the impression that they were not going to take a definite stand against violence. This was not acceptable. There was a meeting to discuss an alternative going on upstairs, so I joined them.*
>
> *Our idea was to have a countercultural alternative for those who didn't want to be downtown for the demonstrations. I don't know where we hit on the name Vortex I. During that time, there were music festivals like Bullfrog I, then Bullfrog II, so we thought there might be a Vortex II.*
>
> *There were different branches of the group. You had people involved in antipoverty work. Another group, that I fell into, were small shop owners. Bobby Wehe had a head shop on Tenth Avenue and was involved with a commune in Southern Oregon. He was the super hippie. He wowed people. He liked calling the group planning Vortex "The Family." It wasn't like we all agreed on the name.*
>
> *My shop was the Isis Gallery. It was in the same building as the Wayfarer Restaurant, Beaver Hall and Buffalo Head Nickel. I was not*

much of a hippie. I barely fit within the counterculture. And I didn't fit that well in the New Left, largely because of Vortex. Vortex was the last straw. When the PAJ found out about it, they were very upset.

How did we get permission for Vortex? It's one of the mysteries. What I understood was that three times people from our group went to the governor's office to get his support. I have no idea who was at the meetings. We didn't have any budget for advertising. We didn't have money, connections or even an organization. This drove Bobby Wehe up the wall. He wanted great musicians. He contacted them, and they said no.

Apocalypse Not

When the American Legion arrived and demonstrations started, Outside In nurse Linda Rice hunkered down in the makeshift shelter. The clinic had moved into the Unitarian church's basement, out of harm's way.

"The first day or two we were anxious because we were told they might throw Molotov cocktails at us, and the police could be bashing heads," she said. "Day after day, nobody came." When volunteers showed up the third day, their security person finally had a chance to try his walkie-talkie. "He said, 'Two women and a dog coming down.' The whole basement just howled laughing."

Contrary to expectations, the PAJ was small and relatively peaceful, with events attracting between 200 and 1,700. Meanwhile, Vortex I attracted 40,000 by August 29. Officials ignored drug use and public nudity violations, and police stationed along the highway helped travelers find McIver Park. Business and government groups set up sanitary facilities, offered free food and stayed out of the way. At the same time, the Sky River Festival in Washougal attracted 30,000. The third planned festival, People's Free Pop, failed to get a permit and joined Vortex.

Glen Swift remembers:

> People for Portland raised money for food. We served people through the steam engine cookers provided by Arnie Zidell. Someone went down to California and got us a trainload of onions.
>
> Vortex was actually two festivals. There was a big meadow for the music festival, and then the lower level by the river was the lifestyle festival, where I was. We had teepees and a mud sauna. People brought guitars.
>
> I was in charge of Shanti Sena. This was Gandhi's idea, and I learned it from the Quakers in New York. People in the community

Action

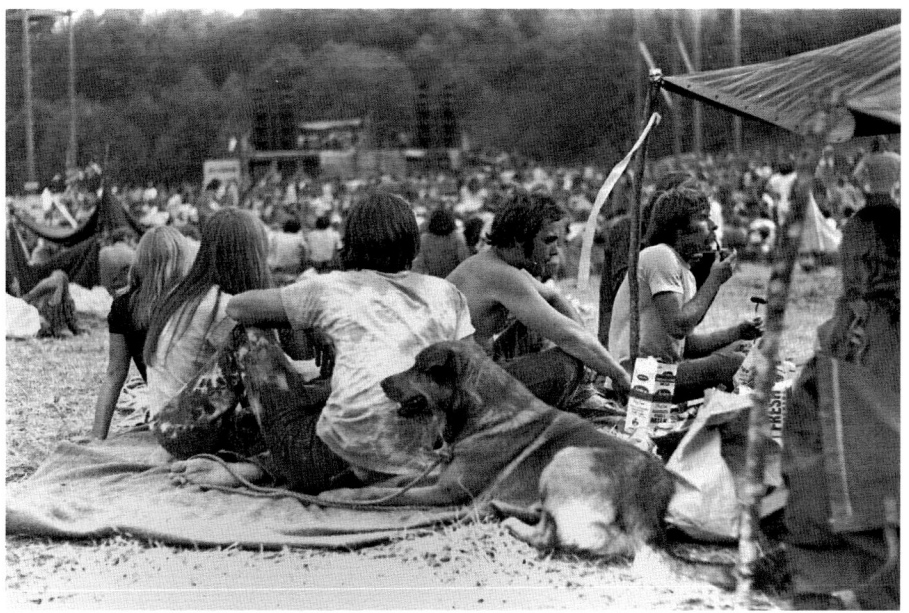

Scene from Vortex. *Courtesy Dick Minor.*

are peacekeepers. They mediate disputes and form a line between angry groups to prevent violence.

I introduced the idea at Vortex. At the press conference, one of the questions was, "Who is going to keep the peace?" I said, "We will keep the peace." They stationed the National Guard and police outside the park. The state gave us walkie-talkies, and we made armbands. I have a picture of myself with one on—nothing else, just the armband.

Our state police liaison arranged to use the grass seed farmers' fields for parking. He told them the National Guard would make sure hippies didn't get in their swimming pools. As things got going, we organized shuttle cars up and down the hill. A woman raised money for the shuttle by holding out a trashcan where people got off.

The people who came to Vortex fascinated me. I saw mostly your average everyday citizens looking to see where their tax dollars were going. Families came with picnics and bathing suits. Half the people in the lower level were tourists.

The Rainbow Family was just starting that year. They wanted a freak-out center, and we coordinated and got teepees. They announced the beginning of the Rainbow Commune at Vortex. Then, in 1971, they

announced the first Rainbow gathering in Colorado would be modeled after Vortex. They still have Shanti Sena.

Retrospective

FBI Memo, September 2, 1970: For information of the bureau, as the PAJ draws to a close, it is the consensus of the entire intelligence and law enforcement community...that the extremely thorough preparation prior to the Jamboree and the unparalleled cooperation among all agencies during its day by day progress led directly to the complete lack of violence or any major disruptive incident throughout the entire six day period.

Maurice Isserman: We thought, now we're organized; we're going to pull this great thing off. Among other things, a potato chip heiress [Penny Sabin] *gave* [the PAJ] *$10,000, a huge amount of money in those days. We bought an offset press for leaflets, and we had an office. We thought people would come from all over, but mostly we thought people from Portland would come.*

So where were those thousands of kids from the student strike in May? The problem was that in the back of everybody's minds was the violence that had taken place during the strike. The fact that the TAC Squad was responsible for the violence, that the only people hurt and hospitalized were the students they attacked, was irrelevant. The connection had been made—antiwar protests lead to violence. Given that connection, no wonder so many young people in Portland decided to head for a rock festival in the countryside rather than march down city streets and potentially get their heads cracked open.

We saw May as the beginning of the flood. But it's hard to sustain the sense of the millennium, living on the edge, apocalypse is coming. The war went on, and Nixon was still in office. Things hadn't changed. What May 1970 represented really in Portland and around the country, where the same scenario played out in a hundred locations, was the beginning of the ebb. We'd reached high tide, and it was beginning to recede.

Hugo du Coudray: Many of my comrades were angry about Vortex, and some still feel that way, but I was delighted. It was far more than one more antiwar parade through town, and a lot less dangerous. It was unprecedented for a state government to sponsor a rock festival, complete with a suspension of drug laws and state police guiding people to the event. Governor McCall's leadership was courageous, creative and humane.

Action

Of course, the sentiment of the crowd was antiwar, and they expressed that with garb, buttons and slogans. It was a peace convention to contrast with the convocation of rabid warmongers in the legion. The governor's men monitoring the event ended up holding hands in an ohm circle with hippies afterward. Vortex would never have happened if not for the Jamboree. We pushed the state government into it. It was an unmatched counterculture coup.

THE BLACK PANTHER PARTY SERVES BREAKFAST

By the time Portland's Black Panther Party started, racial tensions had exploded across the country and heated up locally. Once a bastion of Ku Klux Klan activity, Portland had used real estate practices and neighborhood covenants to channel the majority of its African American citizens into the Albina District. Here, a series of urban renewal projects, including the Memorial Coliseum, Interstate 5 and Emanuel Hospital expansion, repeatedly shifted the neighborhood's cultural center. Discriminatory lending practices encouraged absentee ownership and decay. As elsewhere in the country, Black Portlanders faced racial discrimination, high unemployment, poor-quality schools and tension with the police.

In 1966, Huey Newton and Eldridge Cleaver founded the Black Panther Party in Oakland, California. The group's militant rhetoric put the police

A Portland Black Panther picnic. Kent Ford is in the last row, second from the left. *Courtesy Kent Ford.*

and FBI on alert. While a disdain for pacifism remained constant throughout the country, chapters adapted to local conditions. These interviews with Portland's Black Panther Party leaders provide an insight into the movement here at home.

KENT FORD founded the Portland chapter of the Black Panther Party. In this interview, he cites the high percentage of African Americans fighting and dying in Vietnam as a major and growing outrage. He also talks about help his organization received from the progressive white community. Don Hammerquist, an open communist, was a target of media derision. Jonathan Moscow, who wrote for the alternative paper the *Willamette Bridge*, was instrumental in setting up the Fred Hampton People's Free Medical Clinic and the Malcolm X Dental Clinic. These projects, along with the Children's Free Breakfast Program at the Highland United Church of Christ, ran for several years:

> *I came to Portland in 1961 from the Bay area. I was eighteen years old. Racism here was not as blatant as it was in say, Georgia, Alabama or Mississippi. It was more subtle. Then, you've got the good Oregon people who have a good soul. They don't see your color; they see your character, like Martin Luther King talked about. But the structure we had in the city looked at color.*
>
> *I witnessed police harassment and brutality. I was dissatisfied with the war in Vietnam and our plight here at home. I decided to come in with Huey Newton and Eldridge Cleaver. They had the most progressive program. In Portland, we started in '67, stayed underground for two years and surfaced around 1969. People like Jesse Jackson and Andy Young encouraged people to assimilate into the system, but we didn't want to assimilate. We followed the dictates of Malcolm X.*
>
> *Our organization was down on the streets. I had an apartment on Williams Avenue, and I'd leave the house about 9:30 a.m. We'd see four or five people on a corner, and we'd go up and say, "Look here." We organized with the Peace and Freedom Party, draft resistance groups, Communist Party, Weather Underground. Yeah, they were here. We made alliances with the Asian, Hispanic and progressive white communities. If they were in trouble, we were in trouble. If we were in trouble, they were in trouble. That's the way it was.*
>
> *Survivor programs were the main thing that attracted me to the party. We negotiated a contract with Emanuel Hospital and went into schools to do*

sickle cell testing. When we wanted to open a health clinic, I got a call from a guy at Reed College named Don Hammerquist. I didn't want to discuss it on the phone [since it could be tapped], *so we met, and he told me to call Jon Moscow. We went door to door in the neighborhood asking what kind of clinic people would like, and then we went to the Multnomah County Medical Society. I got involved because nobody cared about people who were disenfranchised from the cradle. Then all these doctors and nurses and other people came forward. Dr. Lendon Smith, a renowned pediatrician who was on ABC every morning, volunteered. Just good Oregon people.*

We also had a breakfast program. I was one of the principals. We recruited kids at Highland School [renamed King School in 1968] *and fed fifty to one hundred every morning. We had pancakes, eggs, toast, hash browns. We got donations from stores and community groups. We made sausage out of hamburger MacDonald's donated. That was another thing. They said we were strong-arming businesses for donations. None of that was true. The FBI started asking local businesses not to donate. They stayed one step ahead of us and one step behind.*

PERCY HAMPTON's parents were among the twenty-three thousand African Americans who migrated to Portland during the 1940s to work in the shipyards. Like most blacks, they were restricted to the Albina District, Guild's Lake and Vanport, a temporary defense housing development that grew into Oregon's second-largest city. On May 30, 1948, the dike holding back the Columbia River broke, leaving Vanport destroyed, fifteen dead and nearly twenty thousand homeless. Many in the black community left Portland. Others squeezed into Albina:

My dad talked about kidnapping his mom off the farm in Arkansas. She was like an indentured servant, but I call it a slave. Every year, the money she owed increased until she owed this guy so much she would never leave. They snuck down there and brought her to Minnesota.

My mom was from Oklahoma and my dad from Arkansas. They came here from Minnesota during World War II to work in the Kaiser Shipyards, and they lived at Vanport. There was so much racism. Even Jantzen Beach had laws that people of color could not swim in their pool.

After the flood, they moved to North Interstate, which was the heartbeat of the black community. There were nightclubs, pool halls, grocery stores, drugstores. Paul Knauls had the Cotton Club, and Geneva's was right up

PORTLAND IN THE 1960s

Children outside their Albina home in the late 1950s. *Courtesy Deborah Patterson.*

the street. Then gentrification came through. It was so unfair to the black community because they'd condemn people's homes and then come back and offer pennies on the dollar. The heartbeat of the black community moved from Williams and Broadway up to Russell and Knox. Now Emanuel Hospital owns that property.

You weren't allowed to move freely. After we sold our house on Interstate, we found a place on Sixtieth and Fremont, but the neighborhood association said they couldn't sell to blacks. We were redlined and ended up on Rodney and Going.

How did I get involved with the Black Panthers? This was 1968. Martin Luther King and Robert Kennedy were killed, and everyone braced for a hot summer. The police were trying to figure out where the pulse was, so they went through arresting people.

I was a square kid. I went to Catholic school so I had different morals and values than some of my partners, and I was scheduled to go to Portland State in the fall. I was going to the store one Saturday evening, and the cops drove up and said, "Boy, where are you going?" I said, "Well, I'm not a boy." I ended up in jail for assaulting a police officer, resisting arrest and disorderly conduct. I never had a record before. My mom told me to stand

Action

up, become active and try to change things. My sister, her boyfriend and I became involved in the Black Panther Party.

We knew they watched us. The FBI named the Black Panthers the most dangerous threat to the stability of the United States, so anything they could do to destroy us they would. When we went to the Oregon Medical Society and asked for permission to start a clinic, the mayor, Frank Ivancie, told them not to provide doctors because of our reputation. Still, they gave us a majority yes. Our plan was to have two or three doctors a night. Soon, we had enough doctors volunteering so each person only had to work once every three months. Then, we talked to the dental society and went through the same process. We gave free dental care, everything from cleanings to extractions.

We decided to start the breakfast program early on, but every time we talked to a church, the police told them, "You don't want that kind of stuff; they'll indoctrinate the kids." But the pastor at the Highland Community Church [Reverend Sam Johnson] didn't have any problems.

We started with fifty kids, and it ran up to about ninety a day. Most waited outside while we got ready because we didn't want them bugging us. After twenty minutes, we'd let them in.

My brother and I did the cooking for my mom. To this day, my sister can't boil water. When the breakfast program started, I was going to Portland State and lived near campus, so I'd take the bus over, jump right in and start cooking. It came out fine. Girls involved in the Black Panther Party came—Linda Thornton, Joyce Radford, my sister Patti Hampton. They helped with cooking, cleaning and getting the kids in and out in a reasonable time. The kids were noisy and wanted to play while they were eating.

Once in a while, parents came. They'd heard horror stories about our indoctrinating kids, not just feeding them breakfast but feeding them other stuff. They also wanted to make sure we gave them something healthy, not a bunch of candy. We welcomed the parents.

After breakfast, I headed back to school. It was the start of black student unions, and there were about thirty of us. My values and their values were different. They were more upper middle class. I was involved in the student strike and antiwar protests, but I didn't occupy the park. I was a high-profile target as it was. And I was a bus door away from going to Vietnam. I had bad grades one term, and they hurried up and changed my status from 4-F to 1-A. Football injuries were the only thing that kept me out of there.

The Black Panther Party newspaper came out of San Francisco, and I was head of local circulation. SDS, the Weather Underground

and Communist Party were on campus, and they sold our papers up and down the avenues. After school, I'd sell papers before heading up to our headquarters. We had a storefront off Martin Luther King Boulevard and held meetings every day.

The Portland Black Panther Party tried to make the changes necessary to help the black community survive. We did make a difference. I show my grandkids where the dental clinic was. We were all about universal health care. I tell them, "You know that breakfast program at school? We started that." I worked for the Laborers Local 296 Union for thirty-six years. I ended up in the office, so we had people come in off the streets. They said, "You don't remember me? You used to give me breakfast over at the church." That happened on numerous occasions over the years.

OSCAR JOHNSON and his parents are native Portlanders. He joined the Portland Black Panther Party while a student at Portland Community College and later worked as a special service technician for the phone company:

As a matter of fact, if Malcolm X hadn't died, there probably wouldn't have been a Black Panther Party. They went by his teachings. They started as a group of guys getting together to defend the black community. Later, once they were recognized, they set up social programs like free breakfast, healthcare and sickle cell testing. They really got into those social programs.

I lived in about every black community we had in Portland, including Vanport. I remember as a kid going in a store, and the lady wouldn't serve us. I didn't know why. "Can I get a candy bar?" and she said, "No." This was in the St. John's area. We went swimming up at Pier Park

I first heard about the Black Panther Party when Huey [Newton] got shot. Then, my cousin, Tommy Mills, recruited me into the Portland chapter. He gave me the reading list, and we'd talk. The Portland Chapter had between fifteen and twenty active members. Others didn't put a lot of time into it, but they were still members.

I became assistant to Floyd Cruse, the [local] minister of information. He did the public speaking, and I did the writing. We wrote for liberal newspapers and put out a bulletin about culture or people being killed down South, things like that. We had to sell the Black Panther newspapers so we slipped our bulletin in there with them.

I'm not sure how the breakfast program started, but one day it did. One of my jobs, when I got off work, was to go pick up people and take them over to the church so they could start cooking. I worked the night shift and

went to Portland Community College. Sometimes I'd solicit funds. We went to every business on MLK. About 60 percent of the businesses were black, but there were a lot of white people down there, too.

The breakfast program was in the church basement where the kitchen was, and they had a room with tables set up. The kids came around in a line for eggs, sausage, toast, milk. They got a good breakfast. What used to get me was when they wanted more. These cute little guys and girls, they'd come up with big eyes.

What would I like people to remember about the Black Panthers? They were a people-oriented organization. They weren't just a bunch of guys carrying guns. In most cases, we didn't believe in turning the other cheek and getting dogs put on us. Malcolm X was completely different from Martin Luther King. King was a pacifist. Malcolm believed in self-protection.

GEORGE OBERG LEADS THE SECOND FOUNDATION

By the time the Second Foundation formed, Portland's Gay Liberation movement was coming into its own. It started when John Wilkinson responded to a "gay, young and lonely" reader in the February 6, 1970 edition of the city's underground newspaper, the *Willamette Bridge*. "Gay life in Portland stinks, and so does gay life in Seattle, and New York, and San Francisco," he wrote. "There are bars and baths and the streets. That's it."

A flood of letters, articles and editorials followed. Soon, a small group met informally at the Centenary Wilbur Church.

Many felt a formal, chartered organization would spur social and political action. By early 1971, the Second Foundation organized for civil rights legislation, community service, public relations and counseling. It opened a community center in its second-floor space on 258 Southwest Alder Street.

The Second Foundation's first president, George Oberg, grew up on a farm near Vancouver, Washington. A fine arts major at Clark College, he joined FMC Technologies as a lab technician in 1959, eventually becoming a chemist. He served in the army reserves between 1955 and 1963:

For all those trying to turn gay people straight, my father's campaign would have made me straight by now. He was after my ass five minutes past puberty.

I knew I was gay by the time I was four. I was the only guy in home economics class. When someone finally told me about gay bars, I thought

Portland in the 1960s

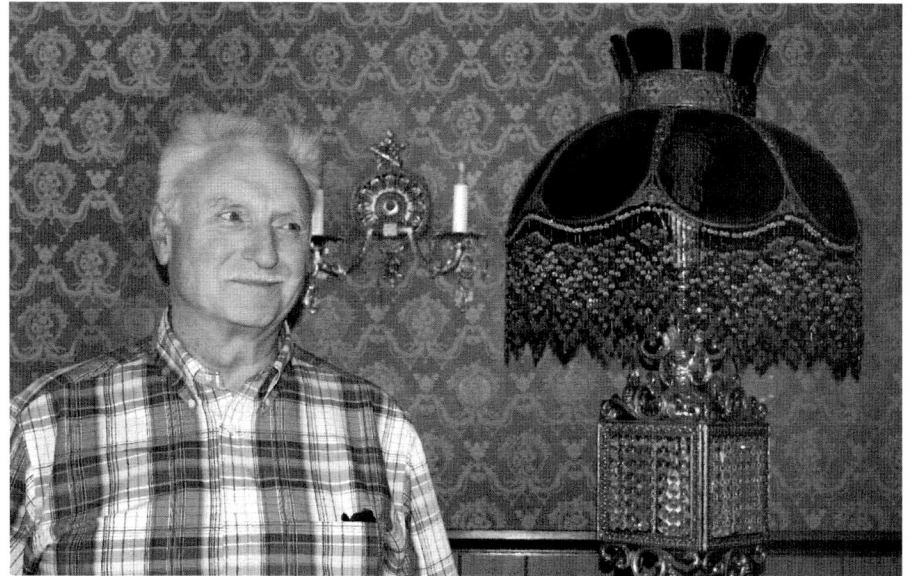

George Oberg in 2011. *Photo by author.*

I'd found Nirvana. This was around the time of the Kennedy Cuban Missile Crisis.

So, I was a chemist at FMC and had a part-time job at the Half Moon Tavern in downtown Portland. Customers were unhappy with gay life being just about bars. They wanted to go hiking, hear music, visit a museum. One afternoon, some kids invited me to a meeting at the Koinonia House at Portland State University.

During the meeting, aggressive political activists overwhelmed shy people. I'd facilitated meetings at the Junior Chamber of Commerce, so I made a circle and passed around some object. Only the person with the object could talk.

Issues came up. Some wanted a gay-friendly place or needed a counselor. Others wanted a garden or hiking group. Soon, we formed an organization called the Second Foundation and started writing a constitution. Someone said I should be president.

As president, I did not run the show. I tried to do a positive and noncombative gay thing. We were not trying to start a fight. We wanted to be accepted as decent people who were gay.

One afternoon, Dave Frederickson said, "George, we've got to go public." I said, "WHAT?" I hadn't told anyone at FMC about being gay. Dave

arranged for us to come out on Dick Klinger's radio program. As we climbed the staircase to the studio, I thought, "Thirteen steps to the gallows." But I'd rather live under a bridge and poor than keep lying about myself.

The next day, my manager at FMC said, "If you need anything just let me know. You have 100 percent backing from the company." From then on, they invited my partner and me to dinners and functions. It was a tremendous boost.

Meanwhile, the foundation started a counseling group. We needed help for people on the verge of suicide. Father Abbott set up a training program for us. I discovered that I was a great talker but not a good listener. I learned a lot.

We also had speaking engagements. I told a high school social studies class about gay people's troubles and what we're doing at the foundation. Students were receptive. The school policy was to have an opposing opinion, so a minister walked in and explained how homosexuality triggered an atomic blast that destroyed Sodom and Gomorrah. The kids laughed him out of the room.

The Oregon State Teacher's Association invited me to speak at the Red Lion. My critiques didn't say one negative thing; in fact, some gay woman wrote, "Thank you—you're doing something I don't have the guts to do." I talked to Mount Angel Seminary students. Mormon boys invited me to their safe house. They weren't anti-church. They just didn't want to be harassed.

That's the sort of thing the Second Foundation did. The best part was showing people that we were not strange, weird or perverted. We were productive. We fit in. Still, years later, people call me radical. They grew up closeted and are afraid of coming out. It's hard to undo that thinking.

DONALD DWAYNE DOWNING HAS A SPIRITUAL EXPERIENCE

As an early gay rights leader, Donald Dwayne Downing focused on organizing a place for gays and lesbians to worship. In this interview, he mentions Darcelle (aka Walter Cole), who became Portland's renowned drag queen, and the 1970 Gay Liberation meetings at the Centenary Wilbur Church:

My coming-out story is interesting. While I studied for the ministry at Cascade College, I worked as a missionary for the Sunday school in Corbett. I drove up to the Grange Hall and conducted worship services. I

had an acquaintance who was familiar with the gay community. He was gay himself, although he was married, and he figured out that I was, too.

On my twenty-first birthday, I went to a gay bar and met a wonderful man named Little Joe. I went back to my fundamentalist church and had three exorcisms trying to stop being gay. When I came out, I dropped religion. I felt God had forsaken me, and I had to accept myself.

Then I had a spiritual experience. I was living with a gay guy who became a Catholic priest. One night, I came home, and he was reading the Bible. A wonderful study Bible that I'd used as a missionary was on the table. I'd marked "S" for sermons in the columns. I hadn't read it in months. I realized that religion, the Bible and my relationship to God were a critical part of my authentic person, and it remains so to this day.

I'll always remember the pioneers who put their jobs and families on the line by coming out. Gay Liberation met one night a week at a church. It was more of a social hour. We chatted, drank coffee and talked. We were trying to accept ourselves as valued citizens and accept gay love and commitment as a reality that society should support. Gay was a new word. Many people felt that homosexuals were unhappy, and it was an oxymoron to call ourselves gay.

I'd heard about Koinonia House meetings through Neil Hutchins and Dennis Kennedy, who passed out notices in gay bars. These grew into the Second Foundation of Oregon. We met at Zorba the Greek and started raising money for the organization. Darcelle lent his bar, and the queens helped organize special fundraising events. George Oberg ran the meetings, stayed in touch with the committee chairs and kept things on track. Many members used pseudonyms. I went by Dwayne Downing. When a member donated office space in the Portland Music Building, the Second Foundation opened a telephone hotline. A lot of calls were, "I'm from out of town, how do I meet gay people in Portland?" Then, we got calls from people who were trying to come out but their work environment was hostile.

At that time, homosexuality was anti-Christ. Consequently, gay Christians had no place to worship. I decided Portland was ready for a gay church and became chair of the Second Foundation Religious Committee. We held services Sunday mornings at 11:00 a.m. in the chapel of the YMCA. I was pastor and led the hymns. An organist played for a Lutheran church, then drove over and played for us.

We worshipped at the YMCA until the Second Foundation moved to Southwest Alder Street and opened a community center. We had a pool table and held dances with a disc jockey on Friday and Saturday nights. We moved the church there.

Action

Portland's Gay Church started at the YMCA. *Courtesy City of Portland Archives, YMCA Building at Southwest Taylor and Sixth, A2004-005.*

I would like people to know that when you're called to the ministry, to the Holy Spirit, obedience is a sacrifice. I had a missionary calling on my life and that is what I did. For me to continue my work, I needed a worship group to carry the message that God loves the homosexual.

LETTERS TO THE *FOUNTAIN*

Like today's social networks, alternative newspapers linked individuals during the 1960s era. When Portland's gay community organized the Second Foundation and opened their community center, they set aside space for the *Fountain* and published between 1971 and 1973.

At first, editor Lanny Swerdlow worked under the pseudonym Dave Laurance. A government fish biologist, he worried that open homosexuality would cost him his job. Before testifying for an Oregon civil rights amendment, he spoke to Governor Tom McCall, who assured him that

Portland in the 1960s

supervisors would not fire him. As Swerdlow anticipated, newspaper reports of the proceedings did out him. "For me, it is one hell of a relief to no longer have to lead a double life," he wrote in his next editorial.

While the *Fountain* covered political and social events, the letters to the editor or "Community Rap" sections may be the most interesting through today's eyes. Identity, family, politics and religion played out in each issue, as shown by this sample:

> COMMUNITY RAP
>
> *The greatest problem in a homosexual community is the under 21 group. In most cases a young man is brought up hearing whispers like "gay is bad" so let's drown out those whispers with screams of "gay is good." Make him aware and help him to understand that homosexuals are not perverted queers. This need to talk is great and this state of confusion can be eliminated with the help of some God-loving gay, who's willing to give his hand and heart to a needing soul.*
>
> *Another problem in the under 21 group is no social life. What I would like to see, and I speak for others also, is a weekly social gathering of some sort, even if it's to play volleyball. I live in a small community, and I'm sure there are at least 100 young gay people like myself that want to get together and get something going. I am willing to help set up some sort of place where gays can come in to rap and get things off their chest and not be ashamed of talking about homosexuality. Where do I find these people? Where do I look?*
> —Dan Blair, July 1971

> COMMUNITY RAP
>
> *One of the worst difficulties for any homosexual, but especially for the young, is the problem of identity. There are no homosexual images in our society with which people want to identify. Those few images that exist are ones of scorn and derision. A lot of young men will resort to the screaming queen stereotype as a result.*
> —Anonymous, July 1971

Action

To all my sisters:
I love all women. That is a very large statement to understand, but it is true. I have never met a woman yet I could not love. I do not imply making love. I just have strong positive (LOVE) feelings. I love you too much to embarrass you by showing my affection in public.

I am angry with people who put fences on my affections. I walk down the street and see women and men holding hands, kissing, arms entwined. I want to scream. It's unfair, because I cannot do this to my love because we are both women.
—Mary K., December 1972

To the Editor,
This is in regard to the Second Foundation of Oregon. I go to the foundation to meet people of my own kind and to meet people with the same interests as I. I depend upon the Community Center for a place to go to have fun and as something to keep me off the street, as do a lot of the other younger people (meaning under 21). As I walked into the center tonight, I noticed a sign on the front door saying that the Second Foundation of Oregon will be closed on December 17 to all people under 21. I think this is very unfair. The community center is meant for "ALL" people all the time. Having a party is fine, but if they want liquor, they should go to the tavern. The foundation isn't a bar or night club.
—Skip Mooney, January 1973

Portland in the 1960s

Community Rap
Being a homosexual and a youth, we find problems with other teenagers not accepting us as we are, and they call us such names as faggot, queer, sissy, etc. Another problem is that older people just use us as bed partners and do not associate with us on a social level. They think that associating with us will open the doors of their closets to straight society.

Since we are very close to our parents, we find that we cannot be honest with them, so we pretend to do what they want us to do like dating girls, etc.
—*Michael Moten, July 1971*

Dear Editor Dave,
I know this comes a bit late to comment on Should You Tell Your Parents, but I have some ideas. So many have said their parents accepted the knowledge, but didn't want to even talk about it again. This is so sad, as parents and child are miserable to say nothing of the barrier it causes between them. Others have related that their parents accepted and were eager to learn all they could, so as to share this part of their son's life. These are in the minority, unfortunately. I knew of one instance that their son was driven away from home by his father at shotgun point. Still others, through fear of the unknown have made up their minds never to accept homosexuality. I personally feel that if true love exists between parents and child, this love will overcome all obstacles, even homosexuality.
—*Phyllis Shafer, December 1971*

With the help of legislators like Vera Katz, Gretchen Kafoury, Steve Kafoury and Gladys McCoy, gay activists like George Nicola worked to include homosexuals within existing civil rights laws. The Second Foundation's political group interviewed and graded local candidates. The 1972 presidential election between George McGovern and Richard Nixon drew much attention:

Action

To Editor Dave Laurence:
If you people who call yourselves gay are also sharp, you won't press your "gay rights" plank because you might saw it in two. Prudence may win the day yet. Minorities generally have quite a bit going for them in the George-McGovern-for-the-People plank. The "typical gay rights" are not only rights they should have, but rights all Americans should have.
—Professor Joseph Portal, November 1972

BEGINNING WITH RED EMMA

Portland's 1960s-era feminist movement began with small get-togethers and expanded to groundbreaking social and cultural institutions. Kristan Knapp (aka Aspen) came of age as things woke up. As the daughter of a liberal United Church of Christ minister, she was exposed to issues but had not participated. After graduating from Marshall High and Oberlin College, she volunteered for an international exchange program.

"In 1970, I went on the third Venceremos Brigade and spent a month in Cuba fertilizing grapefruit trees," she said, referring to an organization that supports the Cuban revolution.

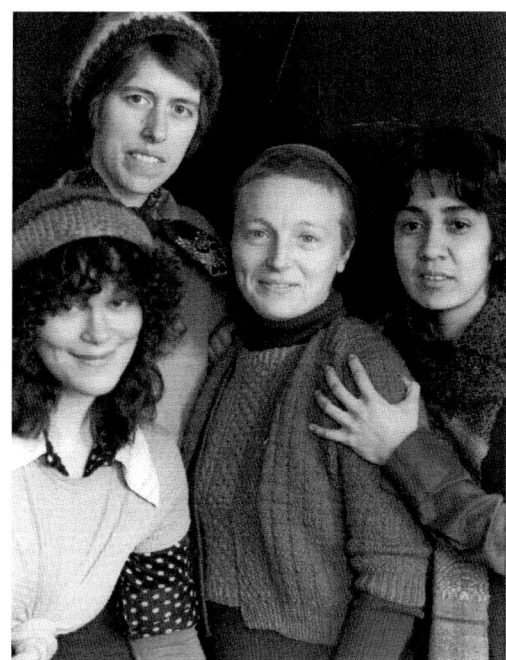

Donna Pollach's portrait of the Izquierda Ensemble. *From left*: Robin Chilstrom, Kristan Knapp (Aspen), Izetta Smith and Naomi Littebear Morena. *Courtesy Susan St. Michael.*

Portland in the 1960s

There were four hundred of us, including Angela Davis's sister. Each night, a group spoke about their political work in the belly of the monster in the USA. Not only did I learn about the Weather Underground and SDS, I learned about Gay Liberation, curiously enough because Cubans weren't into it, that's for sure. This was one year after Stonewall; it was way new. It was a light bulb experience.

Knapp felt her life fall into place. "I came out, moved back to Portland and sought out feminist activities," she said. She met Bonnie Tinker while helping with International Women's Day events. From an activist Quaker family, Tinker's siblings once protested the Vietnam War by wearing black armbands to school. The incident ended with the Supreme Court upholding free speech in *Tinker v. Des Moines School District*. Bonnie Tinker and a group of activists from Grinnell College founded Red Emma, a Portland women's collective named for political activist Emma Goldman. They invited Knapp to join:

Like most collectives, we put all our money in a pot. We experimented with not having personal possessions. Lesbians we met in downtown bars thought we were crazy because we danced together and lived in a group. They came from working-class backgrounds and were not feminist or college educated. They were couple oriented and into masculine and feminine roles. We were androgynous.

Red Emma sought and found projects that helped women. Under the supervision of nurses and Oregon Health Science University medical students, their women's clinic on Hawthorne Boulevard provided pap and pregnancy tests and, later, early abortions. They rented a place on Northeast Prescott Street and Seventh Avenue and founded a halfway house for women leaving prison. "We tried to find a group who needed help from feminist sisters," Knapp said. "We figured they mostly wrote bad checks because they couldn't feed their families.

"Many women at the home had worked as prostitutes to survive," Knapp continued. "Some were drug addicts or had alcohol issues. One woman at Prescott House came from prison, but everybody else was from the streets." As the house evolved into one of the first domestic violence shelters on the West Coast, they renamed it Bradley-Angle after two drug overdose victims.

"We shared the issue of violence in our lives," Knapp said. "We also were oppressed. That empowered us to create institutions to support ourselves. Even someone who was struggling could help someone else, in the same way alcoholics' anonymous works."

Action

Women's Culture

"My whole reason for living was to create women's culture and discover women's history," Knapp said. "How did the women live, and how could we as women live in a self-actualized way that was not dependent on men?" Many agreed, and local institutions blossomed—like Olive Press, A Woman's Place bookstore, *Women's Spirit* magazine, Keep Listening Wilderness Trips and the Women's Studies Program at Portland State University.

"Thinking of a deity as a female form changed everything for me," Knapp said. "I still participate in a circle of women who gather for earth-based holy days. *Women's Spirit* magazine was the beginning of putting those thoughts and ideas together in Oregon, along with the *We'Moon Almanac*. It's about astrology, herbology and phases of the moon."

Knapp attributes much of Portland's success in becoming a women's music center to Naomi "Littlebear" Morena, whom she met in the early 1970s. "Naomi was a hippie street person hitchhiking between here and Los Angeles," she said. "She was self-taught and emerged on her own brilliance." The two teamed up to found Ursa Minor, a lesbian choir that performed

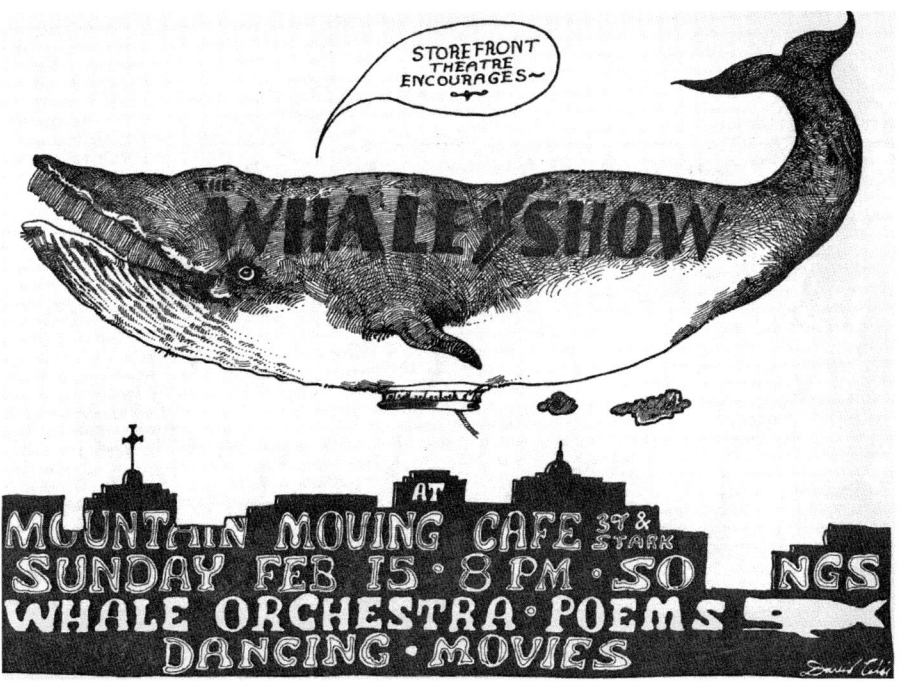

Flyer by David Celsi. *Courtesy of the artist and City of Portland Archives.*

music Littlebear composed. A few years later, Robin Chilstrom and Izetta Smith joined Knapp and Littlebear to form the Izquierda Ensemble, which toured nationally.

"The first record of women's music was the Chicago Women's Liberation Band in 1972," Knapp said. "But in 1972, Maxine Feldman also produced the forty-five single 'Angry Atthis' that was on the juke boxes in the lesbian bars. Naomi Littlebear and Robin Flower backed her up and toured around."

Littlebear and Flower also performed at the Mountain Moving Café. Started by the feminist Mountain Moving Collective, including Ellen Goldberg, Kathy Bethel, Julie Starobin and Kiera O'Hara, the restaurant became the phenomenon of Southeast Thirty-ninth Avenue and Stark. "They served vegetarian food, homemade breads and fantastic desserts like New York cheesecake," Knapp said. "It was popular with all the politicos and became the center to organize everything."

Looking Back

"Whether I have experienced discrimination isn't important," Knapp said, reflecting on women's and gay/lesbian rights since the days she first joined Red Emma. "Nobody should experience discrimination. It's important to be out so people know and like someone who is gay or lesbian and realize that they are contributing members of the community.

"Lon Mabon did us the best service," she continued, referring to the founder of a conservative Christian organization that sponsored anti-homosexual initiatives.

> *He brought the conversation about gays into every sphere—the workplace, churches, social clubs. By the time Ballot Measure 9 was defeated, we used to say, there wasn't a three-year-old who didn't know the words lesbian and gay. This is what will cause change.*
>
> *I didn't come out to my parents immediately but waited to get my own bearings. My parents were liberal and took it pretty well. I was surprised that my mother cried for twenty-four hours. She focused on not having grandchildren and not having me in a white dress. I'm the only girl, so it was a loss to her.*
>
> *My parents offered themselves as a resource by co-founding the Portland chapter of Parents and Friends of Gays and Lesbians. The* Oregonian *refused to run an advertisement about the organization. They said, "We are a family newspaper." That's how far we've come.*

Appendix
1960s TIMELINE

Year	Portland Events	National Events
1958	Karl Leopold Metzenberg opens the Caffe Espresso at 1834 Southwest Sixth Avenue. Portlanders approve the city's first urban renewal project, which destroys fifty-four blocks of the immigrant neighborhood South Portland.	Elvis Presley is inducted into the army.
1959	Eight hundred *Oregonian* and *Oregon Journal* workers begin a strike that will last five years.	Fidel Castro comes to power in Cuba.
1960	The Congress of Racial Equality pickets downtown stores in support of southern lunch counter sit-ins. The Memorial Coliseum opens. The project destroyed Albina's commercial center and 476 homes.	Black college students stage lunch counter sit-ins and found the Student Non-Violent Coordinating Committee.
1961		Freedom Riders defy Jim Crow laws in the Deep South.

APPENDIX

Year	Portland Events	National Events
1962	The Columbus Day Storm kills thirty-eight people and causes $200,000,000 in damages.	Ken Kesey publishes *One Flew Over the Cuckoo's Nest*. Bob Dylan releases his first album. The Cuban Missile Crisis begins.
1963	President Kennedy's visit to a low-cost senior housing project is cancelled when the local NAACP threatens picketing over discriminatory Portland Housing Authority practices.	Betty Friedan publishes *The Feminine Mystique*. Civil rights leader Medgar Evers is assassinated. Reverend Martin Luther King delivers his "I Have a Dream" speech. President John F. Kennedy is assassinated.
1964	The Portland Peace Council commemorates the nuclear bombing of Hiroshima by launching paper lanterns on the Willamette River.	The Beatles appear on the *Ed Sullivan Show*. During Freedom Summer, thousands of civil rights activists, including a group from Oregon, help with the southern voter registration drive. The Civil Rights Act of 1964 passes. The Berkeley Free Speech Movement begins.

1960s Timeline

Year	Portland Events	National Events
1965	Approximately 1,300 Portlanders demonstrate against Selma, Alabama violence. Anti–Vietnam War protestors begin regular vigils at the Armed Forces Induction Center. Whitey Davis opens the Folksinger across from the Central Library.	Malcolm X is assassinated. The first U.S. combat troops land in Vietnam. During the Newport Folk Festival, Bob Dylan uses an electric guitar publicly for the first time. President Lyndon Johnson signs the Voting Rights Act. Riots in the Watts section of Los Angeles result in thirty-four dead.
1966	Ken Kesey's sixth acid test takes place in Portland. Anti–Vietnam War demonstrations during Vice President Hubert Humphrey's visit result in twenty-nine arrests.	The National Organization of Women forms. The Diggers begin their Free Food movement. California declares LSD illegal. Other U.S. states and the rest of the world will soon follow. The Black Panther Party forms.
1967	Vice squad and federal agents seize marijuana and arrest fifty-two. The *Oregonian* runs Drugs and Portland Youth series. Timothy Leary speaks at Portland State College. Allen Ginsberg's May visit to Portland includes a benefit at the Crystal Ballroom. The Charix coffeehouse opens in the basement of the First Unitarian Church. The Psychedelic Supermarket opens.	Spring Mobilization Against the War draws demonstrators in New York and San Francisco. A Golden Gate Park Be-In kicks off the Summer of Love.

Appendix

Year	Portland Events	National Events
1968	A *Newsweek* article predicts young people from around the country will head to Portland en masse. Dr. Charles Spray opens Outside In. The *Willamette Bridge* publishes its first issue. KBOO-FM Radio goes on the air. City commissioner Frank Ivancie closes city parks at night.	Reverend Martin Luther King is assassinated. Radicals take over buildings at Columbia University. Robert F. Kennedy is assassinated. The Democratic National Convention in Chicago results in demonstrations and violence.
1969	Portland State College becomes Portland State University. Portland vice officers seize narcotics in apartments near Lair Hill Park. Twenty to thirty thousand Oregonians participate in the October 15 Vietnam Moratorium.	New York's Stonewall Riot marks the start of the national Gay Liberation movement. The United States puts the first man on the moon. The Rolling Stone concert at Altamont results in one homicide and three accidental deaths. The October 15 Moratorium to End the War in Vietnam draws millions. President Nixon signs the new draft lottery system into law. Black Panther Fred Hampton is shot dead.

1960s Timeline

Year	Portland Events	National Events
1970	The Portland Black Panther Party opens free clinics and a children's breakfast program. John Wilkinson's letter to the *Willamette Bridge* starts Portland Gay Liberation. Sandy Polishuk's (aka Kosokoff) *Willamette Bridge* article invites participants to Women's Liberation discussion groups. On May 6, the Portland State University student strike begins. On May 11, the TAC Squad attacks Portland State University antiwar demonstrators, sending thirty-one to the hospital. From August 28 to September 3, the American Legion Convention takes place in Portland. From August 28 to September 3, the Vortex Festival of Life takes place in McIver State Park.	On March 6, the Weathermen blow up a Greenwich Village town house and move underground. On April 30, President Nixon announces the U.S. invasion of Cambodia. On May 4, National Guard troops shoot and kill four students at Kent State University, triggering a national student strike. On May 14, Police shoot and kill two students at Jackson State University.
1971	The Red Emma Collective opens a women's health center. Portland feminists open Prescott House. The gay newspaper the *Fountain* begins publication. The *Willamette Bridge* prints its last issue.	The Senate gives President Nixon authority to eliminate student deferments under the draft.
1972		Watergate burglars are arrested.

Appendix

Year	Portland Events	National Events
1973	Vera Katz introduces Oregon's first gay rights bill to the Oregon legislature. It fails by two votes.	The U.S. Supreme Court decision *Roe v. Wade* legalizes abortion. U.S. combat troops leave Vietnam, ending an eleven-year war.

BIBLIOGRAPHY

BOOKS

Dietsche, Robert. *Jumptown: The Golden Years of Portland Jazz, 1942–1957*. Corvallis: Oregon State University Press, 2005.

Garvy, Helen. *Rebels with a Cause: A Collective Memoir of the Hopes, Rebellions and Repression of the 1960s*. Los Gatos, CA: Shire Press, 2007.

Gitlin, Todd. *The Sixties: Years of Hope, Days of Rage*. Toronto: Bantam Books, 1987.

Hills, Tim. *The Many Lives of the Crystal Ballroom*. Portland, OR: McMenamins Pubs & Breweries, 1997.

Isserman, Maurice, and Michael Kazin. *America Divided: The Civil War of the 1960s*. New York: Oxford University Press, 2000.

Love, Matt. *The Far Out Story of Vortex I: Part Two of the Beaver State Trilogy*. Pacific City, OR: Nestucca Spit Press, 2004.

Peck, Abe. *Uncovering the Sixties: The Life and Times of the Underground Press*. New York: Pantheon Books, 1985.

JOURNALS

Boag, Peter. "Does Portland Need a Homophile Society? Gay Culture and Activism in the Rose City between World War II and Stonewall." *Oregon Historical Quarterly* 105, no. 1 (Spring 2004).

Brown, Valerie. "Music on the Cusp: From Folk to Acid Rock in Portland Coffeehouses, 1967–1970." *Oregon Historical Quarterly* 108, no. 2 (Summer 2007).

Bibliography

Gibson, Karen J. "Bleeding Albina: A History of Community Divestment, 1940–2000." *Transforming Anthropology* 15, no. 1 (January 7, 2008).

Life. "The Legion Goes to Portland: A Protest Fizzles but the Vets Show Their Age." September 11, 1970.

Newsweek. "The Hippie's New Nirvana." May 20, 1968.

Newspapers

Allen, Penny. "The Portland Reporter." *Portland Today*, November 16, 1976.

Berry, Jack, and Magmer, James. "Drugs and Portland Youth." *Oregonian*, February 19–26, 1967.

Bianco, Joe. "Caffe Espresso Young Intellectual Hangout." *Oregonian*, November 12, 1958.

Calaway, Marvin D. "Undercover Agent Declares Hippies Interested Only in Drugs." *Oregonian*, January 18, 1968, section 6M.

Deane, Early. "PSU Art Exhibit Stirs Up Storm; Critics Denounce 'Pornography.'" *Oregonian*, December 3, 1969.

Feldman, Nina Green. "The Charix, a View from the Bridge." *Willamette Bridge*, October 11, 1968.

Floyd, Richard. "Volunteer Workers to Operate City's Health Clinics for Hippies." *Oregonian*, June 12, 1968, section 3M.

Hicks, Bob. "Beyond the Age of Aquarius." *Oregonian*, June 10, 1990.

———. "Death of the '60s." *Oregonian*, July 14, 1991.

Hilliard, William. "500 Join Portland Walk for Peace, Hear Call for Fellowship in the World." *Oregonian*, April 2, 1961.

Jacklett, Ben. "The Secret Watchers." *Portland Tribune*, January 13, 2002.

Keller, Bill. "Breakfast, Clinic Programs Belie Militant Panther Image." *Oregonian*, November 12, 1971.

Klare, Gene. "Let Me Say This About That." *Northwest Labor Press*, November 1, 2002; June 6, June 20, July 4 and July 18, 2003.

Magmer, James. "Police Aide Blames Lectures, News Articles in Upsurge of Drug Users." *Oregonian*, February 9, 1967.

McBride, Charles. "A Church Filled With Living." *Oregonian*, February 2, 1969.

Morning Oregonian. "Tent Colony Is Opposed, Heights Terrace Residents Appeal to Council for Relief." May 13, 1916

Oregonian. "Anti-War Demonstrators Picket Induction Center." July 27, 1967.

———. "Anti-War Rites Draw Support of Oregonians." October 16, 1969.

———. "Artist Colony Lodges." May 1, 1929.

Bibliography

———. "Café Man Absolved in Slayings." May 29, 1959.
———. "Caffe Espresso Owner Termed Far From Beatnik Type." May 16, 1959.
———. "City Begins Hippie Crackdown, Park Use Ordinance Approved." July 12 1968.
———. "City Official Makes War on Hippies after Two American Flags Destroyed." July 11, 1968.
———. "City Starts Machinery to Condemn 'Village.'" October 4, 1962.
———. "Daily Status Planned for Portland Reporter." July 27, 1960.
———. "Dope Raid Arrests Total 52." January 9, 1967.
———. "Free Clinic for Youths to Open in SW Location." June 21, 1968, section 4M.
———. "Hippie Visits Not Desired." May 1, 1968.
———. "Marchers across Nation Protest Vietnam War." April 16, 1967.
———. "Newspaper Ban Stirs PSC Revolt." May 27, 1967.
———. "1,300 Portlanders Hold Protest March." March 14, 1965.
———. "Permissive Attitude of Clinic Stumbling Block to Funding." February 16, 1969.
———. "Pickets Ask Racial Level." March 3, 1960.
———. "Portland Judge Fines Three for Selling Hippie Paper." August 4, 1967.
———. "Portland Men Picket Britons." February 19, 1961.
———. "Scenic Lodge Cottages." May 31, 1918.
———. "So Our Readers May Know, No. 2." November 26, 1959.
———. "Streets to be Vacated." February 16, 1918.
———. "Two Portlanders Fasting in Protest of Blockade." October 26, 1962.
———. "Vice Officers Seize Drugs." May 3, 1969.
———. "Youths Hand Out Leaflets in Protest Against Draft." October 22, 1965.
Oregon Journal. "Hippies Might Make Scene in Portland This Summer." May 1, 1968.
Portland Reporter. "Expansion of Reporter Called Certain." July 5, 1960.
———. "A New Newspaper." February 11, 1960.
———. "Sheriff's Office Alerted before Newspaper Truck Bombed." January 31, 1960.
Schulz, Blaine. "Police Haul off 29 Anti-War Pickets, Youth Booked after Protest in Parking Lot." *Oregonian*, September 28, 1966.
Shoemaker, Mervin. "Kennedy Cancels Speaking Visit in Portland." *Oregonian*, September 20, 1963.

Sullivan, Ann. "Artist Finds Nostalgic Scenes in Doomed Hillside Village." *Oregonian*, October 29, 1962.

———. "Drug Abuse Spreads Among Area Schools." *Oregonian*, March 16, 1969.

Tugman, Peter. "Portland Students Disobey 'Riot Act.'" *Oregonian*, February 14, 1960.

Vanguard. "Barricades Fall after Six Days." May 12, 1970.

———. "Wolfe Stops Classes; Buildings Stay Open." May 8, 1970.

Willamette Bridge. "Nirvana on the Willamette." June 7, 1968.

Zaitz, Clarence. "Risk of Violence Here Highest in Nation, U.S. Warns." *Oregon Journal*, September 5, 1970.

Pamphlets and Theses

Anderson, James A. "Inside Outside In: An Analysis of the Youthful Drug Users in Portland." Master's thesis, Portland State University, 1970.

Buhler, Julie Lorana. "The Civil Rights Movement in Portland, Oregon, 1955–68." Honor's thesis, University of Oregon, 1983.

Corsi, Jerome R., and Ralph G. Lewis. "Confrontation or Accommodation? The American Legion and the People's Army Jamboree in Portland." Lemberg Center for the Study of Violence, Brandeis University, Waltham, Massachusetts, 1972.

Green, Grant Stephen. "One for All and All for Nothing: The Portland Newspaper Strike." Master's thesis, University of Oregon, 1968.

Guimary, Donald Lee. "The Decline and Death of the Portland Daily Reporter." Master's thesis, University of Oregon, 1966.

Hylton, Dory J. "The Portland State University Student Strike of May 1970: Student Protest as Social Drama." PhD diss., University of Oregon, 1993.

Jackson, James Tucker. "Culture War: The Battle for Portland's Lair Hill Neighborhood, 1968." Master's thesis, Portland State University, 2007.

Uris, Joseph S. "The Lair Hill Park Neighborhood on Examination of the Phenomenon of Community Creation." Master's thesis, Portland State University, 1971.

Weinstein, Joel, and Cathy Wood. "PSU Strike." Strike Collective, Portland, Oregon, 1970.

Bibliography

Manuscripts and Archives

City of Portland [Oregon] Archives.
 American Friends Service Committee (AFSC). 2/3, A2004-005, December 31, 1984.
 Black Panthers, A2004-005, December 31, 1986.
 Citizens Coordinating Committee on Vietnam. 1/2, A2004-005, December 31, 1968.
 Lair Hill Park Area. A2011-002, December 31, 1968.
 People's Army Jamboree. 12/12, A2004-005, December 31, 1986.
 Portland State University Demonstration. A2011-002, May 30, 1970.
 Vanguard, the. A2004-005, December 31, 1986.
FBI Bureau File 100-HQ-459278, Section 1–3.

Recorded Interviews

Mercer, Victoria. Interview by Susan Stelljes, 1997.
Richardson, Harper. Interview by Dave Kohl and Barbara Bernstein, 2005.
———. Interview by Tom Richardson, with questions from author, 2011.

Websites

BBC News. "Millions March in U.S. Vietnam Moratorium." www.news.bbc.uk/onthisday.
Chicago Tribune. Topics, Democratic National Convention, 1968. www.chicagotribune.com.
"Chronology, Vietnam in Context." www.washingtonpost.com/wp-srv/national/longterm/vietnam/chronology.htm.
Costello, Lou, and Sid Fields. "Slowly I Turned Step by Step." www.youtube.com/watch?v=9pQii1L8fGk.
Digger Archives. "The '60s Date Machine." www.diggers.org/chrono_dates_list.asp.
"The Portland Zoo Electric Band," www.pzeb.com.
USA Today/CNN Gallup Poll. "Vietnam War." www.usatoday.com/news/polls/2005-11-15-iraq-poll.htm.

INDEX

A

Abel, Ron 116
acid test 27
Actors Theatre Company 82
Agnew, Spiro 117
Agora Coffeehouse 56
Aitken, Julie 65
Albina District 121
Aldermaston 102
Allison, Vivian 83
Altamont 111
American Communist Party 116
American Friends Service
 Committee 46, 102
American Legion Convention 112
American Theater Company 51
Amick, Frank 23
Armed Forces Induction Center
 103, 141

B

Baez, Joan 46, 85
Ballot Measure 9 138
Barricade 108
Bavasso, Julie 60
Bay of Pigs 100

Beaver Hall 117
Behind the Mike 41
Belluschi, Pietro 33
Berkeley Barb 86, 114
Berkman, Craig 115
Bethel, Kathy 138
Black Panther Party 91, 104, 111, 121
Black Student Union 125
Blair, Dan 132
Blue Cheer 17
Bradley-Angle House 136
Brautigan, Richard 75
Brentano, Ron 27, 37
Bruna, Katherine Richardson 82
Buffalo Head Nickel 117
Bullfrog Festival 117
Bunce, Louis 33, 41

C

Caffe Espresso 34, 40, 76, 102
Cambodia 111
Centenary Wilbur Church 25, 79,
 90, 115, 127, 129
Charix 25, 54, 77
Cheesman, Maryalice 69

Index

Chicago Women's Liberation Band 138
Child, Patsy 76
Children's Free Breakfast Program 122
Children's Museum 15
Chilstrom, Robin 138
Citizens Coordinating Committee on Vietnam 102
City Lights Bookstore 27
city parks ordinance 17, 142
Clark, Bud 62
Clark, Don 79
Cleaver, Eldridge 121
Collins, Mary 75
Columbus Day Storm 79
Communist Party 122
Condon, Christopher 89
conscientious objectors 72, 87
Cooper, Alice 86
Corno's 73
Cotton Club 123
Country Joe and the Fish 68, 85
Cruse, Floyd 126
Crystal Ballroom 17, 45, 56, 77
Cuckoo's Nest 65
Curtis, William 84

D

Darcelle (aka Walter Cole) 27, 29, 41, 129
Davis, Angela 136
Davis, Reverend Gary 53
Day, Dorothy 101
Days and Nights Bookstore 40, 102
Deane, Alice 59
Demas Tavern 30
DeWeese, Bill 71
Diggers 24, 45, 88
Dow Chemical 106
Downing, Donald Dwayne 129
draft resistance 80

drug bust 16, 17, 141
Drukman, Mason 102
du Coudray, Hugo (aka Maynard) 46, 103, 106, 112
Duke, Clarence Stanton 41
Duniway Park 21
Dylan, Bob 27, 42

E

East Village Other 86
Emanuel Hospital 121
Ewing, Gary 27, 64

F

Family, The 117
FBI files 112
Feldman, Maxine 138
Fellowship of Reconciliation 102
Ferlinghetti, Lawrence 27, 75
Firesign Theater 86
First Unitarian Church 25, 77
FISH 72
Flower, Robin 138
Fly-by-Night Jass (sic) Band 61
Flynn, Elizabeth Gurley 101
Focus 101
Ford, Kent 122
Fornara, Peter 82, 108
Fort Tricia Nixon 107
Fountain, The 131
Frederickson, Dave 128
Fred Hampton People's Free Medical Clinic 122
Freedom Summer 71
Free People's Pop Festival 116

G

Gallo, Louis N. 21
Gardner, Mary Alice 23
Gay Liberation 136
Gay Nineties 34, 97

Index

gay rights 80, 87
Geneva's 123
Gerety, Anne 56
Gerety, Nick 58
Gilbert, Jim 23
Ginsberg, Allen 44
Glide Memorial Church 80
Goldberg, Arnold 77
Goldberg, Ellen 138
Goldman, Emma 136
Grano, Bill 65
Greater Portland Council of Churches 25
Great Pumpkin 17, 27, 45
Green Mitten 87
Grinnell College 136
Group Theater 59
Guthrie, Woody 37

H

Haertig, Gray 83, 108
Haight Ashbury 77
Half Moon Tavern 128
Hammerquist, Don 122
Hampton, Fred 111
Hampton, Patti 125
Hampton, Percy 123
Hari Krishna 85
Harrington, Michael 101
Harris, David 46, 73, 103
Hart, Patti 33
Hathaway LeRoy 40
Heathman Hotel 78
Hebb, Paul 35
Hedges, John Kearney (Cap) 97
Hell's Angels 64, 111
Hicks, Bob 57
Highland (King) School 123
Hill, Nicholas 56
Hill, Tom 56
Hill, William Lair 15
Holy Model Rounders 61

Honeychild and the Three Bears 76
Hopkins, Gerald Manley 75
Horn, Gene 25
Horowitz, David 108
Howard, Larry 29
Humphrey, Hubert 102, 141
Hustle and Bustle on Russell 60
Hutchins, Neil 130

I

Indisputable Jugband Itself 53
Industrial Workers of the World 90
Ingham, Emery 64
Ingham, Jo 65
International Women's Day 136
Isis Gallery 117
Isserman, Maurice 89, 115
Ivancie, Frank 17, 56, 77, 109, 125, 142
Izquierdo Ensemble 138
Izquierdo, Manuel 33, 38

J

Jackson, Charles Samuel 95
Jackson, Jesse 122
Jackson State University 56, 111
Jazz Northwest 41
Jim Kweskin Jug Band 37
Johnson, Blind Willie 54
Johnson, Reverend Sam 125
Jones, Patrick Lloyd 17

K

Kafoury, Gretchen 134
Kafoury, Steve 134
Kaiser Shipyards 123
Katz, Vera 134
KBOO-FM Radio 83, 88, 108
Keep Listening Wilderness Trips 137
Kennedy, Dennis 130

Index

Kennedy, Robert F. 111, 124
Kent State University 50, 105, 111
Kerr, John and Mary 25
Kesey, Ken 25, 27, 76
KGON-FM Radio 41
King, Reverend Martin Luther 111, 122
KINK-FM Radio 78
Klinger, Dick 129
Knapp, Kristan (aka Aspen) 135
Knaul, Paul 123
Kohl, Dave 80
Koinonia House 128, 130
Kosokoff, Stephen (aka Kaye) 46, 103, 108
KRAB-FM Radio 83
Ku Klux Klan 121

L

Laborers Local 296 126
Lair Hill Park 50
Lamm, Lester 106
Langston, Peter 52
Laura and the Vipers 45
Laurance, Dave 131
Lewis and Clark College 54, 104
Lezak, Sid 102
Libby, Paul 81
Liberation News Service 86
Life magazine 117
Lincoln High 19, 74
Los Angeles Free Press 115
LSD 20, 68, 78
Lyman, Mel 37
Lysistrata 56

M

Mabon, Lon 138
macrobiotic 19
Madison High 23
Malarky, Sue 71

Malcolm X Dental Clinic 122
marijuana 20, 81
Maris, Margo 25
McCall, Tom 117, 131
McCoy, Gladys 134
McDonald, Levi 97
McFarland, Tom 54
McGovern, George 134, 135
McIver State Park 117
McMonies, Elinor 33
McReynolds, Dave 101
Memorial Coliseum 121
Mercer, Victoria 57
Metropolitan Community Church 82
Metropolitan Human Relations Council 111
Metropolitan Learning Center 25, 62
Metzenberg, Karl Leopold 28
Midtown Ballroom 17
Milam, Lorenzo 83
Millar, Branford P. 47
Mills, Tommy 126
Monty Python 60, 86
Mooney, Skip 133
Morena, Naomi "Littlebear" 137
Moscow, Jonathan 122
Moten, Michael 134
Mountain Moving Café 138
Mulligan, Kevin 108
Multnomah County Medical Society 116, 123
Murphy, Francis 41
Museum Art School 36, 50

N

National Guard 113
National Student Association 105
Neighborhood House 15, 20
Newhouse, Don 97
New Left 112
Newsweek 88

INDEX

Newton, Huey 121
Nicola, George 134
Ninth Street Exit Coffeehouse 25, 81
Nixon, Pat 82
Nixon, President Richard M. 58, 91, 104, 105, 111, 134
Nordine, Ken 86
Northwest Labor Press 95
nuclear disarmament 100

O

Oberg, George 127, 130
Ogilvie, Nick 42
O'Hara, Kiera 138
Ohio National Guard 58, 105
Olive Press 137
Oregon Historical Society 36
Oregonian 45, 50, 78, 94, 102, 138
Oregon Journal 87, 94
Oscar Johnson 126
Outside-In 25, 78, 116

P

Pacifica Radio 83
Pander, Henk 19, 56
Parkinson, Lynn 54
Patton, Sharyle 54
Peace and Freedom Party 122
Peace Rites Festival 44
People's Army Jamboree 111
Phantasmagoria 69
photo offset printing 86
PH Phactor Jug Band 17, 27, 45, 68
Polishuk, Sandy 45, 89
Portal, Joseph 135
Portland City Archives 21, 101
Portland newspaper strike 94
Portland Scribe 89
Portland State College (University after 1969) 24, 50, 57, 67, 84, 97, 100, 111, 124, 128

Portland State University Student Strike 105, 120
Portland Students for Peace 102
Portland Tribune 101
Portland Zoo 17, 27
Prescott House 136
Psychedelic Supermarket 17, 64
Pythian 17, 56

Q

Quaker Fellowship 102

R

Radford, Joyce 125
Radio Free Portland 108
Rainbow Family 119
Reagan, Bonnie and Peter 73
Red Emma 135
Red Squad 100
Reed College 36, 44, 52, 71, 89, 101
Reinhardt, Bill 84
Reiter, Norman 109
Rice, Linda 78, 116
Richardson, Austin Harper 72, 79
Rifer, Wayne 75
Rothwell, Dr. C. Easton 33
Rubin, Jerry 19
Russo, Mike 27, 37
Rustin, Dr. Arnold 78
Rustin, Rose 78

S

Schmidt, Ron 117
Schrunk, Terry 54
Seale, Bobby 106
Seattle Repertory Theater 51, 57
Second Foundation of Oregon 127, 130, 131
Seeger, Pete 101
Seer, The 86
Shafer, Phyllis 134

INDEX

Shrunk, Mayor Terry 79, 109
sickle cell testing 123
Simo, Connie 38
Sixth Avenue Records 42
Sky River Rock Festival 116
Smith, Carl 34
Smith, Charles E. 15
Smith, Dr. Lendon 123
Smith, Izetta 57, 138
Smith, Jim 41
Smith Memorial Union 106
Snodgrass, Rondal 44, 71, 81
Society for New Action Politics (SNAP) 44, 102
Society of Strangers 107
Solomon, Norman 85
Sonny Terry and Brownie McGhee 101
Spray, Dr. Charles 77, 116
Springers 56
Starobin, Julie 138
Stelljes, Susan 57
Stereotypers Local 49 95
Stewart, Larry 108
Stickney, C. Walter 31
Stoner, Bruce 67
Stonewall 136
Storefront Theatre 51
Student Non-Violent Coordinating Committee 53, 105
Students for a Democratic Society 105, 111, 125, 136
Survival 89
Swerdlow, Lanny 131
Swift, Glen 117

T

TAC Squad 109
Thirteenth Avenue Gallery 27, 35, 40
Thorenson, Howard 75

Thornton, Linda 125
Tinker, Bonnie 136
Trimble, Charles 100
Tweedy Brothers 27, 45

U

Underground Press Syndicate 86
Unitarian Church 54
United Church of Christ 135
University of Oregon 103
Upward Bound 44
urban renewal 15, 29, 40, 121
Uris, Joe 17, 56, 101
Ursa Minor 137

V

Valdez, Antonio 17, 86
Vanguard, The 47
Vanport 67, 123
Venceremos Brigade 135
vice squad 141
Vietnam Day Committee 103
Vietnam Moratorium 105
Vietnam War 48, 56, 72, 100, 105, 111, 122, 136
Village, The 31
Vortex I 117

W

Wardwell, Don 41
War Resisters League 72, 88
Washington High 69, 72
Watergate 91
Watts, Allen 46
Wayfarer 60, 117
Way Out Café 27, 69
WBAI-FM Radio 83
Weather Underground 105, 111, 122, 126, 136
Weggler, Becky Krall 74

Wehe, Bobby 118
Weiner, Howard 116
Weiskopf, Doug 108
Weissert, William 46
Wells, Michael and Mary 83, 86
We'Moon Almanac 137
White Eagle Tavern 58
Whitehead, Hannah 75
Whitehead, John 75
White Panther Party 113
Widman, Harry 50
Wilkinson, John 89, 127, 143
Willamette Bridge 50, 65, 83, 87, 103, 115, 122, 127, 135
Willamette Learning Center 25, 82
Willamette Rising 90
Williams, Cecil 80
Wolfe, Gregory 106
Woman's Place Bookstore 137
Women's Liberation 89
Women's Protective Division 79
women's rights 80, 87
Women's Spirit magazine 137
Women's Studies Program 137
Woodstock 68
Wykoff, John 95

Y

YMCA 130
Young, Andrew 122
Young, Gretchen Enyart 31
Young, Ric 57

Z

Zaharakis, Michael 108
Zappa, Frank 86
Zidell, Arnie 118

ABOUT THE AUTHOR

Polina Olsen is the author of *Stories from Jewish Portland* (The History Press, 2011) and other books on local history. She grew up in New York and was active in the Student Peace Union and Vietnam Peace Parade Committee during the 1960s. She traveled throughout Asia and South America for several years and in 1977 settled in Oregon with her British husband, Andy. She is a University of Oregon graduate in computer science and worked for high technology companies for more than twenty years.

Polina Olsen works as a freelance writer in Portland, Oregon, where she lives with Andy and cats Baba Ghanoush and Koshka.

Visit us at
www.historypress.net